AMPHOTO'S
Complete
BOOK OF
Photography

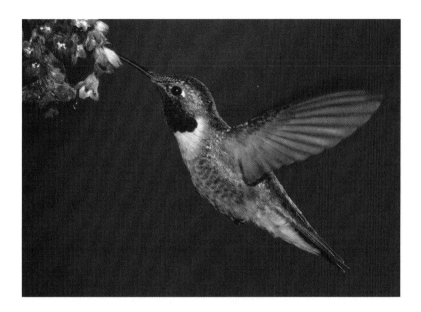

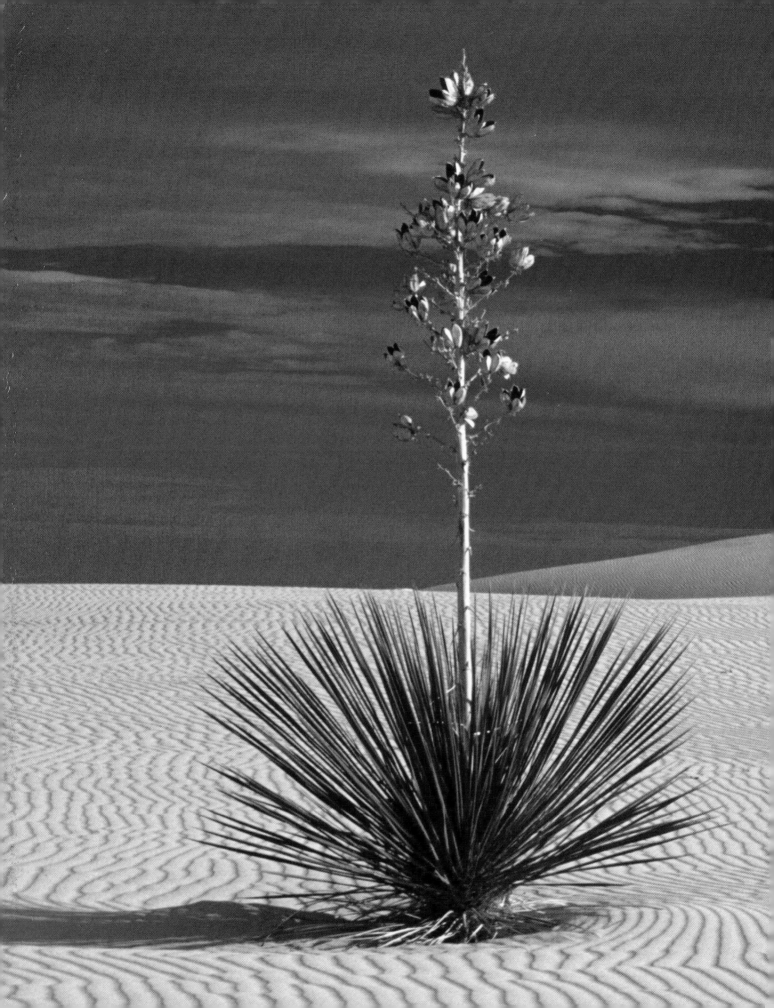

AMPHOTO'S
Complete
BOOK OF
Photography

HOW TO IMPROVE YOUR PICTURES
WITH A FILM OR DIGITAL CAMERA

Jenni Bidner

PHOTOS BY
Russ Burden

AMPHOTO BOOKS
an imprint of
Watson-Guptill Publications
New York

CREDITS & ACKNOWLEDGMENTS

Jenni Bidner developed the concept, content, and text for this book. Russ Burden shot all the photographs except those otherwise acknowledged in the captions.

We would like to thank photographers Tony Amenta (scuba-diving shot on page 187), Nick Burden (finger photograph on page 10), Steven I. Rosenbaum (infrared image on page 23), and Meleda Wegner (Jen Bidner's photograph on the opposite page and photographs of the police dog on page 132 and the rolling dog on page 135). The owl photograph on page 27 and the wolf on page 139 were taken at the Wildlife Science Center in Forest Lake, Minnesota (find them on the Web at www.wildlifesciencecenter.org).

We would like to acknowledge the editing contributions of Dr. Fred J. Heinritz, along with the talented staff at Amphoto, editor Patricia Fogarty, and designer Areta Buk. Russ Burden would like to thank his wife and son, who have supported and encouraged him to pursue his lifelong dream of photography.

Senior Acquisitions Editor: Victoria Craven
Editor: Patricia Fogarty
Designer: Areta Buk
Production Manager: Hector Campbell
Text set in 10-pt. Berkeley Book

First published in the United States in 2004 by Amphoto Books,
an imprint of Watson-Guptill Publications,
a division of VNU Business Media, Inc.
770 Broadway, New York, New York 10003
www.amphotobooks.com

Library of Congress Control Number: 2004111154
ISBN: 0-8174-3486-0

Printed in the U.S.A.

First printing, 2004

1 2 3 4 5 6 7 8 / 11 10 09 08 07 06 05 04

About the Author & Photographer

JENNI BIDNER, AUTHOR

Jenni (Jen) Bidner is the author and photographer of numerous books on photography and one on search and rescue dogs entitled *Dog Heroes: Saving Lives & Protecting America.* She is the former editor of *Petersen's Photographic, Outdoor & Travel Photography, Canon Insight,* and other magazines. Her photographs and articles have appeared in numerous magazines and newspapers around the world.

In her spare time, Jenni is a member of the volunteer canine (K9) search and rescue community, training and handling her two search dogs, Yukon (German shepherd) and Ajax (German shorthair pointer, pictured).

Jenni Bidner lives in the Chicago area and can be contacted by email at bidner@mail.com.

RUSS BURDEN, PHOTOGRAPHER

Russ Burden is a professional photographer specializing in nature and people. His images have appeared in numerous publications worldwide and on calendars produced by Kodak, the National Audubon Society, the Sierra Club, and the National Wildlife Federation.

Twenty-seven years of experience as a school teacher has honed Russ's ability to create before-and-after photographs that quickly and clearly demonstrate photographic technique.

Russ is able to combine his dual talents as a teacher and photographer in his nature photography workshops and the tours he leads in locations around the United States, including the Oregon coast, Grand Teton National Park, and the Slot Canyons in Arizona. He also conducts autumn tours to New England. Visit www.russburdenphotography.com for information on upcoming workshops. Russ can also be contacted at burden@ecentral.com.

Contents

Introduction

Writers always hope you'll read their books from cover to cover, and this one begins with basic information about cameras, film, and lenses. However, it is also designed to be modular. You can jump to the chapters that interest you at the moment—at the start of spring, that might be the one on photographing flowers—and learn the techniques the pros use, or just brush up on your skills.

If you're shooting with a digital camera, you'll find that all the chapters, except the one on film, relate to you.

In the past, much of a photographer's skill was in mastering complex camera functions. Automation of these functions—from auto-focusing to rear-curtain flash synchronization—have made much of the technical side of photography almost invisible. Today, designing your photograph and utilizing the automated functions creatively is what separates the masterpieces from the snapshots.

Almost half of the techniques in this book can be used with any camera, including a simple, one-time-use disposable camera. If you have a higher-end point-and-shoot camera with a few user-selectable options, nearly two-thirds of the book pertains to you. And the entire book will be useful to photographers who enjoy the advanced capabilities and accessories of an SLR camera, such as filters and interchangeable lenses.

In this book, you'll find that mastering exposure goes far beyond getting it "right." You'll learn how to manipulate aperture and shutter speed selections to create precise effects. The various chapters cover most of the accessories that can improve your film and digital photography, from tripods to flash and filters.

Design is the heart of good photography, as it is with good artwork of every type. At first glance, the concepts introduced in the chapter on composition may seem simple; for example, when you look at the photographs in the section that describes the use of lines (see pages 94–95), the ideas can be easy to see. But when you're at the scene, camera in hand, and looking at the three-dimensional world, such advice can be challenging to execute. Theoretical book learning is great, but photographers must practice those lessons in the field until they become instinctual.

Every type of photography has its own set of technical concerns. Whether you want to shoot portraits of people, sports action, scenes you come across in your travels, flora and fauna, or even underwater or aerial images, this book delivers the information you need to succeed.

Good luck, and enjoy your shooting adventures!

How to Use This Book

COLORFUL ICONS WILL HELP YOU FIND THE INFORMATION THAT IS RIGHT FOR YOU

THIS BOOK IS DESIGNED to help photographers improve their pictures. A vast array of photographic equipment is available, and the features and capabilities of different types and brands of cameras vary greatly. Even point-and-shoot cameras have advanced so much in capability that it is now possible to achieve outstanding results with these so-called "snapshot" cameras.

The pages in this book carry symbols coded by color—for any camera (including point-and-shoots), some cameras (including high-end point-and-shoots), and single-lens-reflex (SLR) cameras—that will help you quickly determine which techniques and which pictures are possible with your camera. In many sections, blue sidebar boxes suggest "tricks" for making a point-and-shoot camera perform like a more advanced SLR camera.

If you have not yet purchased a camera or are considering upgrading, read pages 10–11, which describe the advantages and disadvantages of SLR and point-and-shoot cameras.

Digital Cameras

A digital camera is really just a "traditional" film camera that uses the digital computer medium, rather than film, to record images. Because digital cameras come in low- and high-end point-and-shoot models, as well as single-lens-reflex (SLR) designs, the camera-type system used in this book is equally valid for film and digital cameras.

Any Camera

Pages coded with the blue "any camera" symbol provide advice to photographers who shoot using film or digital technology with a disposable camera, a point-and-shoot, or a single-lens-reflex (SLR) camera.

Some Cameras

For the techniques described on pages with this symbol, you'll need a high-end point-and-shoot camera or an SLR. For example, these pages describe techniques you can achieve using an extended zoom range or specialized exposure modes and flash options.

SLR Cameras

Your camera will need specialized functions to achieve the effects on these pages—for example, advanced exposure modes that allow you to select certain apertures and shutter speeds; a wide choice of interchangeable lenses; exposure compensation options; or use of accessory flash. Usually these advanced features are available only with a single-lens reflex (SLR) film or digital camera, but a few high-end point-and-shoot cameras also have them.

POINT-&-SHOOT USERS

Throughout the book, blue boxes like this one will give you tips for performing advanced functions with a point-and-shoot camera.

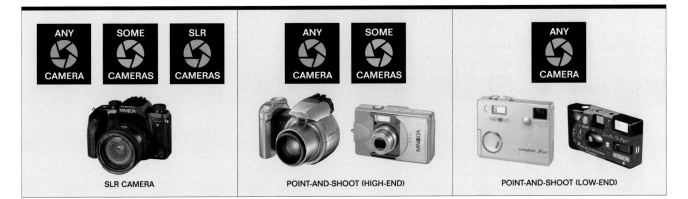

SLR CAMERA POINT-AND-SHOOT (HIGH-END) POINT-AND-SHOOT (LOW-END)

Point & Shoot or SLR?

EACH HAS ADVANTAGES & DISADVANTAGES

THE FIRST DECISION a photographer faces is the type of camera to use. The basic choice is between point-and-shoot cameras and single-lens-reflex (SLR) cameras.

Point-&-Shoot Cameras

Point-and-shoot cameras tend to be compact and easy to use. Low-end models may be focus-free, meaning they do not automatically focus and require that your subjects be within a certain distance range for good results. Better cameras provide focusing options, a zoom lens, specialized exposure modes, sophisticated flash options, and other features.

Point-and-shoot cameras are a lens-shutter design. As such, they have two lenses—one to take the picture and one for viewing the scene. (If your finger strays onto the picture-taking lens, you may not see it in the viewfinder, but it will certainly be visible in the print.)

With distant subjects and average conditions the lens-shutter design is not an issue. Particularly when you want to shoot a subject up close, your photographs could suffer from "parallax error" (described in more detail on page 153), in which parts of the subject are cut off in the final image.

Another problem is that most point-and-shoot cameras have heavily center-weighted autofocus. This means that if your main subject is off center, the camera will focus on the background, not on the main subject, but you won't see the lack of focus in the viewfinder. You can get around this difficulty by practicing the focus lock technique described on page 112.

Note that there are a few SLR cameras that are so small and easy to use that they seem to be point-and-shoot cameras. It is their through-the-lens viewing design that separates them from their lens-shutter counterparts.

SEPARATE VIEWFINDER

LENS

Point-and-shoot cameras are especially susceptible to missed focus. Because you are looking through a separate viewfinder lens, you won't see that your picture is out of focus (top left). To avoid this problem (bottom left), use the focus lock technique described on page 112. With a point-and-shoot camera you may not see your own fingers in front of the picture-taking lens (right). Photo © Nick Burden

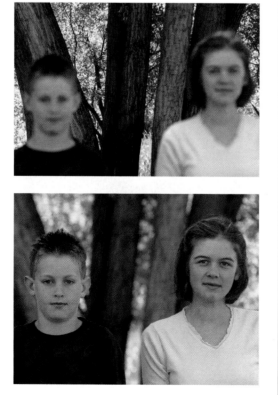

SLR Cameras

Single-lens-reflex (SLR) cameras offer through-the-lens (TTL) viewing. The advantage is that you see most of the effects of the lens and can verify in the viewfinder that the camera is autofocusing (or you are manually focusing) on the right picture element. Depth-of-field preview on some cameras allows you to see how the aperture setting will affect your final pictures (see pages 35 and 180–181).

Many SLR cameras also offer sophisticated autofocusing, with multiple "islands" to detect and track off-centered or moving subjects. In addition to being able to continuously focus on moving subjects, they offer extremely fast shutter speeds (such as 1/8000-second) for freezing the action.

An often overlooked creative advantage of SLR cameras is the availability of different exposure modes that give you full control over aperture and shutter-speed selection.

If you choose not to use these various exposure modes, most modern SLRs offer a program (P) mode that gives excellent results in general shooting situations.

Interchangeable lenses (see pages 24–29) provide options that are impossible with a point-and-shoot camera. You have a choice of super-wide angles, telephoto lenses for distant subjects, macro lenses for close-ups, and zooms that encompass part or all of that range.

Other accessories for SLR cameras include powerful accessory flash, studio-style flash units, remote triggering devices, underwater housings, and more.

Manual-focusing SLR cameras are popular with photography students both because they are economical and because they require the photographer to "learn" the controls. Low-end autofocusing models are highly automated and offer few manual controls. Top-of-the line professional models offer both.

Most SLR cameras accept interchangeable lenses, allowing you to creatively alter your pictures through your selection of focal length. The photo on the left was taken with a macro lens; for the one on the right, the photographer used a 20mm ultra-wide-angle lens. (See pages 24–29 for more on lenses.)

LOOK FOR THESE BOXES

Throughout the book, blue boxes like this one suggest ways you can use a point-and-shoot camera to achieve or mimic the techniques of more sophisticated cameras.

What About Digital Photography?
THE LINE BETWEEN DIGITAL & FILM CAMERAS IS GETTING THINNER

DIGITAL CAMERAS are cameras that shoot computer pictures rather than using film. (Okay, it's a little more complicated than that—but not much.) They offer a few features that film cameras can't, but it's the recording medium that's the basic difference. Digital cameras fall into the same point-and-shoot versus SLR categories indicated in this book by the blue, green, and red symbols (any camera, some cameras, and SLR cameras, respectively).

In the simplest terms, a digital picture is a computer-language file that describes what a picture should look like. Seconds after you've taken a picture with a digital camera, you can view the image on the camera's monitor. To save images more permanently, you'll need to transfer them to a computer, microdrive, or CD burner (usually via a cable, memory card reader, or wireless connection).

Once the digital files are on your computer, they can be "read," and the data creates a photograph you can see on your computer monitor. This picture file can be sent to a printer or shared with other computers (via a cable, email, or upload to a Web site). It can also be manipulated and changed with photo-editing or graphics software. A few fancy printers let you print the pictures without using a computer.

What's a Pixel?
A digital picture is created from individual picture elements (called pixels). Each pixel holds a little bit of the picture. On a much smaller scale, a pixel is like an individual piece in a jigsaw puzzle. When all the pixels are put together, the picture emerges.

The more pixels in a picture, the higher the resolution. Not all pixels are the same, so resolution alone is not the final factor in determining quality. In general, however, the higher the resolution, the more detail a digital picture can hold.

The Importance of Resolution
The number of pixels (dots) in a picture determines the pixel resolution. A picture that is 1000 pixels across and 1000 pixels high is a megapixel in size ($1000 \times 1000 = 1,000,000$). One million pixels equals one megapixel.

When a digital print is described, the resolution can also be indicated in terms of pixels per inch (ppi). The 1000×1000 megapixel image described above could be 10×10 inches at 100 ppi ($100 \times 10 = 1000$).

Certain output devices (such as computer monitors, ink-jet printers, and traditional photo printers) require a certain number of pixels (or dots) per inch (ppi or dpi) to give good results. (Though technically different, the terms dpi and ppi are often used interchangeably.) If you know the dpi you need, you can multiply it by the final size you want in order to determine how high a resolution you need. For example, many PC computer monitors are set at about

Just like traditional film cameras, digital cameras are available in point-and-shoot (left) and SLR (right) models. The classifications in this book (the blue, green, and red icons) are all applicable for digital camera users as well.

100dpi, so to create a 4×6-inch image on the monitor for emailing you'd need at least a 400 × 600-pixel-resolution image.

Ink-jet prints usually look good at 150ppi (or greater), so that means 600 × 900-pixel resolution for a good print. The ppi specification should not be confused with the dpi (dots per inch) specification on your ink-jet printer, which relates to how the ink is put on the paper, not the ppi requirements of your digital picture. Because 200 to 250dpi is recommended for 4×6-inch digital prints made by a minilab photoprinter, you'd want a resolution of 800 × 1200 to 1000 × 1500 pixels for good results.

For any of these applications, you could use resolutions that are higher than necessary, but they would take longer to process, send, and print—much longer! Most photographers shoot or scan at a high resolution so they can have all the pixels they may need, but then also save copies (with slightly different names) at lower resolutions as the need arises.

Digital Camera Features

There are a few features on a digital camera that you won't find on a conventional film camera. They include removable memory, digital zoom, and settings for file format, color mode, picture size or resolution, and equivalent ISO (equivalent "film" speed).

MEMORY. Digital cameras require memory to save the digital image files when a picture is taken. Memory is usually measured in terms of megabytes (MB). Some cameras have internal memory, like the memory on your computer hard drive. Some use removable memory, not unlike the way your computer can save files to CD disks (about 700MB of memory), Zip disks (100 or 250MB), or the now archaic floppy disks (1.4MB). Most can be erased and reused over and over.

REMOVABLE MEMORY. Different camera models use different formats of removable memory. By far the most popular are the Compact Flash memory card series, SmartMedia type wafers,

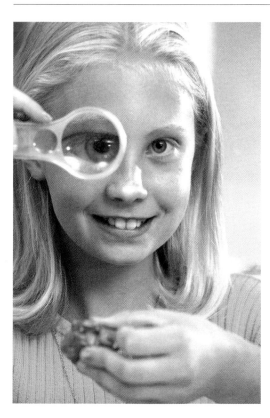

The image on the left was shot and saved at high resolution. The photographer saved the one on the right at low resolution. High-resolution pictures can be made into large prints. Low resolution pictures cannot, but they can be emailed faster and are better for Web sites.

and memory sticks. Whatever the form, what you want is memory that can be removed and swapped, in much the same way that you switch rolls of film. If you fill up a memory card or stick but don't want to stop shooting to download the images to your computer, you can just remove the card or stick and add another one. Removable memory cards and sticks are available in different capacities, such as 64 megabytes (64MB) or 512 megabytes (512MB).

A few inexpensive digital cameras do not have the option of removable memory cards or sticks; instead, the images are recorded on the camera's "hard drive." Once this internal hard drive is full, you have to transfer the images to a computer or other storage device and then erase the pictures from the camera's memory (this function is sometimes called "format" or "reformat") before there is "room" to shoot more.

DIGITAL ZOOM. This option is not as good as it sounds. Digital cameras with *optical* zoom lenses are great, because the lens works to alter the angle of view to give you wider or narrower (magnified) fields of view. Using an optical zoom lens does not affect the resolution of the picture, because it happens before the light hits the imaging sensor.

Digital zoom, on the other hand, is unrelated to the lens. It merely crops the center portion of the image, making it appear that you have zoomed in to a more telephoto setting. However, it is basically just cropping. Moreover, digital zoom does not utilize the entire imaging sensor and thus effectively reduces the resolution. If you're shopping for a camera, compare only the optical zoom specifications (and not the digital) if you want to judge apples to apples. Then turn off the digital zoom feature when you're shooting. If you want to make the subject bigger in the final image, move closer. Or plan on cropping it later with photo-editing software—the results will be better that way.

FILE FORMAT. Some digital cameras offer the option of two or more file formats. By far the most common file format for digital photographs is the jpeg (pronounced "jay-peg"). It is a compression format, meaning the

file size can be greatly reduced without too much degradation of the overall quality. The name of a jpeg photograph ends in the file extension ".jpg"; this part of the file name may be hidden in some Mac and PC operating systems.

Some cameras shoot in a high-quality "raw" or proprietary format that requires special software to view or convert the images into standard file formats. TIFF is a format found on some cameras. It is a professional format that has a larger file size than jpeg. However, TIFF is the preferred format for high-end retouching and reproduction in magazines and books. The name of a TIFF photograph ends in the file extension ".tif"; again, this part of the file name may be hidden in some Mac and PC operating systems.

COLOR MODE. This handy feature gives you minute control over the color of your image. In its simplest form, you can select between color and grayscale (commonly called black and white). Some cameras add saturated color, sepia (brown-toned grayscale), and similar options. A few high-end cameras provide color-temperature control that allows you to correct overall color casts (see pages 174–178 for a discussion of color temperature). All of these color modes can be achieved with photo-editing software. Many photographers prefer to shoot with the neutral or auto-color mode and manipulate the effects later, an approach that allows them more options.

MULTIPLE PICTURE SIZE (RESOLUTION) SETTINGS. Most cameras offer these options. For a given amount of memory, you can choose between shooting a lot of smaller images that can't be enlarged to huge sizes and shooting a smaller number of high-resolution images that can be printed in poster sizes or used for professional applications. Since a 3-megapixel image can easily be enlarged into a beautiful 8×10-inch picture, you may decide to select this size even if your camera has 5-megapixel capability. The file for a 3-megapixel picture is considerably smaller than one for a 5-megapixel image, so you can take more 3-megapixel pictures before you have to stop and change memory cards.

On the other hand, if you think you'll want to greatly enlarge your photo or publish it in a magazine or book, you should switch to the highest resolution the camera offers. The same is true if you think you might crop the image later, because cropping reduces the overall resolution as you "throw away" parts of the picture.

EQUIVALENT ISO. Cameras that offer multiple equivalent ISO settings are handy, too. Like film, higher-number ISO figures mean better low-light capability (see pages 18–19). Also similar to film is the fact that the low-light capability comes at a price: Higher equivalent ISO settings result in reduced overall quality of the image.

GOING DIGITAL WITH A FILM CAMERA

If you're not ready to invest in a digital camera, don't worry. There are plenty of ways to "digitize" traditional images so that you can retouch or manipulate them on the computer, share them through email, or post them to a Web site.

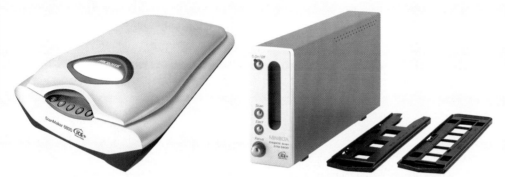

Flatbed scanners (left) make it easy to scan photographic prints, artwork, and other relatively two-dimensional objects. A film scanner (right) creates high-resolution scans of your negatives and slide (transparency) films.

Poor film processing or heat damage caused an unpleasant color cast in this film image (left). After the transparency was scanned in a film scanner and then saved to a computer, it only took 15 seconds to alter the overall color using photo-editing software (right).

Once in the Computer

Once you have images that are digitized (either directly from a digital camera or through the use of a scanner), there are countless things you can do with them.

1 **EMAIL.** You can email images to friends and family. It's best to save a lower-resolution copy of the image for this purpose, because "low-res" images take less time to be sent and received. Most computer monitors display images at about 75dpi (Mac) or 100 dpi (PC) at normal display settings. (See information on resolution on pages 12–13.)

2 **POST TO A WEB SITE.** You can post digital images on your own Web site. Most Internet service providers now offer free homepages. Or you can find an inexpensive host like Homestead or Geocities and use their online software to quickly and easily build your own site.

3 **RETOUCH & IMPROVE.** Photo-editing software has become so simple that you can make big improvements, changes, and manipulations the first time you try. Popular programs that retail for less than $100 include Adobe Elements, MGI PhotoSuite, and Microsoft Picture It. With a little practice, you can correct color problems, improve brightness and contrast, retouch blemishes in portraits, remove distracting background elements, combine photographs, add text, and more.

4 **PRINT AT HOME.** Once you've used software to perfect your images, you're ready to print. High-performing, photo-realistic ink-jet printers are now available for less than $100—but beware: The cost of papers and inks can be substantial! More expensive printers offer archival inks that won't fade if displayed for long periods, as well as water-resistant inks.

5 **SPECIALTY PAPERS.** If you want to get high-quality prints, you'll have to use glossy photo paper, which is about as expensive as having reprints of film negatives made at a photo minilab. The advantage in doing it yourself is that you have greater control.

Specialty papers are available in all sorts of textures, including a pebbled surface for a watercolor look or paper with a metallic silver or gold foil-like surface, which is great for festive holiday cards or an old-time tintype look. Pre-scored greeting-card papers make creating holiday cards fun and easy, and your kids will love tattoo, T-shirt transfer, and sticker papers. There is even fuzzy paper for making doll house rugs and other crafts.

6 **ONLINE PHOTO LAB.** If you don't want the hassle or expense of printing your images, you can upload them to an online photo lab like Shutterfly or Ofoto. There, you can create galleries and then order prints, calendars, or greeting cards of the images, as well as share the galleries with family and friends so they can order their own prints. Some one-hour labs are also starting to offer such services.

7 **NEWSLETTERS.** The family newsletter has never been easier. Many software programs have design templates to get you started. Just type your headlines and stories and then add pictures.

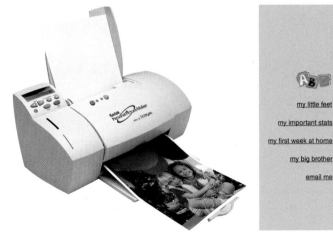

LEFT: Even inexpensive ink-jet printers can now deliver prints that are almost indistinguishable from prints recorded on film and developed and printed by a photofinisher.

RIGHT: Once your images are digitized, it's easy to create your own Web site. Your Internet provider may offer free homepages, or you can use a host site. Use easy and inexpensive software to design your site.

8 SMALL BUSINESSES. Pre-scored and pre-designed brochure papers make it easy to create professional results for business brochures. You can even buy a version that has a pop-out business card. Mail-order paper companies like Paper Direct have endless ideas and suggestions. With this technology, small businesses can print hundreds of brochures, or just one or two that can be individualized for a special purpose.

9 FUN FOR THE KIDS. Your children will love the digital camera. Not only does it provide them with instant gratification, but you don't have to pay for all the film and processing—though you might need to put the youngsters on a paper and ink allowance.

Vendors

The easiest way to convert film or prints into digital files that can be viewed on your computer is to use a commercial vendor. Your one-hour or other photo minilab may offer PhotoCD or a similar service in which they give you a CD of your images along with your negatives and prints. Others will scan individual images for you, but this is much more expensive. The price usually varies with the resolution (see "The Importance of Resolution" on pages 12–13). Professional-quality, high-resolution scans can be very expensive.

Home Scanners

Home flatbed scanners are a great way to scan your prints, artwork, and other flat items. Simply lay an image on the scanner's glass, close the cover, and you're ready to digitize it. Most scanners come with software that walks you through the process.

Film scanners will also scan your 35mm negatives or slides (and sometimes other formats). Because negatives and slides are so small, they require a higher-resolution ("high-res") scanner. Such scanners usually cost more, but they deliver better-quality results. (See the sidebar on page 15.)

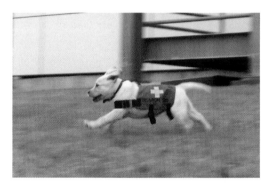

It took less than three minutes to remove distracting elements from the image on the left. Photo © Jen Bidner

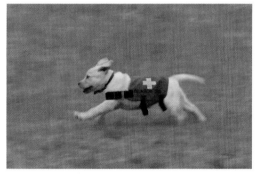

It's easy to retouch (remove) blemishes from a portrait with photo-editing software.

All About Film

Get several photographers in a room and start talking film, and you'll learn that most serious photographers have their favorite films and are very loyal to a particular film brand, if not to an individual type of film within the brand. You'll also find that such preferences vary greatly from individual to individual.

Films are made for different purposes, in the process sacrificing certain qualities to enhance others, and the various manufacturers engineer them using proprietary technology. As a result, there are minute and sometimes quite visible variations in the way different films record an image.

Even if you're shooting 100 percent digital, the basic concepts regarding film are important to understand. Low-light capability, contrast, color, and tonal reproduction are all factors controlled by the digital camera's imaging sensor and on-board computer, which together are the equivalent of film. The "equivalent ISO" settings on most high-end digital cameras relate to film ISO speeds. As with film, higher equivalent ISO settings provide better low-light capability, but they come at a cost in terms of overall quality.

ONE OF THE FIRST decisions you'll need to make is the speed of film you should use. Speed—a measurement of the film's light sensitivity—is measured in terms of ISO numbers: The lower ISO numbers are "slower," and the higher ISO numbers are "faster." Fast films are very sensitive to light and can record a proper exposure in dim light.

So-called slow films—those labeled ISO 100, ISO 64, and lower—tend to have better overall quality than faster films. Their colors and contrast are brighter and truer, and they produce smoothly gradated tones. Designed to be used in bright situations for the best results, they are a great choice for general outdoor photography on bright days with high-end cameras.

Slow films can be used in dimmer lighting, but the low light level may mean you won't be able to select action-stopping shutter speeds, and that can result in blurred pictures. Many professional nature photographers opt for the quality of slow films but mount their camera on a tripod so that stationary subjects will be recorded sharply during long exposures.

Faster films allow you to freeze the action in dimmer lighting situations. As you move into higher ISO films, you'll also start to see a comparative degradation in quality. Your pictures could begin to appear "grainy," especially when enlarged. The color and contrast may also suffer.

Because of differences in the performance of films of different speeds, some experienced photographers are constantly changing from one film to another, depending on the amount of light hitting the subject. Others choose a favorite film and use accessories such as flash (see pages 50–67) or tripods (see page 43) to compensate. Still others select the middle ground and use a midrange film like ISO 200 or ISO 400 most of the time.

Brands & Product Lines

There are numerous brands of film, including the big names Kodak, Fuji, Agfa, Konica, and Ilford. Each manufacturer produces films that have different characteristics in terms of color, contrast, tonality, and overall quality.

Even within the same company, some manufacturers have different brand names for different markets or specialties. For example, Kodak makes a slide film called Elite that is marketed primarily to the advanced amateur photographer, as well as a professional line called Ektachrome.

The decision about which film is "best" often comes down to individual aesthetic choice. Try the various brands and decide which you like the best.

WHICH SPEED TO USE?

Your choice of film speed will depend upon the type of camera you are using. SLR users can use slower, better-quality films because they tend to have "faster" lenses, stronger flash, more shutter-speed choices, and the option of using a tripod.

Most point-and-shoot camera users should choose ISO 200 for general outdoor shooting, ISO 400 on overcast days, and ISO 800 for action or indoor photography. Low-end point-and-shoot cameras perform best with ISO 400 and faster films.

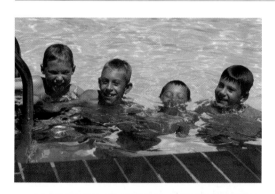

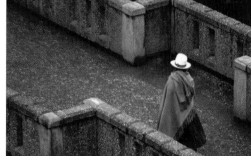

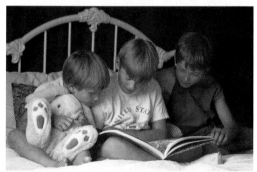

TOP LEFT: Use ISO 100 film in bright, sunny situations with high-end cameras.

TOP RIGHT: Switch to ISO 200 when shooting in the shade or in less than perfect weather, or when you're using a telephoto setting.

BOTTOM LEFT: Select ISO 400 or faster films for low-light situations, when you're shooting indoor with flash, or for action photography. If you have a low-end point-and-shoot camera, you may want to always use ISO 400 and ISO 800 films.

BOTTOM RIGHT: ISO 800 films are the choice for fast-action and low-light situations.

Although today's ISO 800 films are exceptional (especially when compared to the films of just a few years ago), the difference in quality can be seen through side-by-side comparison of ISO 100 and 800 film. The image on the left was shot with ISO 100 film, and the one on the right was shot with ISO 800.

Prints or Slides? Indoor or Outdoor Film?
OTHER ISSUES THAT WILL INFLUENCE YOUR DECISION

Prints or Slides?

Do you want to shoot color print film, which yields a negative that is made into a print? Or "slide" film, which delivers a positive image on transparency film, often in the form of a 2×2-inch mounted slide?

You can have prints made from your slides, but it is usually more expensive and takes considerably longer than taking a roll of negatives to a one-hour lab for printing.

Many professionals use slide films, which they sometimes call "chromes" or "transparencies." These films tend to have better grain and reproduction quality than negative films, and many of their clients require them.

With these advantages, everyone would shoot slide film if it weren't for several disadvantages. For starters, it requires precise exposure. While you can still get good results with color print film if you accidentally under- or overexpose it, the same is not true of transparency film.

The exposure most be so precise that photographers often bracket (intentionally shoot a series of pictures of one subject that are overexposed, normally exposed, and underexposed) to make sure they get at least one perfect exposure. Obviously, this can be expensive in terms of the quantity of film required.

Slide films are also more expensive to purchase, process, and print. They are also more susceptible to damage from heat and age, and have a comparatively short shelf life. Unless you are a serious amateur or professional photographer, you'll probably be happy with color print films.

LEFT: Slide films (also called transparencies or chromes) create positive translucent images on film. They often come back from the lab individually framed in a 2×2-inch cardboard slide mount.

TOP RIGHT: Both prints and slides are positive images.

BOTTOM RIGHT: The most common film is "color print" film, which creates a negative image that must then be converted to a positive print.

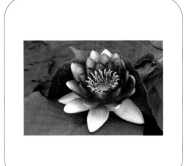

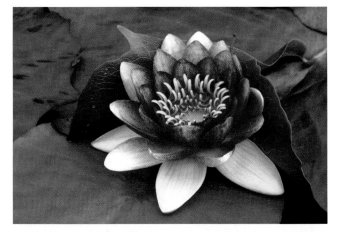

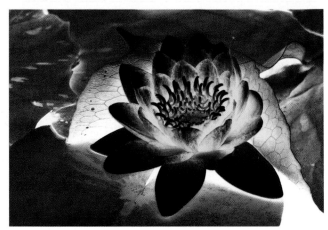

THE DOWNSIDE OF SLIDES

If slide films ("transparencies" or "chromes") have such great quality, why doesn't everyone use them?
- They're more expensive to buy, process, and print.
- They're unforgiving of under- and overexposure.
- Professional versions require refrigerated storage and have limited shelf life.

Daylight-balanced versus Tungsten-balanced Film

Film is also offered in different color balances. Why do photos taken indoors under household lamps look yellow? It's because most films are balanced for daylight use, which has a bluer color cast. Compared with outdoor light, tungsten bulbs, such as those used in household lamps, give off a yellower light. Our eyes quickly adjust and make everything look "normal," but film cannot do that.

Tungsten-balanced films make images taken under tungsten lights look normal in color. However, if tungsten film is shot outdoors, the result is a pale bluish image.

Fluorescent lighting, which is on the green side, does not look great with either film. A light-pink filter will help correct the color. (See pages 76–81 for more details on using filters.)

LOAD YOUR FILM IN THE SHADE

To capture an image that's free of unintended exposure to light (left), keep your film in the plastic container whenever it is not in the camera, and try to load it in a dimly lit area. Direct sunlight hitting the film or even the canister can cause streaks and bright spots on some of the frames (center). Film loaded in direct sunlight could be ruined (right). At the very least, turn your back to the sun and load the film while shading the camera with your body.

Tungsten-balanced film looks good when shot under tungsten lights (right), whereas daylight-balanced films record a yellow cast in the same lighting (left).

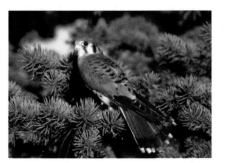

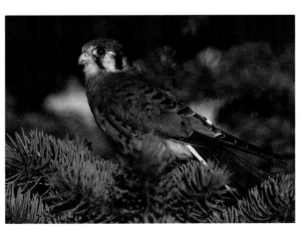

Daylight-balanced film looks good when shot in daylight (right), whereas tungsten-balanced film appears blue and washed-out when shot outdoors (left).

Black-&-White & Specialty Films
GOING BEYOND THE ORDINARY

Black-&-White Film

In addition to color film there is "old-fashioned" black-and-white film. Classic black-and-white film is processed in a darkroom, either by the photographer or by a lab.

When color film first became readily available in the 1930s, photographers fell in love with the new technology. Today many fine art photographers have returned to the black-and-white medium because of its inherently different view of the world. Our eyes see the world in color, so images rendered in tones of gray give us an alternate view and turn our attention to the noncolor elements of photography, such as textures, shadows, and composition.

Another advantage of black-and-white photography is that the darkroom gives the photographer immense control over the final look of the image. You can increase or decrease the contrast, "burn" certain areas to make them darker, and "dodge" other portions of the image to make them lighter.

Another big plus is that during the shooting stage you can purposely under- or overexpose an image, and then alter the development time to compensate. This technique allows you to increase or decrease the tonal range of the image and otherwise alter its quality and artistic effect.

Black-and-white film also enables you to use color filters to selectively change the tones in the images you shoot. For example, putting a red filter over the lens will give your black-and-white landscape images extremely white clouds against a vibrant sky. See pages 82–85 for more details.

Chromogenic Black & White

Today black-and-white photography is easier than ever with the advent of chromogenic black-and-white film. This film can be processed in the machines and chemicals that are used for color print films, so you can have chromogenic black-and-white film processed at a photo minilab along with your color images.

Infrared Films

Infrared film, a specialty film that is sometimes used for scientific and artistic purposes, records light in the invisible spectrum as well as visible light. It is manufactured in both a color and a black-and-white version. The latter is recognizable for its ethereal rendition of the world and the way it depicts some green foliage in glowing white. The color version creates outlandish colors, like pink trees and green skies.

EASY BLACK & WHITE

Want to try black-and-white, but don't want to take the time to learn or use a darkroom? Try chromogenic black-and-white films.

Unlike normal silver-halide films, these are dye-based, like color negative films. This means your local photo minilab can process and print them on the same machines they use for color prints. You'll get back gorgeous sepia-toned images for a lot less money (and time) than it takes to develop and print traditional black-and-white negative films.

Our eyes see in color, but black-and-white film depicts the world in an inherently different manner. It emphasizes tones and textures.

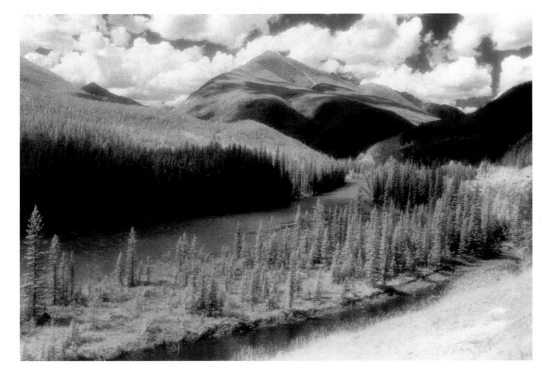

Black-and-white infrared film creates an unusual rendition of the world when shot with a deep-red (87C) filter. One typical characteristic is that green foliage becomes white and seems to glow. Photo © Steven I. Rosenbaum, www.sironline.com

How to Use Lenses

Before a film or digital camera records an image, the light needs to pass through the optical elements of the lens. The lens can be either built into the camera or interchangeable, as with most SLR cameras.

Lenses vary in optical quality, optical design, and focal length. Focal length is the most important factor. It determines how much the lens alters the scene in terms of angle of view and magnification. Lower-number focal lengths (such as 28mm) show a wider view, while higher-number focal lengths (such as 200mm) magnify the scene as binoculars would do.

These figures stay consistent for 35mm film cameras but change if you use smaller (Advanced Photo System, or APS) film, larger film (for medium- or large-format cameras), or digital cameras (the imaging sensor changes with the model). If you're using any other camera than a 35mm film camera, refer to the "35mm film equivalent" focal-length numbers in your instruction manual to convert the references in this book.

ONE OF THE MOST VALUABLE FEATURES of a high-end camera is the ability to change the focal length of the lens. On point-and-shoot cameras this means using the zoom lens setting, which is usually operated by buttons or a toggle switch marked W (for wide angle) and T (for telephoto settings). On SLR cameras, zoom lenses often have a ring on the barrel that is rotated when you want to zoom the lens from wide to telephoto. On most SLR cameras, you also have the option of switching lenses entirely.

Wide-angle Lenses

Lenses with a low-number focal length are called wide-angle lenses, because they show a wide angle of view of the scene in front of you. A standard wide-angle lens is 28mm or 35mm; ultra-wide-angle lenses include 20mm and 18mm. One of the biggest assets of wide-angle lenses is that you can "fit" many people or things into the picture, even if you're close to the subject. This feature makes a wide-angle lens a great choice for, say, group portraits in cramped spaces or making the interior of a tiny car look huge.

Wide-angle lenses are popular with landscape photographers because these lenses make landscape scenics seem vast. They also offer relatively close focusing distances (compared to telephotos) and better relative depth of field (see pages 35–37). When used close to the subject they can cause distortions, which can be either a disadvantage or an advantage, depending on your creative intent. (See examples on pages 26–29.)

Portrait Lenses

Wide-angle lenses are certainly convenient for portraiture, because you can shoot the pictures from a very close range. However, they tend to distort the features of the person—a phenomenon that becomes more dramatic the wider the angle of the lens (that is, the lower the focal-length number, such as 28mm or 20mm) and the closer you are to the subject.

SLR CAMERAS OFFER DOZENS OF LENS OPTIONS

20MM

35MM

50MM

THE AVERAGE LOW-END POINT-AND-SHOOT CAMERA comes with a lens that has only one focal length, such as 35mm or 50mm, and you're stuck with that setting. To fit more of the screen in the viewfinder, you'll need to step back. And to get a closer view, you'll need to move closer.

105MM

HIGH-END POINT-AND-SHOOT CAMERAS add zoom capabilities for a wider selection of focal lengths, such as 35mm to 105mm. Not only does this mean less walking to get closer or farther away, but it gives you some of the big creative advantages discussed in this chapter.

200MM

MOST SLR CAMERAS allow you to change lenses. Most accept literally dozens, including single focal length, zoom, and specialty lenses. In addition to the camera manufacturer's own lenses, independent manufacturers like Sigma and Tokina make lenses that are compatible with many SLR systems. A very few SLR cameras have a built-in zoom lens that cannot be changed; these are sometimes referred to as ZLR cameras.

400MM

MACRO

You'll get much better portraits if you step back and switch to a moderate telephoto lens or the T lens setting on a point-and-shoot camera. Many photographers consider 105mm the ideal portraiture setting, but anywhere in the range of 80mm to 135mm is suitable.

POINT-&-SHOOT USERS

Some cameras have a portraiture mode, usually labeled with an icon of a face. Portraiture mode usually sets the camera's lens to the telephoto (T) zoom setting and weighs the exposure toward a wide aperture in order to blur the background.

Telephotos & Super-telephotos

Beyond the 135mm portraiture range are the "long" lenses with high focal-length numbers. Technically, the word "telephoto" refers to a particular lens design. However, it is commonly used to describe any lens with a long focal length (such as 80mm and higher), and we use it this way in this book. These lenses magnify the subjects on the film, making them seem closer and larger in your pictures.

The big advantage of telephotos is that, even when you can't get close, you can shoot distant subjects such as wildlife or sports action on the playing field.

Teleconverters

You can extend your focal length by 1.4X or 2X with a teleconverter, a small, light lens attachment that fits between the lens and the body of the camera. A 2X teleconverter, for example, turns a 200mm lens into a 400mm for much less money (and less added weight) than if you used a 400mm lens. Unfortunately, using a teleconverter entails some minor quality degradation and a loss of light.

Macro Lenses

The macro lenses (see pages 154–163) have extremely close focusing capabilities, allowing you to take a picture in which the subject is life-size (or larger) on the film. The longer the focal length of the macro lens, the farther away from the subject you can be and still achieve the size magnification.

ABOVE: Wide-angle lenses can distort the features of your subject. The distortion becomes greater the closer you get to your subject and the wider the angle of the lens (the lower the focal length number). Photo © Jen Bidner

RIGHT: Wide-angle lenses are popular with land-scape photographers because they emphasize the magnitude of the vista and allow you to include more elements than would be captured by a telephoto lens.

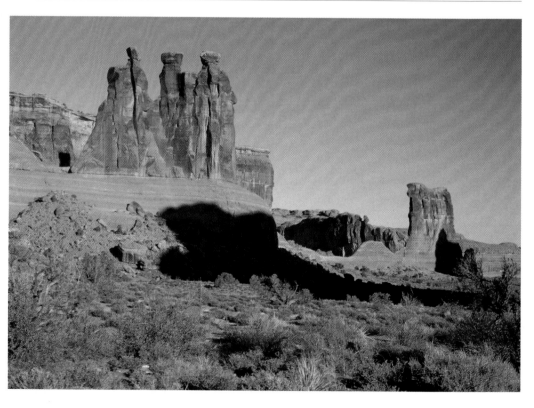

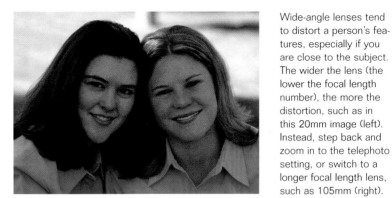

Wide-angle lenses tend to distort a person's features, especially if you are close to the subject. The wider the lens (the lower the focal length number), the more the distortion, such as in this 20mm image (left). Instead, step back and zoom in to the telephoto setting, or switch to a longer focal length lens, such as 105mm (right).

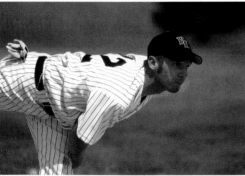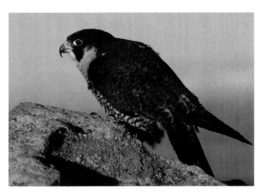

Telephoto and super-telephoto lenses are good choices for taking frame-filling pictures of distant wildlife (right) and recording sports action from the side-lines (left).

Macro lenses have a closer than normal minimum focusing distance, allowing you to take frame-filling pictures of small subjects. A 200mm macro lens lets you photograph a skittish subject from farther away than a 100mm or 50mm macro lens would allow.

The Power of Perspective
ALTERING YOUR POSITION & YOUR FOCAL LENGTH CHANGES RELATIONSHIPS

IF YOU STAND IN ONE POSITION and zoom a lens, you're basically cropping the picture in the camera, reaching out and bringing the subject closer so that it will appear larger in the final image. Little else changes in the picture, with the exception of minor optical "distortion" (which can be both good and bad) related to the lens construction.

It is not until you change your shooting position that you can really start altering the relationships between different elements in the picture. Understanding these changes means you can use them to your creative advantage.

In the series of images of the man and his car, the photographer tried to keep the size of the man approximately the same and then shot the image with four different focal lengths—24mm, 50mm, 100mm, and 200mm.

To keep the man the same size, the photographer had to move much closer to the subject for the wide-angle shots and almost clear across the parking lot for the 200mm telephoto shot.

The important thing to notice in this series is how the background changes in relation to the main figure. At 24mm, the building in the background looks small, distant, and unimportant. As the focal length gets longer, the building in the background gets larger and larger, until it appears much larger and very close, even though the driver did not change parking spots. With camera position and focal length alone, the photographer was able to radically alter the relationship between the foreground (the man and car) and the background (the building).

Similarly, while the foreground tree remains relatively unchanged in the landscape images below, the photographer was able to make the mountain range look closer and more imposing in the telephoto version.

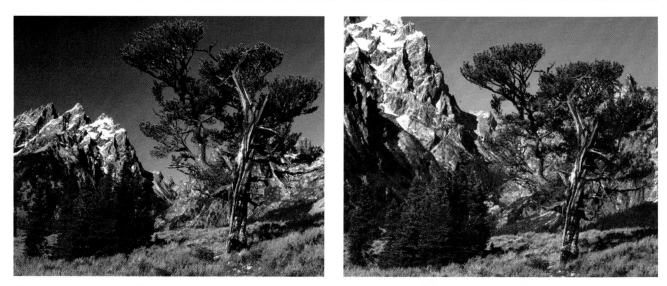

Using a wide-angle lens (left), the photographer was able to make the mountain look more distant and less imposing. Moving farther away from the tree and zooming to a telephoto setting (right) kept the tree the same relative size but altered the perspective so that the mountain looks closer and larger.

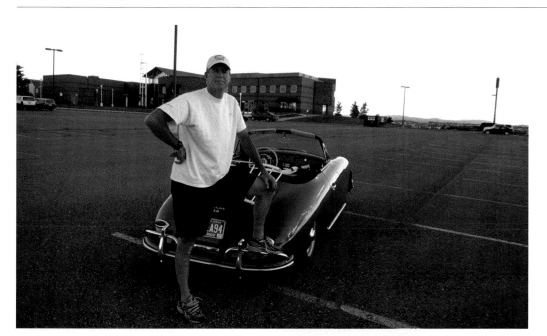

At 24mm, the building in the background looks very distant, and the parking lot looks vast (top). As the photographer switched from 24mm to 50mm (center left), 100mm (center right), and finally 200mm (bottom) focal lengths, the building appeared increasingly close to the subject. Neither the building nor the parked car moved, but the perspective was altered because the photographer backed up so that the man would remain approximately the same size in all the photos.

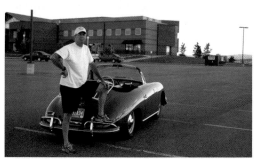

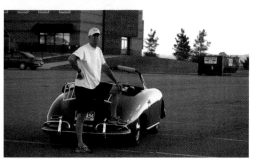

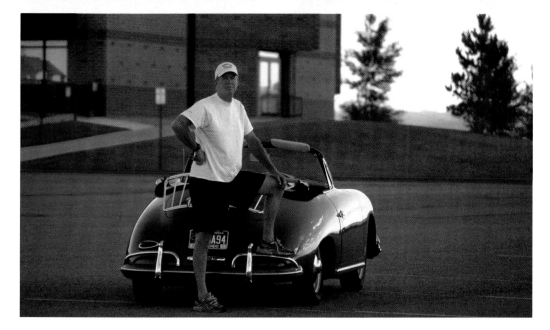

Getting the Right Exposure

The "right exposure" means that a picture is neither too dark nor too light. But exposure choice involves far more than just that. Exposure choices can be used in creative ways that can radically alter the look of your pictures.

When your camera "takes a picture," it opens a curtain (the shutter) to allow light to enter a hole in the lens (aperture or f/stop) for a certain amount of time (shutter speed). This light exposes the film to create the picture. A certain quantity of light is needed for the right exposure with a given film. Dimmer lighting conditions require longer shutter speeds and/or wider apertures to deliver an adequate amount of light to the film.

Faster (high-number ISO) films need less light to make a proper exposure in a given situation than slower (low-number ISO) films. Therefore, you can select a faster shutter speed, a narrower aperture, or both if you select a faster film. Or if you choose a slower, higher-quality film for the same lighting conditions, you will need to select a slower shutter speed, a wider aperture, or both.

If you're using a digital camera, you will probably have a choice of equivalent ISO settings. The rules are precisely the same as with film—a higher-number equivalent ISO gives you better low-light capability but sacrifices overall quality. A lower-number equivalent ISO delivers better color, contrast, and tones, but you'll need comparatively slower shutter speeds and wider apertures.

YOU HAVE THREE MAJOR WAYS to control the quality and creative outcome of your image through exposure: your choices of film, aperture setting, and shutter speed. Film is discussed in detail on pages 18–23. The aperture setting controls how much is in sharp focus in front of and behind the subject (pages 36–39). And shutter speed affects how sharp or blurred certain elements or the entire picture will appear in the final image (pages 40–47 and 184).

Potential Exposure Problems

There are several situations in which lighting conditions can make it difficult to get a good exposure. Luckily, color print films are very forgiving, and you can get adequate results with images that are not shot at the optimum exposure. However, you will get the best results if you take the time to "help" your camera achieve proper exposures. And should you use slide/transparency films, you will notice a degradation of the image if you are even a half-stop off in exposure.

Images that have been underexposed tend to look grainy and have poor contrast, with little detail in the shadows, and they may take on a bluish tone. Overexposed images lack details in the highlights and can look washed-out.

High-contrast situations are often beyond the contrast range of most films. The most common example is when direct sunlight both illuminates highlights and casts deep, dark shadows. You may not be able to get details in both the shadows and the highlights unless you use shooting techniques that reduce the contrast range, such as fill flash (see pages 53, 116–117, 136–137, and 150) or reflectors (pages 117, 159, and 172–173) that lighten the shadow side of the subject.

Proper exposure of extremely light or dark subjects may require intentional over- or underexposure (see pages 33–34 and 137).

The Important Relationships

Shutter speeds and apertures, which are mathematically related, are each set in increments of "stops," or exposure value (EV)

Understanding Exposure

CHOOSING THE CORRECT EXPOSURE IS A CORNERSTONE OF YOUR TECHNIQUE

units. One full stop (1.0EV) difference is equivalent to doubling or halving the shutter speed, such as going from 1/250-second to 1/500-second (twice as fast).

Apertures are more difficult to sort out because the numbers are not as simple as shutter-speed numbers. Common full-aperture increments (from widest to narrowest) are f/2, f/2.8, f/4, f/5.6, f/8, f/11, f/16, f/22, and f/32. Some lenses have apertures of f/3.5 or f/4.5, but these are actually half or partial apertures, not full-stop increments.

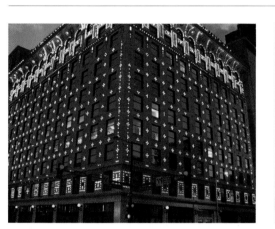

LEFT: Low-light situations need longer shutter speeds, wider apertures, or higher-speed films to achieve proper exposure.

RIGHT: High-contrast situations, such as high sun on a face, can be difficult. You may not be able to get detail in both the highlights and the shadows. Unless you are willing and able to reduce the contrast difference with fill flash or other techniques, you will need to make a choice and expose for either the highlights, the shadows, or somewhere in between. The decision is usually based on whether the most important subject details are in the highlights, shadows, or midtones.

AVOIDING FLARE & SUNSPOTS

Your image can be degraded if you allow direct sunlight to hit the lens, because the image could acquire flare, which shows up as reduced contrast and hotspots, as in the photo on the left. Shading the lens with your hand, a hat, or a magazine will help avoid this problem. Flare can be especially bad if you include the sun in the picture. A small shift in position can tuck the sun behind the subject for a backlit silhouette (right).

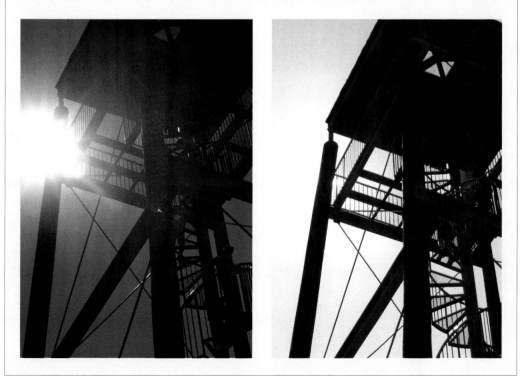

Each full-aperture change halves or doubles the area of the hole in the lens, so that half or twice the amount of light is let through during a set period of time (as determined by the shutter speed). A wide aperture (such as f/1.4, f/2, or f/2.8) has a bigger hole and lets in more light at a given shutter speed. Thus, in a given lighting situation you can use a faster shutter speed with a wide aperture than you can when using a narrow aperture.

Like shutter speeds, film speeds are based on doubling or halving the numbers. Doubling the ISO makes the film one stop more sensitive to light. Selecting ISO 200 film instead of ISO 100 film allows you to select either one f/stop narrower an aperture or one shutter speed faster in any given lighting situation. On a typical sunny day, this would mean that instead of shooting at f/16 and 1/125-second with ISO 100

film, you could use ISO 200 film and select f/22 and 1/125-second or f/11 and 1/250-second. Numerous other combinations of aperture, shutter speed, and film speed would deliver the same amount of light (see chart below).

Apertures also affect depth of field, which controls how much of your picture in front of and behind your actual focusing point is in sharp focus. (See pages 35–39 for details.)

Shutter speeds determine how blurred your subject or other picture elements will be. If the shutter speed is the most important factor to you (for example, if you need a fast, action-stopping shutter speed for sports), then select your shutter speed and let the aperture fall where it may for proper exposure.

The bottom line is that you can juggle these three factors—film speed, aperture, and shutter speed—to control the look of your images.

WHAT'S AN F/STOP?

An aperture (f/stop) setting refers to the size of the hole in the lens that allows light to pass through to the film when the shutter is open. A large-number f/stop (such as f/22) is a smaller hole than a small-number f/stop (f/2.8).

WIDE APERTURE | NARROW APERTURE

EXPOSURE FOR TYPICAL SUNNY DAY

	f/2	f/2.8	f/4	f/5.6	f/8	f/11	f/16	f/22	f/32
ISO 100	1/8000	1/4000	1/2000	1/1000	1/500	1/250	1/125	1/60	1/30
ISO 200		1/8000	1/4000	1/2000	1/1000	1/500	1/250	1/125	1/60
ISO 400			1/8000	1/4000	1/2000	1/1000	1/500	1/250	1/125
ISO 800				1/8000	1/4000	1/2000	1/1000	1/500	1/250

EXPOSURE FOR SHADE OR HEAVY OVERCAST SKY

	f/2	f/2.8	f/4	f/5.6	f/8	f/11	f/16	f/22	f/32
ISO 100	1/2000	1/1000	1/500	1/125	1/60	1/30	1/15	1/8	1/4
ISO 200	1/4000	1/2000	1/1000	1/500	1/125	1/60	1/30	1/15	1/8
ISO 400	1/8000	1/4000	1/2000	1/1000	1/500	1/125	1/60	1/30	1/15
ISO 800		1/8000	1/4000	1/2000	1/1000	1/500	1/125	1/60	1/30

A fast shutter speed can freeze the action. Compare the results when the photographer used first a 1/15-second (left) and then a 1/250-second (right) shutter speed. At 1/15-second the ball is just a blur of green.

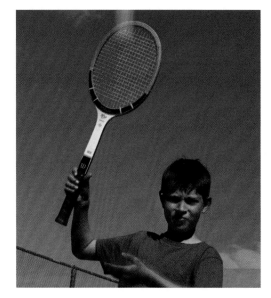

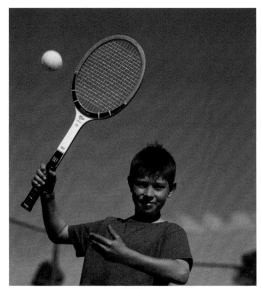

Exposure Modes

Most SLR cameras offer exposure modes that let you optimize these decisions. Aperture-priority mode enables you to select an aperture, and the camera automatically matches it with the "right" shutter speed. Shutter priority is the reverse, allowing you to select the shutter speed, with the camera automatically providing the right aperture. Program mode selects both for you. In manual mode you select both.

How the Meter Works

Your camera's built-in meter assumes everything you point it at is a middle gray tone in terms of reflectivity. Because of this, if your subject is especially dark or light, the meter will want to over- or underexpose the image, respectively. Most high-end cameras meter several areas in the scene (multi-segment or multi-pattern

metering) and then use sophisticated algorithms to evaluate the information and "correct" the exposure. They do a fairly good job in most situations. Other methods for improving the results include backlight detection and pre-flash to test the reflectivity of the subject.

Exposure Compensation

Some high-end point-and-shoot cameras and most SLR cameras allow you to use exposure compensation to intentionally under- or over-expose the image in order to make blacks look black (underexposure) and whites look white (overexposure). Photographers usually select these settings in third-stop (0.3EV) or half-stop (0.5EV) increments.

In the series of the black sculpture below, note that the straight exposure without exposure compensation is not truly black because

If your subject is dark or black, your camera may overexpose the image. To correct for this, you can select –EV exposure compensation to intentionally underexpose (darken) the image and bring it back to a correct exposure. In this series of images, the one at top left was made at +0.6EV, the one at top right at +0EV, the one at bottom left at –0.6EV, and the one at bottom right at –1.3EV exposure compensation.

the camera overexposed the image to try to make it look gray. Underexposuring the image by reducing the light reaching the film (−1.3EV) darkens the image and makes it black again.

In the snow-scene comparison below, the white snow tricked the camera's meter into underexposing the image. The result was too dark; the image turned blue overall. Adding light through +EV exposure compensation brought the image back to white.

Flash Exposures

Cameras can also have difficulty with flash exposures. The bottom left image is typical of photographs taken in dim lighting with autoflash mode. In this case, the entire exposure is based on the flash illumination, the aperture/shutter speed combination does not allow the background light to record on the film, and the result is a black background. With more sophisticated flash programs, such as night or slow-synch flash (bottom right), the camera balances the background light with the flash illumination, so that both record on film during the long exposure.

Flash exposure compensation gives even more control. It allows you to under- or overexpose the flash portion of the image. Photographers often select −1.0EV flash exposure for filling shadows (fill flash) on bright, sunny days.

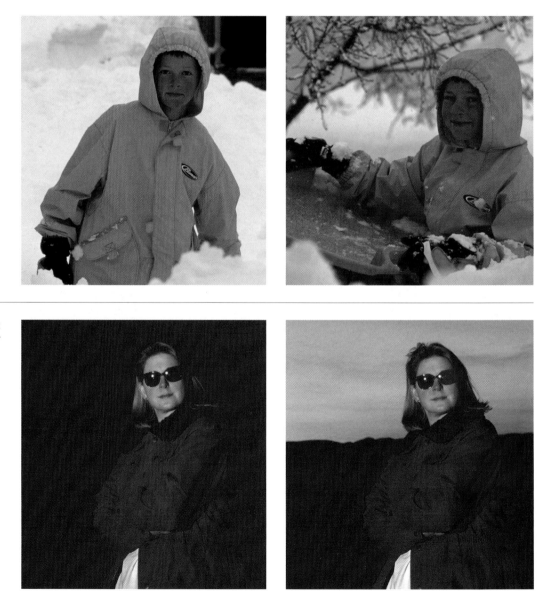

Using +EV exposure compensation helps make white or well-lit scenes bright (left) and prevents them from looking blue or under-exposed (right).

Both images were shot at f/8 with the same power of flash. Therefore the flash exposure stayed constant. However, in the left image, the shutter speed was too fast to allow the background light to record on film. In the right image, the aperture was still f/8, but the shutter speed was slower, allowing the existing natural light (the sunset) to record on film without affecting the flash exposure.

APERTURE SIZE (f/stop selection) also affects how much of your picture in front of and behind your actual focusing point is rendered in sharp focus. This is called depth of field. Wider apertures bring less into focus than their narrower counterparts. If depth of field is important, then select your aperture for it, and let the shutter speed fall where it may for proper exposure.

In the sequence below, the photographer did not move the camera or change the focus or aperture. Notice how the runner gradually comes into sharp focus as he gets closer to the main subject (the woman).

See the two following sections for more about depth of field and aperture setting as a creative tool.

A wide aperture minimizes depth of field, allowing you to record selective parts of the image out of focus. You can manipulate depth of field to emphasize the main subject.

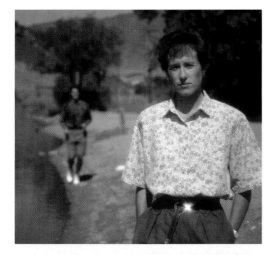

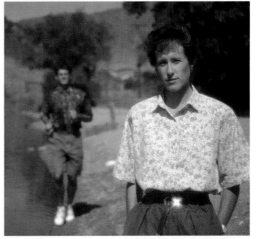

In this sequence, the photographer did not move the camera or change the focus or aperture settings. Notice how the runner gradually comes into sharp focus as he gets closer to the woman.

When to Use Wide Apertures

A WIDE APERTURE CAN SEPARATE THE MAIN SUBJECT FROM THE BACKGROUND

MOST SLR CAMERAS (and a very few high-end point-and-shoot cameras) allow you to select your preferred aperture in a given situation. This is usually called aperture-priority exposure mode. You simply select your aperture of choice within the range of the lens, and the camera tries to match it with the shutter speed that will deliver the "right" exposure.

Thus aperture-priority mode puts the creative decision of depth of field (see page 35) into the hands of the photographer.

When you don't want the background to distract from the subject, select wide apertures (low-number f/stops like f/2.8 or f/4) for backgrounds that are as out of focus as possible.

Aperture (f/stop) can be used to creatively alter an image. In these two nature images, a wide aperture (f/4.5 or f/5.6) helps isolate the subject or a portion of the subject from the background.

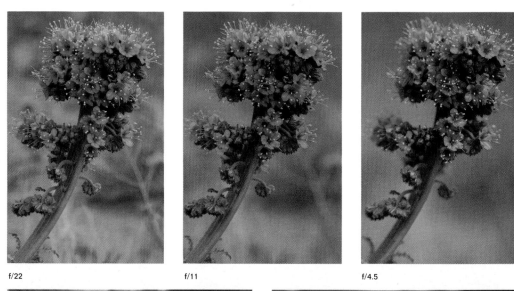

f/22 f/11 f/4.5

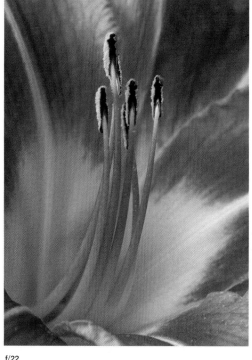

f/22

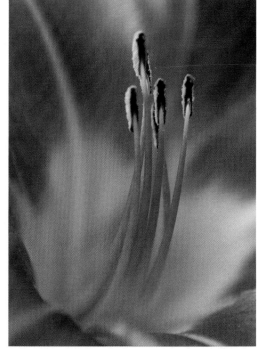

f/5.6

f/22

Notice how the background goes from sharp and distracting to softly blurred as the aperture changes from f/22 to f/4.

f/16

f/11

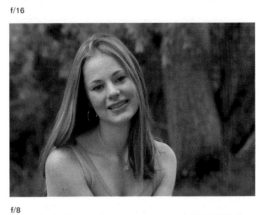

f/8

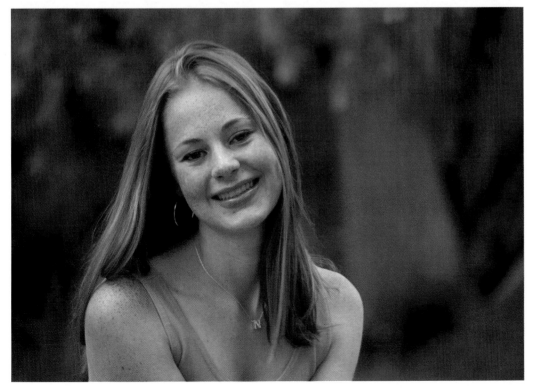

f/4

When to Use Narrow Apertures

F/22 & F/32 WILL GIVE YOU MORE PICTURE ELEMENTS IN SHARP FOCUS

THE PREVIOUS PAGES showed how to put a background out of focus using a wide aperture. But what about the times when you want as much as possible in sharp focus? Using aperture-priority exposure mode on an SLR camera, select a narrow aperture (a high-number f/stop like f/22 or f/32).

Landscape photography is a great example, especially if you use the foreground-midground-background techniques discussed on pages 98–99. The sharpening effect will be greatest with wide-angle lenses, and you will seemingly be able to get "less" in focus as you switch to longer focal length lenses.

It is important to remember that narrow apertures let in less light than wide apertures, so the camera will need to couple your aperture selection with slower than normal shutter speeds. On a bright, sunny day this may not be a problem, because f/22 at 1/60-second would be a typical exposure with ISO 100 film. But you may need to switch to a faster film if you are using longer lenses (which require faster shutter speeds for hand-holding), shooting action, or working in dimmer lighting.

Another alternative is to switch to a tripod, which will hold the camera steady during extremely long exposures. Unfortunately, if the subject is moving, it may still appear blurred because a motionless camera records only stationary objects sharply. (See pages 40–41 and 127 for a comparison of shutter speeds in action photography.)

POINT-&-SHOOT USERS

Most point-and-shoot cameras don't let you select apertures. However, some high-end models have special shooting modes, such as landscape (usually indicated by an icon of a mountain) and portrait (usually an icon of a person's head and shoulders).

You can use these modes to weigh the camera toward maximum depth of field (landscape mode) and minimum depth of field (portrait mode). It's not perfect, but it can help.

Landscape images that combine a distant scene with a foreground element require maximum depth of field to get as much as possible in sharp focus. Achieve maximum depth of field with a given lens and subject by selecting the narrowest aperture possible (the largest-number f/stop, such as f/32).

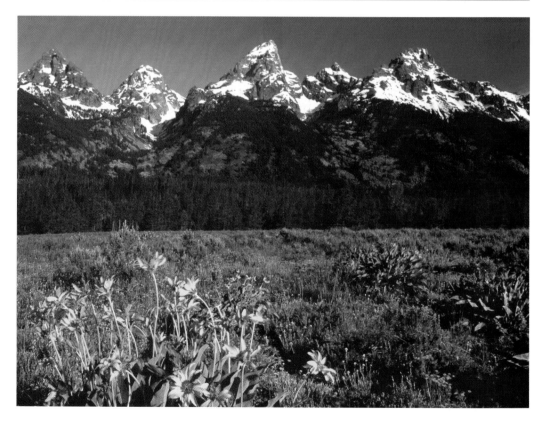

A wide aperture setting results in a photograph of a row of crayons in which focus falls off at both ends and in the immediate foreground (left). It is not until the aperture is narrowed to f/32 that all the crayons snap into sharp focus (right).

CAN'T GET ENOUGH IN SHARP FOCUS?

If you can't get enough depth of field to get everything in sharp focus with a given aperture and lens, as in the image on the right, reconsider your shooting angle. Depth of field is the plane of sharp focus that runs perpendicular to your lens. Aperture selection determines the "depth" of this plane. Just by rotating around your subject so that most of it is parallel to your shoulders, as in the image below, you can get more in sharp focus by matching the plane of sharp focus.

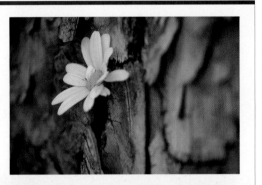

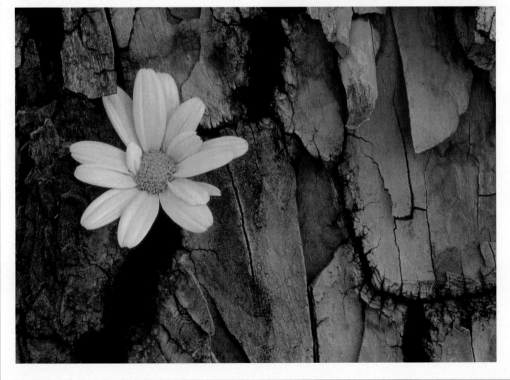

When to Choose Fast Shutter Speeds
YOU CAN FREEZE THE ACTION WITH YOUR SHUTTER-SPEED SELECTION

PHOTOGRAPHERS typically want to take control of the camera's aperture or shutter speed when they want to freeze fast action—when they are shooting players on a soccer field, running animals, or the flick of a fishing line. In order to freeze fast-moving subjects sharply on film you will need to select a fast (short-duration) shutter speed.

Focal-length Considerations
The focal length of the lens you're using has a big impact on how fast a shutter speed you'll need. A high-number focal length magnifies the image on the film, meaning that just a small movement of the subject will seem much greater on the film than if it were less magnified. Thus, you'll need to use faster shutter speeds with telephoto lenses than you will with wide-angle lenses.

Minimum Shutter Speeds
Just to avoid camera shake, you'll need to use a shutter speed that is at least as fast as 1/focal-length-of-lens—for example, 1/200-second with a 200mm lens. If you're tired or shooting in windy conditions, you may need an even faster shutter speed. Add subject movement and you'll need to use even faster shutter speeds.

The trick is to learn how much faster you'll need to go. For example, trying to freeze the line of a fly fisherman in the image below required a very fast shutter speed (1/1000-second) because the line was moving very rapidly across the viewfinder.

At 1/30-second, the background is relatively sharp, but the moving bicyclist is very blurred (left). A 1/250-second exposure freezes the action so both the moving bicyclist and the stationary background are recorded without blur (right).

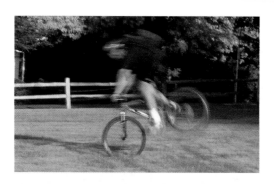
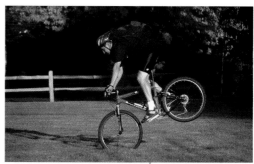

The whipping fishing line is frozen in mid-air by a 1/1000-second shutter speed.

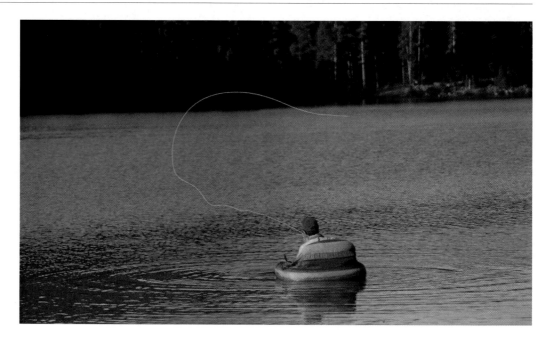

Exposure Modes

Some cameras have an action exposure mode, which weighs the camera's automatic exposures toward faster shutter speeds. Or you can use shutter-priority mode and select a shutter speed that you feel is fast enough to freeze the image on film, based on the speed of the subject and the lens you are using.

If you're unsure about what shutter speed is fast enough, you can also select aperture priority and select the lens's widest aperture, such as f/4 or f/5.6. This will force the camera to match this widest aperture with the fastest shutter speed for the given amount of light (see the chart on page 32 for examples).

Need More Speed?

If you are at the widest aperture on your lens and you're still not at a fast enough shutter speed, switch to faster film or use the panning technique (see pages 127 and 135).

POINT-&-SHOOT USERS

Most point-and-shoot cameras are not good at shooting action, because they tend to have poor aperture and shutter-speed ranges. If you're using a point-and-shoot, you'll be limited in how fast a shutter speed you can achieve.

For the best results, use high-speed films like ISO 400 and ISO 800, and pan the images (see pages 127 and 135). Panning helps maximize sharpness on a moving subject. To successfully pan, you must track the subject in the viewfinder before, during, and after the actual exposure.

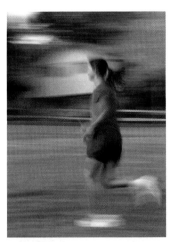

1/8-SECOND

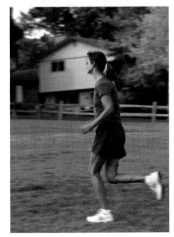

1/15-SECOND

This series shows how shutter speeds affect the final image, as well as how panning helps maximize subject sharpness with "borderline" shutter speeds. At 1/125-second (below) the background is relatively sharp, while the moving subject is very sharp. As the shutter speeds get slower, both the subject and the background blur, yet because the photographer kept the subject in the center of the viewfinder during the longest exposure, the amount of subject blur is a lot less than if the camera had been kept still (as in the example of the bicyclist on the previous page).

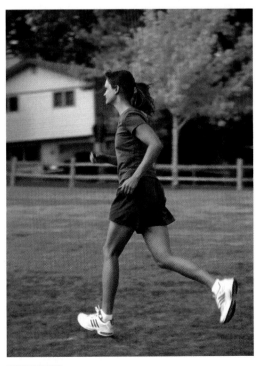

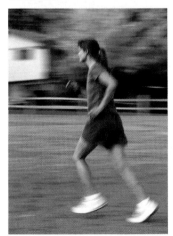

1/30-SECOND

1/60-SECOND

1/125-SECOND

When to Choose Slow Shutter Speeds

SOMETIMES YOU'LL NEED LONG EXPOSURES TO MAKE AN IMAGE LOOK MORE "REAL"

THE VALUE OF SLOW SHUTTER SPEEDS is often overlooked. Photographers sometimes think of slow shutter speeds as just an easy way to maximize depth of field (see pages 35–39) because they permit the use of narrower apertures than normal. However, there are numerous additional situations in which a slow shutter speed can have a major impact on the look of an image.

Fireworks Photographs

Fireworks are an excellent opportunity to use a slow shutter speed. When we watch fireworks, we're enjoying the entire sequence of the firework streaming through the air and then bursting into radiating color—a process that takes several seconds. One isolated instant doesn't communicate the whole experience. You'll get the best results if you leave your shutter open for several seconds to allow the various phases of one firework or even several fireworks to appear on one piece of film.

Since the sky is black, only the bursts themselves will record on film. Fireworks are surprisingly bright, and you should shoot at f/8 with ISO 100 film, or at f/11 with ISO 200 film. Since the sky is black, you can leave the shutter open for several seconds to catch multiple bursts. It's impossible to hand-hold your camera for this long without blurring the image, so you'll need to use a tripod or at least stabilize the camera in another manner (see sidebar).

POINT-&-SHOOT USERS

It's tough to shoot fireworks with a point-and-shoot camera. To help improve your results: Select ISO 100 film, turn the flash off, and steady the camera with a tripod or other method. If your camera has a landscape exposure mode, select it, because it will optimize the camera for a slow shutter speed.

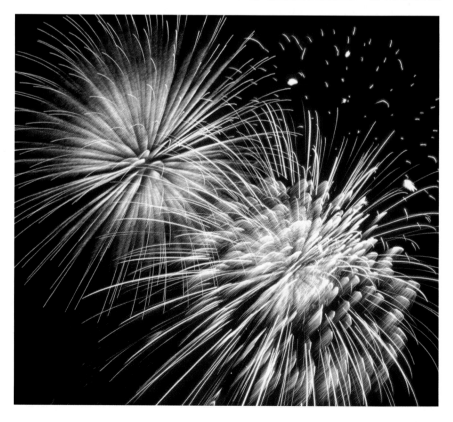

A fast shutter speed freezes just one instant during the relatively long event of a firework's rise to the sky and fanning-out burst (above). A long exposure (often seconds long) will record more of the firework's path, as well as multiple bursts (right).

Panning Images

Slow shutter speeds are also the premise behind panning images of fast action. For this effect, track the subject in the viewfinder while composing and shooting the image. Panning is a great technique for optimizing sharpness with fast shutter speeds, and it creates an artistic blur when done with slow shutter speeds; the result in the latter case is a relatively sharp subject and an extremely blurred background. The examples on page 127 show the difference between panned and unpanned images shot at slow shutter speeds.

TRIPODS & SUPPORTING THE CAMERA

Traditional tripods hold the camera steady on three legs, so that you can take sharp images of stationary subjects during the long exposures required when you use extremely long (slow) shutter speeds.

Some tripods have pan or ball heads that allow you to quickly and smoothly reposition your camera when it is mounted on the tripod. Quick-release plates that can be attached to the bottom of your camera allow you to take the camera on and off the tripod in a moment.

A monopod is a single-legged version of a tripod. Though you need to hold monopods steady during long exposures, they give better results than hand-holding alone.

There are times when a tripod may not be permitted or practical, but don't despair. You can create a tripod with your body by lying on the ground so your two arms and your body become the "three legs" of the tripod.

Alternate camera-stabilization devices have a tripod head on a different type of holding device, such as a window clamp, a wood screw, or even a suction cup.

Leaning the camera against an object like a tree can help you steady the camera for slower-than-normal shutter speeds without blurring the picture. Nestling the camera in a bean bag, pillow, or folded-up coat can also work.

The Key to Great Water Shots

BELIEVE IT OR NOT, YOU PROBABLY *WANT* BLURRY PICTURES OF WATER!

PHOTOGRAPHERS SPEND so much time trying to make sure their pictures are sharp that it is counter-intuitive to intentionally blur photographs of rushing water—but that's the key to success. Instead of freezing every droplet in stop-action with a fast shutter speed, do the opposite.

Begin by mounting your camera on a tripod, so that all the stationary objects (rocks and trees) will be sharply rendered during the exposure. Then select an extremely slow shutter speed to blur the moving water, so it records as a soft, white blur.

To insure that you are selecting the slowest shutter speed possible with an SLR camera,

it's easier if you don't use shutter-priority exposure mode. Instead, select aperture priority and the narrowest aperture on the lens (such as f/32). The narrow aperture lets in the least light during any given shutter speed, so for proper exposure the camera must match it with a slower shutter speed than it would go to at wider apertures.

It's hard to believe, but you still might not be able to get a slow enough shutter speed for the desired effect. If so, try switching to a slower-speed film (such as ISO 100) and consider using a neutral-density filter (see pages 70–71) to reduce the amount of light that enters the lens.

Compare the vast difference in photographs of rushing water taken at shutter speeds ranging from 1/500-second to 1/2-second. If the water is moving more slowly than in this river or if you are using a wider-angle lens, you will need to use even slower shutter speeds to achieve this amount of blur.

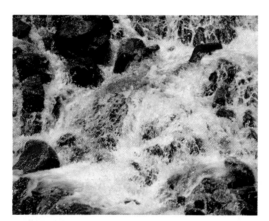

1/500-SECOND

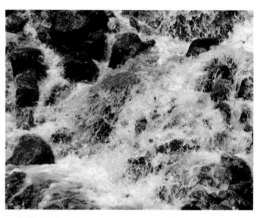

1/250-SECOND

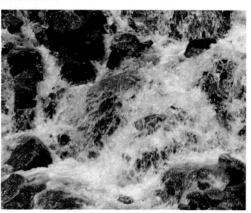

1/125-SECOND

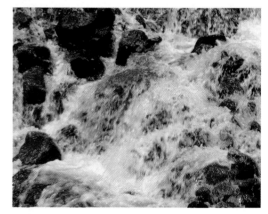

1/60-SECOND

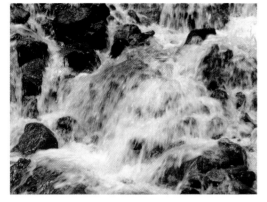

1/30-SECOND

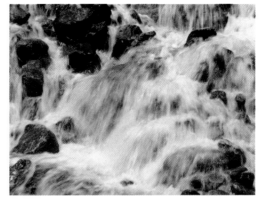

1/15-SECOND

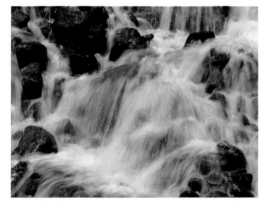

1/8-SECOND

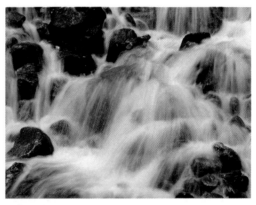

1/4-SECOND

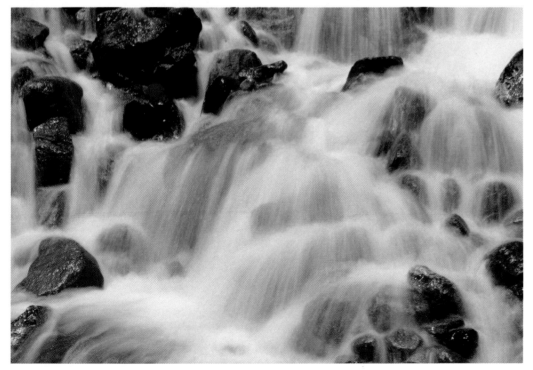

1/2-SECOND

Specialty Blurring

USE YOUR ZOOM LENS OR THE SUBJECT'S MOTION FOR CREATIVE BLURS

THREE CREATIVE USES of slow shutter speeds are fireworks (see page 42), Ferris wheels at night (for a wonderful blur), and zoom-blur (zoom the lens during a long exposure for an explosion of colors).

For the best results with all three techniques, steady the camera with a tripod. Doing so will insure that the only blur comes from the object's motion (or the zoom's motion), and not from camera shake during the exposure.

POINT-&-SHOOT USERS

For the slowest shutter speed possible on your point-and-shoot camera, select flash-off mode and use slow film, such as ISO 100. If your camera has a landscape mode, select it to weigh the exposure toward narrow apertures and slower shutter speeds.

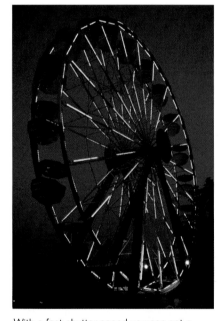

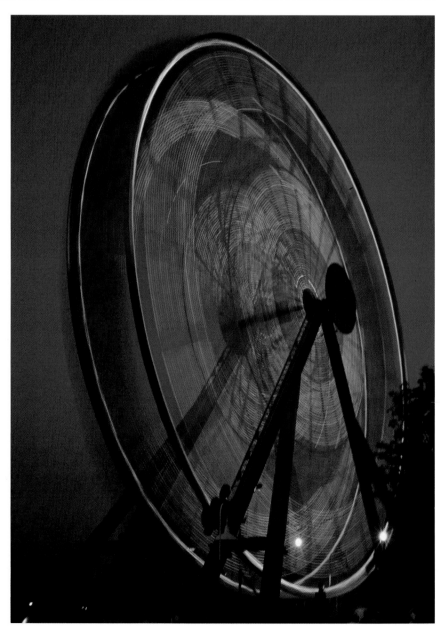

With a fast shutter speed you can get a stop-motion picture of a moving Ferris wheel at night (above). A slow shutter speed turns the photograph into an exciting blur that communicates motion (right). Because the camera was mounted on a tripod during the long exposure, the stationary portions of the scene record sharply, while the spinning parts blur. Without the tripod, camera shake would have ruined the picture by adding unwanted blur to the entire image during the one-second exposure.

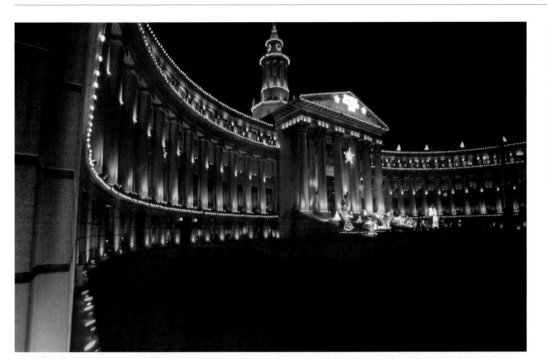

Colorful holiday lights (left) turn into an explosion of color when an SLR lens is zoomed during a long exposure (below). The results differ depending on the direction in which you zoom. This image started at a telephoto setting and zoomed to wide angle.

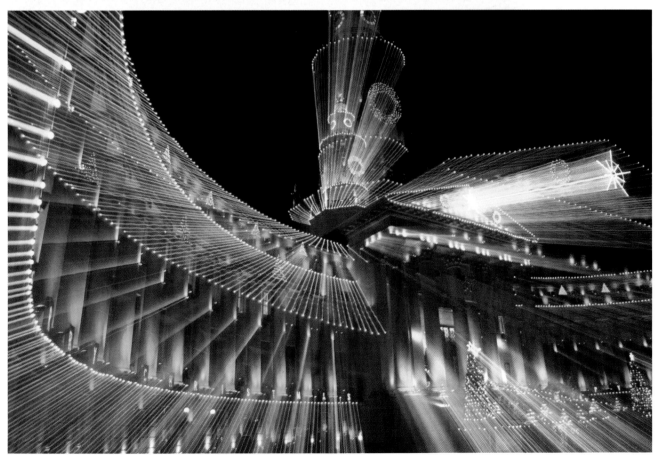

Multiple Exposures

EXPOSE THE FILM MORE THAN ONCE FOR SPECIAL EFFECTS

EVERY ONCE IN A WHILE you may want to purposely make two or more exposures on one piece of film. Called multiple exposure, this technique can be used for creative effect.

ME Mode

Sophisticated cameras sometimes have a multiple-exposure (ME) mode that allows you to shoot two or more images before advancing the film, so that they overlap on one picture. You dial into the camera how many images you want to shoot, and the camera automatically overlaps them and adjusts the exposure to compensate.

Manual ME

If you have an older, less-automated SLR camera, you may be able to do this manually. You can set up multiple exposure in cameras that have a button on the bottom of the body that you must push while rewinding the film. For rewinding, the button disengages the film advancement. To manually set up a multiple exposure, instead of rewinding the film you "cock the shutter" while the button is depressed, and the film does not advance.

You can also run a whole roll of film through the camera twice. For example, you can shoot an entire roll of an American flag blowing in the wind and then rewind the film. (If the leader retracts all the way into the film cassette, use a film leader retriever to pull it out.) Then you shoot the roll again, this time to include a secondary image on each frame. If your camera is not automated, you will need to alter the exposure because the cumulative effect of the two exposures may result in overexposure. Theoretically, this would be one stop less light (in other words, −1.0EV, or half the light) for each half of a double exposure, because the two exposures added together make one properly exposed photograph.

If your subjects are radically different, you may want to bracket the exposure—that is, take several images in which you select more or less exposure compensation. If the two subjects do not overlap exactly, certain parts of the final combination will have more or less exposure and thereby affect the final result.

In & Out of Focus

A popular technique is to take two images of the same subject, but put one of them out of focus. The result will be a sharp image that is overlapped with a softer halo.

To create a sharp image overlapped by a soft halo, make a double exposure of a subject in which one of the two exposures is taken radically out of focus. The left photo is an in-focus exposure; the right photo is the result when that in-focus shot is exposed again, this time out of focus.

Hand-held ME

If you choose to hand-hold your camera during a multiple exposure of one subject and accidentally or intentionally move or shake between the exposures, you will get slightly askew but mostly overlapping pictures. A field of flowers shot hand-help using 8, 16, or even 32 multiple exposures on one piece of film could result in a very abstract and colorful image.

Adding the Moon

Perhaps the most common use of multiple exposure is to add the moon. Before the Photoshop era (when computer image manipulation was impossible, difficult, and expensive), photographers would shoot an entire roll of film of the moon, keeping notes about where they placed the moon in each frame. The sky would record as black (virtually unexposed) except for the moon and the brightest stars. Then they would rewind the film and tuck it into their camera bag, waiting for a landscape or other subject that needed "something extra." At that point, they would re-shoot the moon roll.

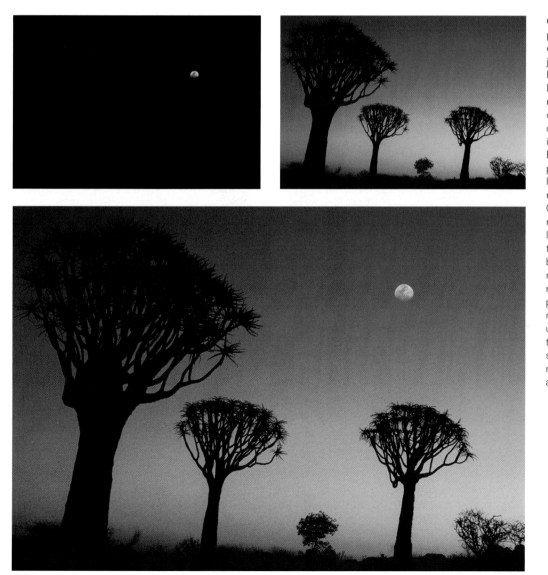

On a clear night, the photographer shot an entire roll of film of just the moon (top left). He rewound the film, leaving the leader out, marked the position of the moon on the cassette, and tucked it into his camera bag. Eventually the photographer found a wonderful landscape subject that needed something extra (top right). The photographer re-shot the landscape subject using the roll of film that had been exposed for the moon (bottom). He did not need exposure compensation, because the moon roll was basically unexposed except for the moon; the earlier shooting did not have much effect on the overall exposure.

Lighting with Flash

Most cameras today have a built-in flash. It can be a flash that you must manually pop up or otherwise activate, or one that fires automatically when needed. Higher-end cameras often have several flash modes that allow you to customize the operation of the flash for optimum results under different lighting situations.

Your camera's built-in flash can be a big help, but it is weak and limited compared to the powerful accessory units you can add to most SLR cameras. Usually the accessory flash is attached to the "hotshoe" on the top of the SLR. A flash that is dedicated to your camera system is the best, because it works with the camera's on-board computer to coordinate exposure, shutter speeds, and flash output.

Some high-end flash units offer advanced capabilities: flash exposure compensation, multiple-flash synchronization, close-up (macro) photography, stroboscopic effects, and rear-curtain flash, which is especially useful for shooting moving subjects at night.

Autoflash Mode

The default flash mode in your camera is called autoflash. Usually the flash fires when the camera "thinks" it is needed because the lighting is dim relative to the film you are using. Instead of switching to a slow shutter speed, the camera fires the flash.

In many situations, such as the snow cave scene (opposite), autoflash delivers a good result. The dark interior of the cave is lit by the flash for a better overall exposure.

Shortcomings of Built-in Flash

Sometimes when the autoflash mode fires, the background in the captured image turns black. This happens because the flash is combined with a narrow aperture and a fairly fast shutter speed—there's enough time for the relatively powerful and instantaneous flash to record on film, but not enough for the surrounding ambient (existing) light to record. In the example on the opposite page, the shady background turns black with autoflash illumination.

Another major shortcoming of built-in flash is the power of the unit. Even with fresh batteries, built-in flash units have very short range. Check your instruction manual to find out how far you can be from your subject and still have a reasonable expectation that the image will be properly exposed. For some cameras this might be less than 10 feet with ISO 100 film.

If your subject is beyond the distance range of the camera's flash, the result will be an underexposed image. The same will be true if your batteries are weak.

Flash Fall-off

In some cases, if you are using a lens that sees a wider angle of view than the flash can cover, you may get a dark outer edge where the flash cannot reach.

Flash Burn-out

On the flip side, being too close to your subject can cause flash burn-out—the flash cannot reduce its power enough and overexposes the subject. You can also get burn-out

LIGHTING WITH FLASH

 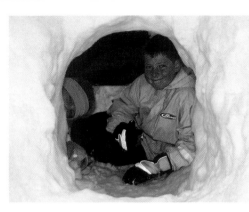

Autoflash (right) will lighten the boy, who was shadowed by the snow cave (left).

Autoflash mode (right) sometimes causes the background to turn black.

LEFT: Flash fall-off results in a dark ring around the outer edges of the image. It occurs when the lens captures a wider view of the scene than the flash can cover or when your subject is beyond the flash range.

RIGHT: If an object in the foreground gets between you and your main subject, the flash can create burn-out, turning the foreground object into a bright, distracting, and out-of-focus blob.

51

if a foreground element, such as a person's head or a tree branch, is in the path of the flash. The result will be a glaring white or bright spot in the foreground.

Red-eye Reduction

A third problem that arises with built-in flash is the red-eye phenomenon. This problem is most likely to occur when the flash is close to the lens and thus on almost the same axis, allowing the flash to bounce off the retina of the subject's eye, which appears red in the final image. One of the advantages of SLR cameras with accessory flash units is that the flash is raised up and far away from the lens axis, eliminating the problem of red-eye completely.

Some subjects, especially light-eyed individuals, seem more prone to red-eye in photographs than others. And photographs of animals often show a "green-eye" version of the problem.

This phenomenon can be reduced with red-eye-reduction flash mode, which is usually indicated on the camera by an eye symbol or an eye and lightning bolt symbol. Different cameras handle red-eye reduction in different ways; the most common is to fire a series of pre-flashes or shine a very bright lamp. The goal is to close down the subject's iris, so that less of the flash illumination can bounce off the back of the eye. These techniques do not always completely eliminate the problem, but they do reduce it. The downside is that a pre-flash or a lamp can cause a delay in the firing of the shutter; in other words, you can miss the moment. Also, some people react negatively to the bright lights, so that sometimes you avoid the red-eye but get an unflattering, startled expression in its place.

Red-eye-reduction flash mode (bottom left) reduces or eliminates the appearance of red-eye in pictures of people taken in low-light situations (top left). Red-eye can easily be corrected in the computer if you digitize your film or shoot your picture with a digital camera. For example, in Microsoft Picture It, just click on the eye and the software repairs it (top right). Photos © Jen Bidner

Animals sometimes get a green-eye version of the red-eye phenomenon (bottom right). Red-eye-reduction mode will reduce green-eye.

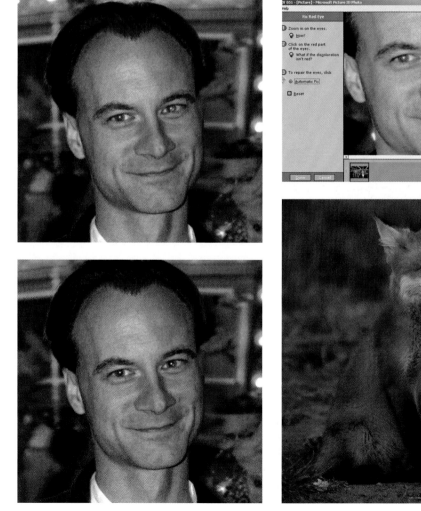

You may prefer to forego red-eye-reduction mode and use a red-eye correction pen to fix your color prints later. If you plan to digitize your film-based photographs, you can easily correct red-eye with photo-editing software. Some programs like Microsoft Picture It have a two-click command for repairing red-eye in the computer.

Fill-flash Mode

One of the most useful flash modes is fill flash, which is designed to be used when part of a nearby subject is in deep shadow.

The most common use for fill flash is when you're taking a portrait outdoors at high noon, when the position of the sun causes deep shadows under the eyes, nose, chin, or hat brim. Fill flash adds light to the front of the subject to lighten these shadows.

On most cameras, the fill-flash illumination is set at about one stop less exposure than the existing light so it won't overpower the existing sunlight. Higher-end point-and-shoots and some SLR cameras enable you to adjust the power of the fill so it is stronger or weaker. This gives the photographer a lot of control. Weaker fill is subtle and almost undetectable to the untrained eye, while stronger fill makes the subject pop out from the more distant background.

POINT-&-SHOOT USERS

Fill-flash mode can make a considerable improvement with images in which a nearby subject has deep shadows. When in doubt, use it!

Since fill flash is usually set to deliver the flash at about one stop less than (that is, half) the main light, it will rarely do harm and may well improve the image. It can brighten a dully lit subject and add a highlight to your subjects' eyes.

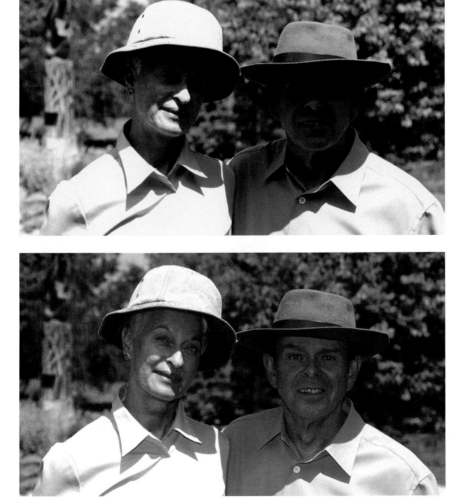

Sunlight casts dark shadows on the faces of the subjects (top). Fill flash lightens these shadows so that the faces are again revealed in detail (bottom).

Force-flash Mode

Force-flash mode fires the flash regardless of the lighting situation or the film in use. It is similar to fill-flash mode, but instead of just filling the shadows, force flash becomes the main light.

If your camera doesn't offer fill-flash mode, you can use force-flash mode as an alternative. But be aware that the flash will be at full exposure and therefore may overpower the existing light. It may also cause the background to look darker in the final image, in an effect similar to that of autoflash.

Night or Slow-sync Flash

A few cameras offer a flash mode that is sometimes called night flash or slow-sync flash. The symbol is usually the flash lightning bolt combined with the word "slow" or a symbol of a moon and star.

In this mode, the flash is combined with a slow shutter speed. The dimmer natural or existing light can be recorded during the long exposure, while the powerful flash instantaneously lights a nearby subject.

In the examples on the opposite page, the straight (nonflash) image shows the man and his car as a silhouette. Autoflash (not shown) would have illuminated the man and the car, but the background may have gone black. Night-flash mode allows both the last glow of sunset and the flash-illuminated man to record on the same piece of film.

This mode could also be used to take a picture of a person in front of city lights or amusement park lights at night. Just be certain that your subject is within the distance range of your flash; otherwise, it will be underexposed.

Another use for night flash is for an indoor picture in which the light source—birthday candles, a desk lamp, or a chandelier—is in the picture. The long exposure will enable these lights to glow brightly on film; they will have a yellow cast on daylight-balanced film. Meanwhile the flash provides front light on the subject and freezes the subject during the long exposure. Since the flash is the main light (and neutral in color when used with daylight-balanced film), the overall color is good.

Flash-off Mode

In the scene showing a car at sunset (opposite), if you decide you want a silhouette, you might not want to use your camera's flash. On some cameras the flash automatically fires whenever the light is dim. If you want it not to fire, you might have to select flash-off mode.

Force-flash mode brightens a nearby subject and helps to separate it from the background.

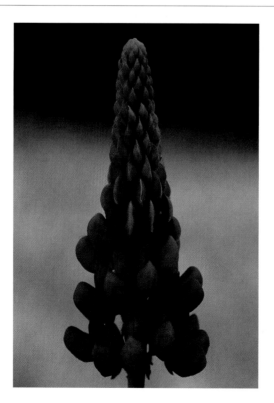

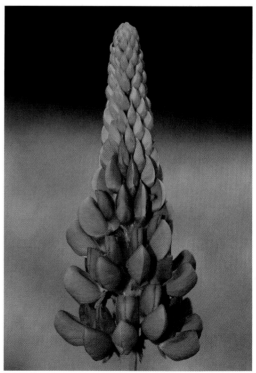

Force-flash mode is similar to fill flash, except the flash is stronger and becomes the main light. Note how it lightens the shaded subjects so they are closer in exposure to the brighter sunlight in the background.

Slow-sync flash mixes flash illumination with a long exposure to record the warm glow of a lamp (right).

Night flash combines a flash to illuminate the foreground subject with a slow shutter speed to record dim background light.

Fireworks are a great time to select flash off. Because it is nighttime, the camera may want to fire the flash. If it does, the exposure won't be good because you cannot "light" a fireworks display with your camera. Instead select flash-off mode and use a slow-speed film. The goal is to use a very long shutter speed so you can get one or more bursts in one shot (see page 42 for an example).

Flash-off mode is a good choice in any other situation when the light itself is the subject, such as a sunset scene, neon lights, a stained-glass window, or a fire. Likewise, if a shadow is the subject, flash would ruin the effect.

If you decide to use flash-off mode in dim lighting, be sure you either have high-speed film loaded or are prepared to steady the camera during a long exposure, or both.

Flash & Motion

Any time you mix flash with a long exposure and moving elements you have the risk (and possibility!) of ghosting. This phenomenon is easier to understand if you think of the result as three pictures combined: a flash picture, an existing light blur, and their interaction. The flash portion freezes the subject on the film in an instant. The existing light (which is usually much dimmer than the flash) records the

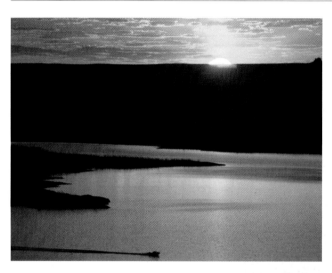

TOP LEFT: When your subject is the light itself (a sunrise), you can't light it with flash, so select flash-off mode.

TOP RIGHT: Candles produce dim lighting, but you can use them for illumination if you use ISO 800 or faster film and hold the camera very steady.

BOTTOM LEFT: The last glimmer of sunlight can look beautiful on your subject, but it can be dim enough for your camera to automatically kick in the autoflash. Select flash-off mode if you want to preserve the look of the natural light.

BOTTOM RIGHT: Stained-glass windows glow with sunlight, making the light itself the subject. Even though the interior of the building was dark, the photographer selected flash off.

moving subject (or the moving foreground and background elements) as a faint blur.

The third element—interaction—occurs if the background lights are bright and the subject moves. Black edges will appear around the edge of the subject if he moves after the flash is fired and blocks the bright background light during the long exposure (because the flash and the existing-light parts of the photo no longer line up). Similarly, the edge of the subject can appear to melt away if, after the flash is fired, the subject moves and enables the bright light to partially record over his flash-frozen image. All three effects can be seen in the image at right.

Slow-synch flash mode can create "ghosting" if your subject is moving in front of a bright background. The edges of the subject may acquire a black halo or appear to "melt" away. Photo © Jen Bidner

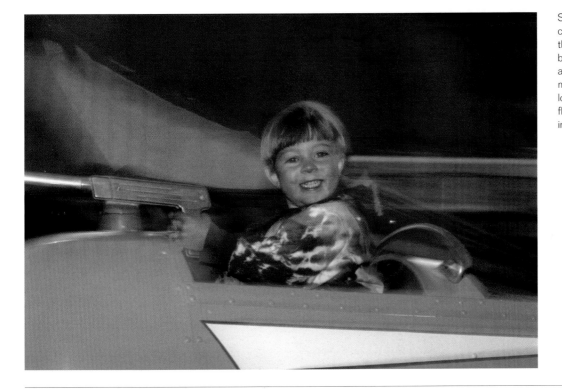

Slow-sync flash mode can cause ghosting when the subject is moving, because existing natural and man-made lights blur movement during the long exposure, while the flash freezes a moment in the action.

Straight flash (left) and slow-sync flash mode (right) create different results. The latter combines a long exposure with flash illumination. When the ambient light is bright, it blurs movement lit by the existing light during the long exposure.

Accessory Flash

SUPPLEMENT BUILT-IN FLASH WITH POWERFUL UNITS ATTACHED TO YOUR CAMERA

Accessory Flash for SLRs

The best accessory flash unit is dedicated to your camera of choice. This means that it works seamlessly with the camera's exposure and auto-focusing systems to achieve proper exposure. When some high-end accessory flash units are combined with high-end cameras, they offer advanced capabilities. Some flashes send out an undetectable pre-burst to test the distance of the subject for precise autofocusing in the dark or to test reflectivity for proper exposure of especially light or dark subjects (see page 34).

Manual Flash Units

Though they are uncommon today, a few economical manual accessory flash units are still available. To use them properly, you must match the aperture and film speed you are using to a scale on the flash. The flash will deliver the "right" exposure for a subject within a certain range (a chart is usually printed on the back of the unit). If you accidentally select a different aperture or the subject moves out of range, your results will be under- or overexposed.

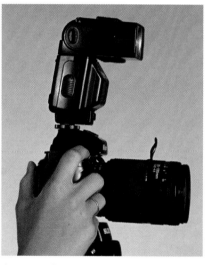

Accessory flash units (above) usually attach to the hotshoe on the top of an SLR camera. They are more powerful than the units built into most cameras. Not only do they have a separate battery pack for more power and longer service, but their range is greater. This twilight photograph of a speeding car didn't work well without flash (top right), but a powerful accessory flash allowed the photographer to illuminate the distant subject, while panning the camera to create an evocative image of speed (bottom right).

Flash-synchronization Speed

Flash is fast and appears instantaneous to our eyes. Unfortunately, the construction of some cameras can cause flash-synchronization problems. In the past, in order to achieve super-fast shutter speeds, cameras had a divided curtain that would move across the film plane during the exposure. At speeds faster than 1/250-second, some part of this curtain would be covering the film when the flash fired, resulting in a vertical black stripe on the picture.

In recent years, camera construction has changed, and many cameras offer flash-synchronization speeds of 1/1000-second and faster. Better cameras matched with dedicated accessory flash units usually won't let you accidentally shoot the picture with synchronization that is too fast. But cameras and flash units with less automation will, so you need to read both your camera's and the flash unit's instruction manuals to determine the fastest synchronization speed.

WHY ACCESSORY FLASH IS BETTER

1 IT'S MORE POWERFUL. Accessory flash units have their own battery source, so they can illuminate more distant subjects without draining your camera's battery.

2 IT'S DEDICATED. If your accessory flash unit is dedicated to your SLR camera, it will work automatically and seamlessly with the camera's autofocusing and exposure modes. Some dedicated accessory flash units actually help your camera's autofocusing by shooting out a pre-exposure flash that measures the distance to the subject. Others use a pre-flash to "test" the subject's reflectivity; this function helps to avoid the accidental overexposure of dark subjects and the underexposure of light subjects.

3 YOU CAN TILT & SWING IT. Some accessory flash units let you tilt the flash upward, for softer bounce-lighting off a reflector card or the ceiling; tilt it downward, for lighting subjects that are very close; or swing it sideways, for reflecting off walls.

4 IT HELPS WITH EXPOSURE COMPENSATION. High-end accessory flash units allow you to select an exact amount of under- or over-exposure (in comparison to the ambient light). These units are ideal for fine-tuning fill flash or balancing window light with the flash illumination.

5 YOU CAN USE IT OFF CAMERA OR REMOTELY. Some accessory flash units can be used off camera and thus provide versatility in the position of the flash. These units usually communicate with the camera via a cable or an infrared or radio signal.

6 YOU CAN CREATE MULTI-FLASH EFFECTS. Certain off-camera flashes can be synchronized, allowing you to create multiple-flash, studio-style effects. Some units can be "slaved" to fire when they see another flash (such as the on-camera flash) go off. Or they can be synchronized via a cable or infrared or radio signal.

7 YOU CAN USE IT WITH OTHER ACCESSORIES. You can attach all sorts of accessories to your flash that will modify its output—among them, miniature softboxes, diffusion panels, and bounce cards (all of which soften the lighting).

Accessories are available for SLR flash units that mimic the professional results of studio photography. A miniature softbox is placed over an accessory flash (left) to soften the light in the same way a large softbox is used in studio portraiture (right).

Bounced Off Ceiling

Most accessory flash units can be tilted upward so that the flash head in the unit is pointed upward or downward. Pointing it toward the ceiling enables the photographer to bounce the flash off the ceiling. Although this reduces the amount of light that hits the subject, it softens the lighting and changes its angle. Pointing it down will help with close-up pictures; a straight-on flash may be too high and will entirely miss the subject.

Beware of colored ceilings, because the image may pick up that tone. You may also get underexposed images with manual accessory flash units because of the loss of light during the flash process. If so, "lie" to the flash and set it for a slower film speed (or narrower aperture) than you are actually using. This will force it to put out more light.

Reflected Off Card

Similar, but more controllable bounce flash can be achieved by pointing the flash head upward at a reflector card. Doing this eliminates the problem of using bounce flash when the ceiling is too distant or strongly colored, or when there is no ceiling.

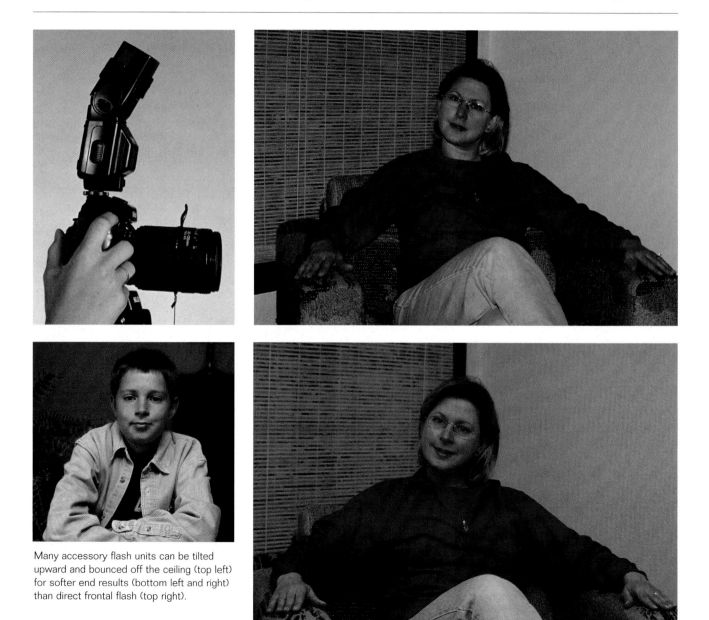

Many accessory flash units can be tilted upward and bounced off the ceiling (top left) for softer end results (bottom left and right) than direct frontal flash (top right).

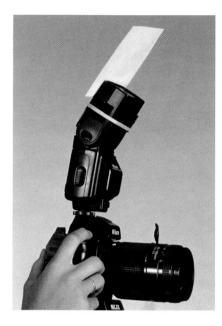

Most accessory flash units can be pointed upward at an accessory reflector (left). You can buy a reflector that optimizes reflectivity, or simply make a version by attaching white cardboard to the flash head with a rubber band. Straight flash can create a harsh effect (top right). Reflected flash softens the contrast (bottom right).

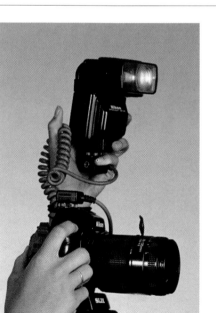

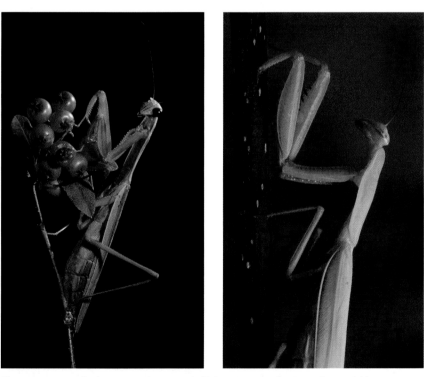

Some accessory flash units can be moved off the camera and triggered via a cable or an infrared signal (left). This allows you to make the flash illumination more directional, such as the rim light on this praying mantis (center). You can also shoot it through diffusion material or bounce the light off a white wall or white card to create softer lighting (right).

Specialty Flash

HIGH-END ACCESSORY FLASH UNITS OFFER EXTRA CAPABILITIES

SIMPLE ACCESSORY FLASH UNITS are available for under $50, but you'll spend far more if you want advanced capabilities. Some flash units offer the ability to fire the flash off camera and remotely, and some can achieve specialty effects like rear-curtain flash, stroboscopic lighting, and macro lighting.

Off-camera Flash

Some accessory flash units can be removed from the camera's hotshoe and still operate as if they were attached. They must communicate with the camera through a cable or invisible signal (such as infrared). Moving the flash off camera can be useful in these situations:

DIRECTIONAL LIGHT. Frontal light may not be the most flattering. Moving the flash off camera

can add a more directional look to the lighting. This technique can be as simple as mounting it on a bracket ("arm") that attaches to the tripod thread on the camera. Or you can hold it up with your free arm (for high front lighting) or attach it to a tripod or light stand.

CLOSE-UP SUBJECTS. Most accessory flash units will "overshoot" (that is, miss) a close-up subject because their position (usually higher than the camera) puts them at the wrong angle for lighting a close subject. A few offer a downward tilt of 5 to 10 degrees to help compensate, but that may not be enough. Moving the flash off camera assures that you can point the flash directly at the subject. (See pages 160–163 for other close-up flash solutions.)

A flash that can be removed from the camera's hotshoe (top left) allows you to point the flash directly at a close-up subject. Here a photograph of flower stamens (bottom left) becomes more dramatic with the use of fill flash (right).

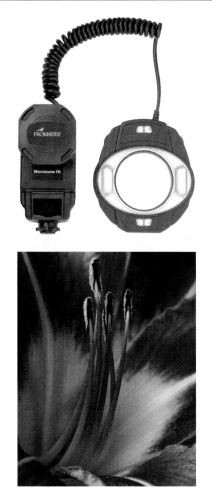

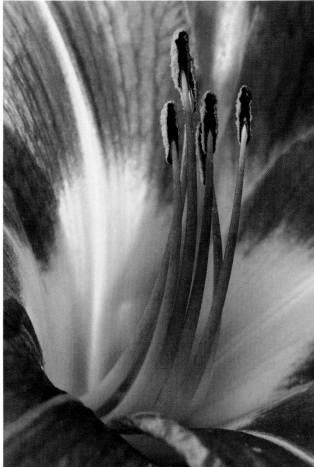

Rear-curtain Flash

You won't need rear-curtain flash mode very often, but when you do it is indispensable—and only a few high-end camera and flash combinations offer it. It's related to night/slow-sync flash mode, which combines a flash exposure with a long shutter speed (see pages 34 and 54–55). If your nighttime subject is lighted and moving during the exposure, you'll be glad to have rear-curtain flash.

You'd want to use this specialty flash to shoot a boy walking with sparklers, a car at night with its headlights on, or a torchlight ski parade. If you photograph these subjects with the normal (default) flash mode, here's what happens: The shutter opens; the flash instantaneously fires; the shutter remains open for the remainder of the exposure; and the shutter closes, ending the exposure. This is known as front-curtain flash, and it is the way most cameras and flashes work.

In the example below, a boy walks from the right to the left side of the frame; the boy is frozen at the start (right side) by front-curtain flash; and then the flashlights blur to the left during the rest of the exposure, making it look as if the boy is moving backward in the final image. You could of course have him walk backward to make the picture look correct.

POINT-&-SHOOT USERS

If your camera has night/slow-synch flash, have your subject walk backward during the exposure. Without rear-curtain flash, this is the only way to make the motion look as though it's going forward.

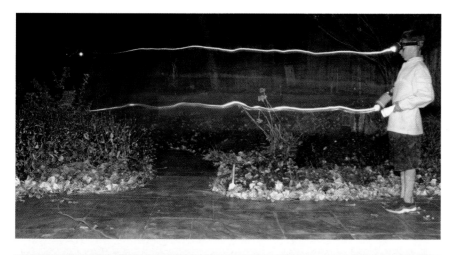

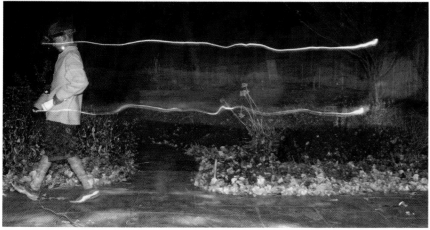

In standard front-curtain flash (top), the flash is fired first, making moving, lighted subjects look as though they are moving backward. Rear-curtain flash (bottom) fires the flash at the end of a long exposure.

Until recently, in fact, models sometimes ran backward or cars were driven backward for this effect.

It is much easier instead to use rear-curtain flash, which is available with some camera and flash units. The sequence in this example is as follows: The shutter opens; the shutter will remain open for the remainder of the long exposure; the flash fires immediately before the shutter closes; and the shutter closes, ending the exposure. This would make the picture look "correct."

Stroboscopic Effects

A few flash units offer stroboscopic effects, in which a series of mini-flashes go off during a long exposure. The primary uses for this type of flash are to communicate motion in stop-action, to create overlapped images, and to analyze a fast action such as a golf swing. If shot against a black background, stroboscopic flash creates overlapping images as each mini-flash goes off. The result is similar to what you get with slow-sync flash, but instead of a blur for the secondary image, you get equally exposed, overlapping versions (see example below).

Extra-powerful Flash

Accessory flash units are more powerful than built-in units, but they may not be adequate for "distant" subjects. Extremely powerful flash units are popular with wedding photographers because they can illuminate vast churches and large groups, and can shoot hundreds of pictures. Specialized focused-flash units designed to be used with telephoto lenses are favored by wildlife photographers who shoot from a distance.

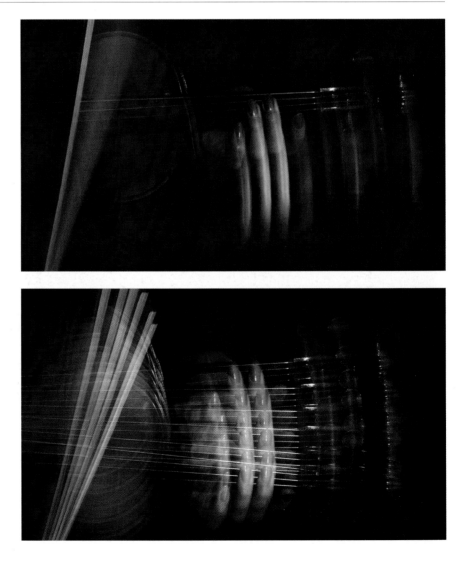

Some cameras and flash units offer strobo-scopic mode (bottom), which fires a series of mini-flashes. It is great for a stop-action analysis of a moving subject. Stroboscopic mode is different from slow-sync flash (top), which fires one flash and creates a blurred secondary image of the moving subject.

A "potato-masher" type of professional flash is stronger than most accessory units (left), making it a good choice for wedding photographers and other professionals who need more power (right).

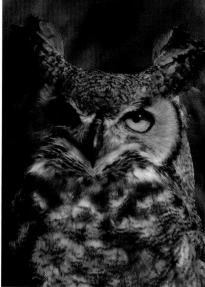

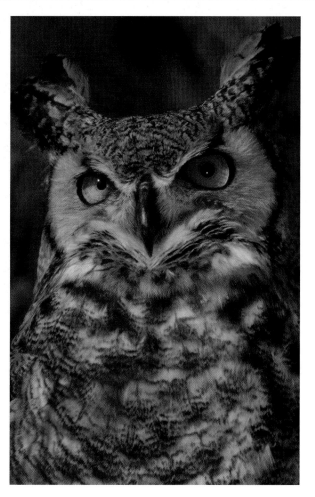

Extremely powerful focused flash (top left) can add fill when you're using telephoto lenses. Detail can be lacking in photos taken at a distance and without a flash (bottom left). A powerful fill flash makes for more detailed and more interesting images (right).

Flash Exposure Compensation

SOPHISTICATED FLASH UNITS CAN BALANCE THEIR ILLUMINATION TO THE EXISTING LIGHT

AUTOFLASH CAN DELIVER an exposure that properly illuminates the subject with a powerful burst of light but results in a dark or black background. This effect occurs because the background is too distant to be lit by the flash, and the aperture/shutter speed combination does not allow the dimmer existing light to record brightly on film.

In many cases, you will get the best result when you balance the existing light with the flash exposure so that they both record well.

In the example shown on these pages, the flash power and aperture (f/5.6) are kept constant, but the shutter speed is varied. Since the flash occurs in an instant, it properly exposes the nearby subject in all six of the images, regardless of the shutter speed.

The variations in the background occur as the shutter speed changes to allow the background fire and fireplace to get brighter. In the photo below, the background starts at five stops under the flash exposure and is almost black. For the image at the bottom of the opposite page the ambient light and flash exposures were approximately equal.

High-end cameras offer dedicated flash compensation, so that you can automatically select how much brighter or darker you want the flash illumination to be in comparison to the daylight or existing light.

You can also control the flash manually, by altering the shutter speed, so long as you stay below the flash's maximum synchronization speed (often as slow as 1/250-second).

In this series of images, the aperture and flash power remained constant so that the nearby woman was exposed the same in all the pictures. However, the photographer varied the shutter speed for each image, and the ambient light varies from five stops underexposed to full exposure.

FIVE STOPS LESS THAN FLASH OUTPUT (–5.0EV)

FOUR STOPS LESS THAN FLASH OUTPUT (–4.0EV)

THREE STOPS LESS THAN FLASH OUTPUT (–3.0EV)

TWO STOPS LESS THAN FLASH OUTPUT (–2.0EV)

ONE STOP LESS THAN FLASH OUTPUT (–1.0EV)

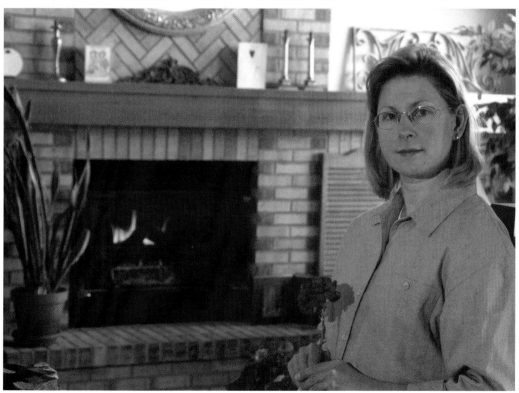

BALANCED WITH THE FLASH (0.0EV)

The Magic of Filters

Filters are one of the most powerful photographic accessories, because they can deliver a tremendous amount of control over the look of the image. Some filters are very subtle, while others can dramatically turn a throw-away image into an award winner. The trick is knowing which filter to use, and when.

Some filters work by selectively allowing certain rays of light to enter your lens while excluding others. Some—like diffusion, fog, and speed filters—can bend or scatter the light for special effects.

Polarizers are great for removing reflections from glass, water, and flora. Colored filters add a warm or cool cast or dramatic tones to a color image. These same filters can be used with black-and-white film for radical shifts in the relationship of an image's tones, such as using a red filter to darken a blue sky without otherwise affecting the clouds. Rotating graduated neutral-density and graduated color filters can save the day if you have a bright sky and a dark foreground or vice versa.

Digital photography makes many filters obsolete, because color correction and enhancement are so easily done with a computer. But polarizers and other filters that affect only certain parts of the image are still very useful. In theory, you could replicate them in the computer, but not without a lot of extra work and skill.

THE MOST COMMON FILTER is the screw-on variety that attaches to the front of the lens. (See the sidebar on page 71 for more on this and on the other main type, modular filters.)

Before buying a screw-on filter, you'll need to know the filter diameter of each of your lenses. Don't confuse focal length with filter diameter, even though both are measured in millimeters (mm). You can purchase filters for each lens (and each filter diameter size), or use one large filter and get step-down rings to retrofit it to each lens. The latter saves money, but if it is a filter you will be using a lot, screwing it on and off your lenses can be an inconvenience.

UV & Skylight Filters

The most common filters are the UV and skylight filters. Though different, their effect is similar. UV filters remove ultraviolet light that is invisible to our eyes but can cause a color cast on film. Skylight filters, pale pink in color, remove the slight bluish atmospheric haze seen in many outdoor pictures. Both filters are usually inexpensive, and either has the added advantage of protecting your valuable lens from damage. It's a lot cheaper to replace a scratched filter than a whole lens.

Polarizers

Polarizing filters (polarizers) are the next most common filter because they are so versatile. A polarizer will often remove unwanted reflections from nonmetallic objects, such as the surface of water, the shine on leaves, or windows. By reducing the reflection or glare, you can get more saturated images.

POINT-&-SHOOT USERS

If your camera doesn't take filters, you may be able to use an accessory filter holder made for point-and-shoot cameras. However, these can be difficult to use with polarizers and graduated filters, because they must be rotated to the "right" spot; however, you won't be able to see that through the lens, so you'll have to guess. (Remember, the definition of a point-and-shoot camera is that you are not looking through the picture-taking lens.)

MOST SLR & A FEW POINT-AND-SHOOT CAMERAS CAN ACCEPT FILTERS

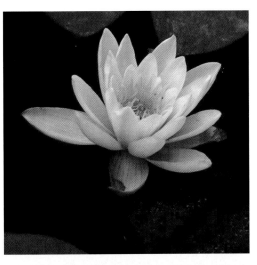

POLARIZING FILTER

A polarizer can reduce distracting reflections on the surface of water. Depending on your angle to the subject and the lighting, this can either darken the surface of the water or reveal what is underneath.

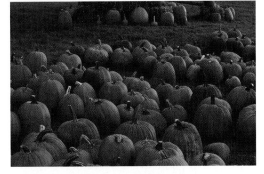

Many types of flora have highly reflective surfaces (left). A polarizer can sometimes remove the glare from pumpkins, leaves, and grass. The result is a more saturated image (right).

Use a polarizer to remove the reflection off windows and other glass surfaces.

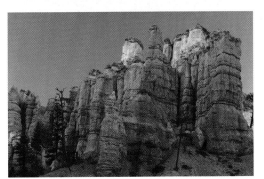

By darkening the sky, a polarizer can reduce the contrast ratio between land and sky, allowing better exposures of both (right).

Another popular use for polarizers is to darken blue skies. This technique produces dramatic sky images and allows the foreground to appear lighter in comparison to the darkened sky.

These filters come in a revolving mount that you spin while looking through the viewfinder and watching until you achieve the "right" amount of polarization. Note that polarizers do not always work, depending on your angle to the object, how it reflects the light, and the position of the polarizer. In situations in which the effect is too much, you can rotate the filter back for partial polarization.

Most of today's autofocusing cameras require that you use a circular polarizer, because linear polarizers can interfere with the camera's polarization-based autofocus and metering systems.

Neutral-density (Gray) Filters

You won't need a neutral-density (ND) filter very often, but when you do, it's invaluable. ND filters cut down the amount of light entering the lens so that you can use slower than normal shutter speeds.

The prime example is shooting rushing water. Such images look best with super-slow shutter speeds, such as 1/2-second or slower. ND filters come in different strengths; the two most common are one stop (2X) and two stops (4X). The filters should be neutral gray. Avoid cheap versions that sometimes have a green or pink cast.

Graduated Filters

The graduated neutral-density or graduated color filter is considered indispensable by some outdoor photographers. These filters start with color or ND on top and gradually fade to clear at about the halfway point.

The idea is that many landscape scenes have a bright sky and a relatively dark foreground, especially at dawn or dusk, before direct sun brightens up the land. This difference in exposure is often beyond the capability of the film, so you either get a great sky and a black landscape, or well-exposed land and a washed-out sky. With this filter you can darken the sky without affecting the foreground, thereby allowing the film to record detail in both parts.

Photographers often choose orange/tobacco colors for sunset, pinks for dawn, blue for cloudless skies, and neutral gray when no added coloration is wanted.

On pages 92–93, we show how it is often better to compose images with a high or low horizon line. Since a screw-in filter can only be rotated, but not raised or lowered, the gradation to clear will work only on a centered horizon line. Therefore, if you do a lot of landscape photography, you may want to consider a modular filter system (see the sidebar on page 71), which allows you to raise or lower a rectangular filter so that the gradation matches your composition.

On rare occasions, you can even put the filter on upside-down, to darken a bright foreground (such as a snow scene).

POLARIZING FILTER

Polarizing filters can make a dull sky (left) far more dramatic, by darkening the sky to emphasize the clouds (right).

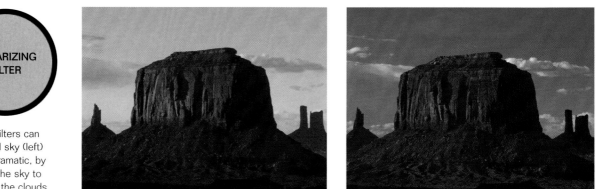

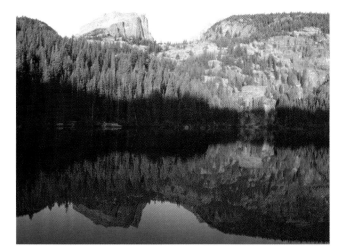

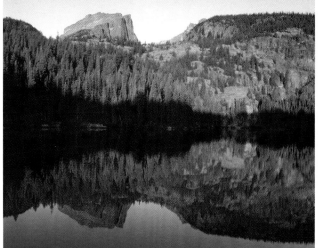

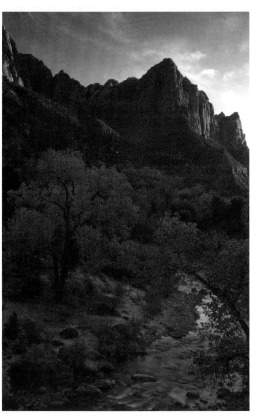

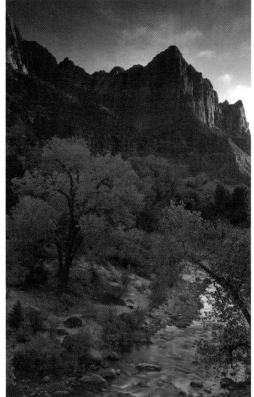

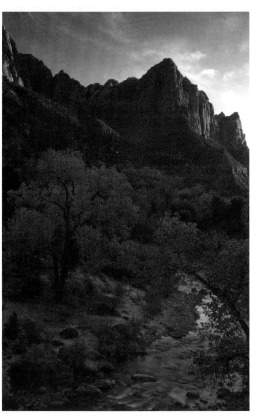

GRADUATED
ND FILTER

GRADUATED
PINK FILTER

Graduated filters help darken the sky, so that both the landscape and the sky will be well exposed. For the photo at top right, the photographer got better detail in both foreground and background, and darkened the sky by using a graduated neutral-density filter. In the photo at bottom right, a graduated pink filter helps to color the sky and sharpen detail in the foreground.

FILTER TYPES

SCREW-ON FILTERS. These are the most common type. Simply screw them onto the front of your lens. Size is based on the filter diameter of your lens. Larger filters can be fitted to multiple lenses with step-down rings, but this is not a good choice for graduated filters.

MODULAR FILTERS. Modular filters have an adapter that attaches to your lens. You then slip rectangular filters into the adapter and you're ready to go. One filter can be used for all your lenses. In the case of graduated filters, you can raise or lower the filter to match the horizon line.

Filters for Special Effects

FUN EFFECTS CAN BE ACHIEVED WITH THESE FILTERS

THERE ARE NUMEROUS "special effects" filters that go in and out of vogue as aesthetic trends change. The trick when using any of these filters is to not get swept away in the technology and use the filter just because you have it. Play with the filter to learn how it works, and then use it when it truly enhances the subject.

Star/Cross Filters

Among the filters that have stood the test of time is the star or cross filter. This type of filter turns most specular (mirror-like) highlights and direct light sources—candles, the sun, and reflections on a bright, sunny day—into brilliant stars or crosses. Star/cross filters are commonly available in a 4-point (cross), 8-point, 16-point, or variable design.

Prism Filters

A prismatic version of the cross filter is also available. This filter, sometimes called a diffraction grating, turns specular highlights and direct light sources into pretty rainbow colors. Some prism filters have different patterns, such as slashes of color rather than stars.

A similar filter that came on the market a few years ago is the rainbow filter. It is not a prism, but it literally adds a faint rainbow to your picture. However, it is hard to finesse this filter into a realistic rainbow. Today, with the wonders of digital software, it is probably easier to add a rainbow on the computer.

Diffusion & Fog

Though different in construction, and slightly different in effect, diffusion and fog filters are both designed to "soften" images. They are especially useful for lending a romantic feeling to portraits and landscapes.

A diffusion filter creates the look of a sharp image overlaid by a secondary less-sharp version. The best diffusion filters do not reduce contrast. High-end diffusion filters come in several different strengths. The effect can also be increased or decreased through your aperture selection; it is strongest at wide apertures.

A fog filter softens the image by scattering the light across the whole image. It lowers the contrast of the scene and tends to produce a glowing or halo effect around light sources in the picture. Like the diffusion filter, it comes in several strengths and has the greatest effect at wide apertures. Some photographers intentionally overexpose images when using fog filters to give the light, airy feeling of a foggy morning.

Multiple-image Filters

There are numerous versions of multiple-image filters, but the principle is the same for all of them—they produce multiple versions of a portion of the image. Your distance from the subject, your focal length, and your aperture selecion can affect the look of the picture, so experiment.

Star or cross filters add a brilliant star or cross pattern to light sources and specular (mirror-like) highlights.

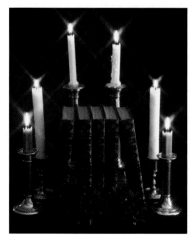

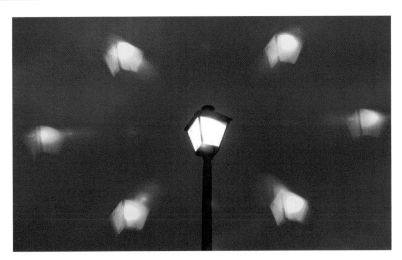

Prism filters work best if there is a direct light source or specular highlight in the scene (left). The photo (right) shows the dramatic results of using a prism filter.

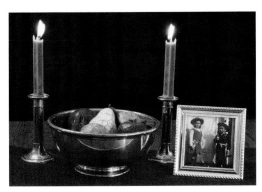

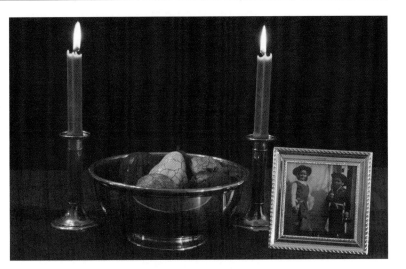

A fog filter softens the image and tends to create a halo around direct light sources.

Multi-image filters create a repetition of the central subject. These filters are available in many different patterns.

Vignettes affect the outer portion of the image. Black vignettes (right) darken the corners, while a clear vignette simply softens the edges (below).

Vignettes

Vignettes are available as both filters and glassless lens attachments. The effect is to block or alter the corners or all outer portions of the image so that you get a black, colored, or clear soft frame around the picture.

Homemade Filters

You can make your own soft vignette by smearing petroleum jelly on the outer portions of an old UV filter. The result will be distortion of the jelly-covered portion and a normal image where there is no jelly. The more jelly you use, the greater the effect. Use an old or scratched filter, because it will be hard to clean well after you use it.

You can make another great "filter" by placing a piece of sheer stocking material over your lens and securing it with a rubber band, creating a soft effect that is especially good for portraits. Compare the results of using warm-colored stockings with those provided by white and by black stockings.

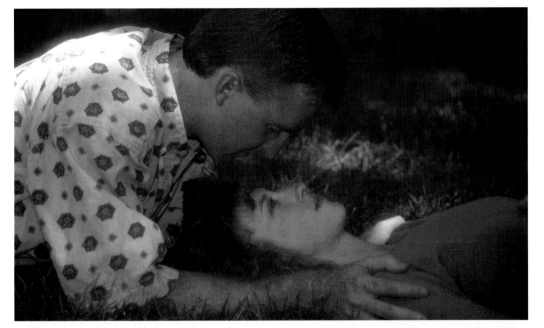

TOP: You can create your own filter for soft effects by smearing petroleum jelly on a UV filter. Here the photographer put it around the outer section of the filter, leaving the center sharp.

BOTTOM: By smearing petroleum jelly on the outer portions of a UV filter, the photographer created an artistic effect.

Color Correction & Conversion Filters

CORRECT DRASTIC COLOR PROBLEMS CAUSED BY THE TYPE OF LIGHTING

THE HUMAN BRAIN does a wonderful job of color correction. Natural light takes on varying color casts at different times of day or under different weather conditions. Likewise, man-made lights vary in their color. We see these differences when we move from one type of light to another—such as from yellowish indoor lighting to cooler daylight—but for only a few seconds. Then our brain readjusts the scene to neutral, and we no longer notice the color cast.

Film, however, cannot do this. Regular color print film sees warm household lamp bulbs as yellowish, fluorescent lighting as greener, mid-day sun as neutral, shade as cooler (bluer), and a rainy day as very blue. Photographers use filters to return the color balance to normal (neutral), unless they want a certain color cast for creative purposes.

Some color can be corrected during the printing process or in the computer if you digitize the image (see pages 16–17), but you will achieve the best results if you get close to the correct color through the use of filters.

Fluorescent Filters

A common problem photographers face while shooting indoors is fluorescent lighting. These lights appear on the greenish side, which partially explains why people rarely look their best under fluorescent lighting. Though not perfect, a magenta-colored fluorescent filter can help correct the problem.

A fluorescent filter (left) helps remove the green tone from a scene lit by fluorescent lights (right).

A comparison of an outdoor scene shot with daylight film (left), tungsten film (center), and tungsten film with an 85B conversion filter (right).

Tungsten/Daylight Conversion

Have you ever noticed how yellow your indoor photos look if you don't use flash? That's because most films are daylight-balanced, meaning they deliver accurate color in mid-day sun or with flash. Warmer tungsten lights (such as standard household bulbs) are much yellower, and the pictures take on this cast.

Placing a blue-colored 80A filter over your lens will correct for this problem. You can also solve the problem without a filter by using a tungsten-balanced film (see page 21 for more details). The three examples below compare the options.

Or if you've chosen tungsten-balanced film and then decide to move out into daylight, you'll get a pale bluish cast to the picture. Using an orange-colored 85B filter will warm up this image and bring it back to a more neutral tone. The three examples of the boy photographed outside (opposite page) demonstrate this.

You may have noticed that you use cool (bluish) filters to correct warm (yellowish) pictures and vice versa. This is because blue and yellow are opposite colors and therefore neutralize each other. The color wheel shown on page 84 lays out such relationships, with opposite colors appearing on opposite sides of the wheel. The wheel shows why you can use a cyan-colored "red-eye marker pen" to neutralize the red cast on photographic prints that have the red-eye phenomenon (see page 52).

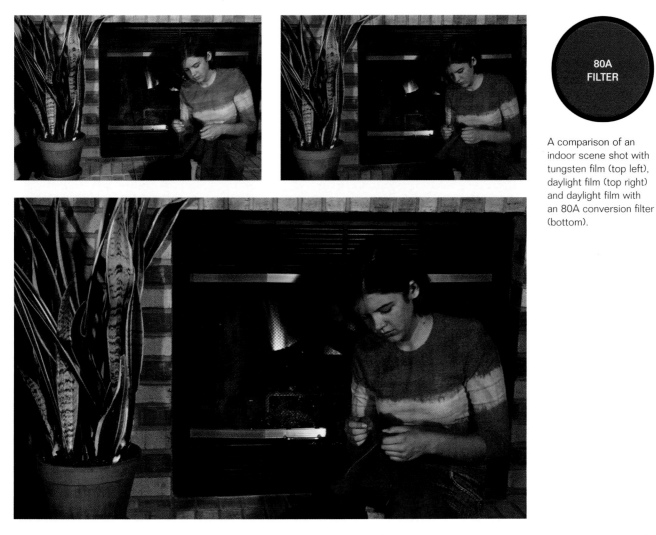

80A FILTER

A comparison of an indoor scene shot with tungsten film (top left), daylight film (top right) and daylight film with an 80A conversion filter (bottom).

Color Enhancement

USE FILTERS TO FINE-TUNE THE COLOR OF YOUR IMAGES

SMALL COLOR CHANGES in your photographs can make a big difference in the final result. You can make the images warmer or cooler, or even add a vibrant overall color cast. Without using filters you can correct some of the problems during the printing stage. Likewise, these changes can be made in the computer, if you're planning to digitize your film images (see pages 16–17). But if you're shooting slides you'll probably want to use filters.

Warming Filter

Because daylight film is balanced to give neutral results under sunny mid-day conditions, it records bluish images earlier in the morning, under cloud cover, on rainy days, or in the shade. If the bluish cast isn't desired, an 81 series filter will remove some of it. The 81 filters come in different strengths; 81A is the mildest, and 81B and 81C get progressively stronger.

Sunset Filter

Far stronger than a warming filter is a sunset filter, which adds a very strong, warm-orange tone to an image. As its name implies, it is most commonly used to enhance a dull sunset or to warm up the background for a silhouette image of the main subject.

An orange-toned sunset filter enhances the color of a dull sunset scene.

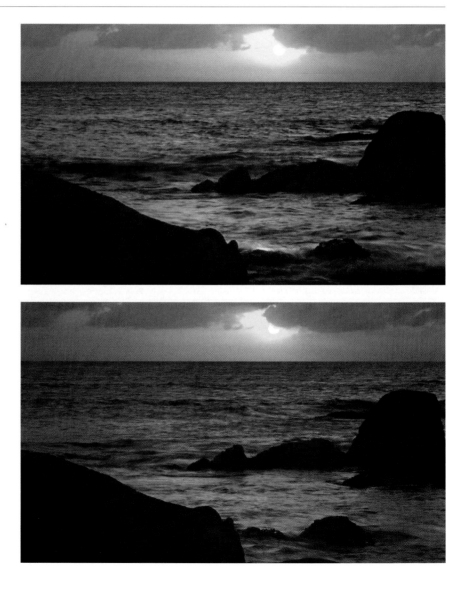

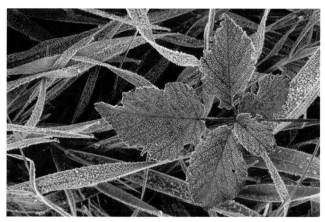
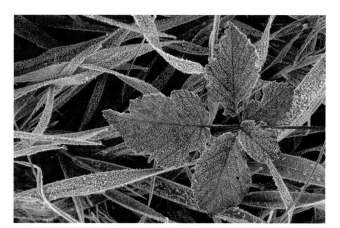

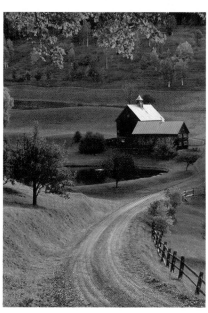

WARMING
FILTER

A warming filter creates a warmer, more pleasant final version of the shaded image of a leaf (top right) and a rural scene (bottom right).

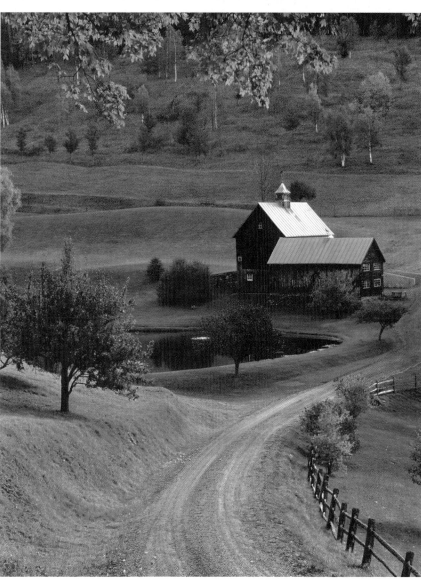

Cooling Filters

Less common than warming filters are blue-toned cooling filters that take the warm cast out of an image. Blue suggests words like "cool," "cold," "night," and "refreshing." Adding a blue tone to "cool" an image can be a creative effect.

You can also take this concept to extremes and use a deep-blue filter. This is an old Hollywood film technique, designed to turn a bright, sunny day into a "moonlit" scene.

Enhancing Filters

A popular filter for outdoor photography is the color-enhancing or -intensifier filter. The most common enhancing filter is made of didymium glass that intensifies red and orange tones while causing only minimal overall change of neutral colors and other tones. The biggest weakness of enhancing filters is a tendency to weaken green-toned subjects. They are especially useful for fall foliage, when greens are not present. Color-intensifier filters are also available for greens and blues.

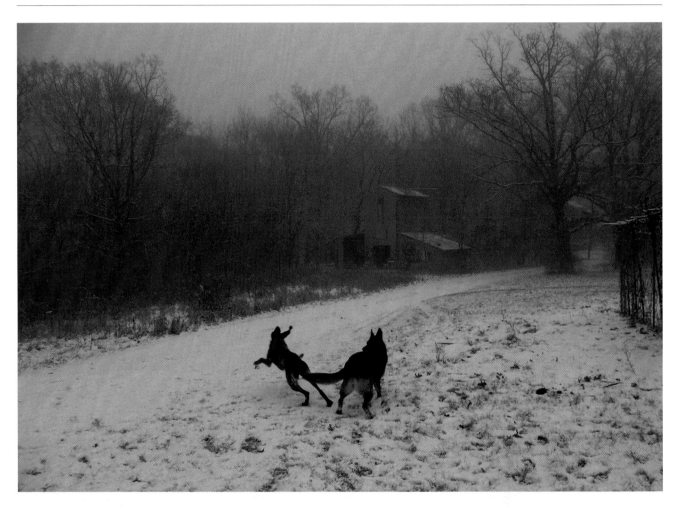

A blue filter makes an already frosty scene look even colder. Photo © Jen Bender

COOLING FILTER

ENHANCING
FILTER

An enhancing filter brings out the red tones of the rock formations (top right). A photograph made with a red-enhancing filter (bottom right) brings out the color of the flower petals but weakens the green leaves.

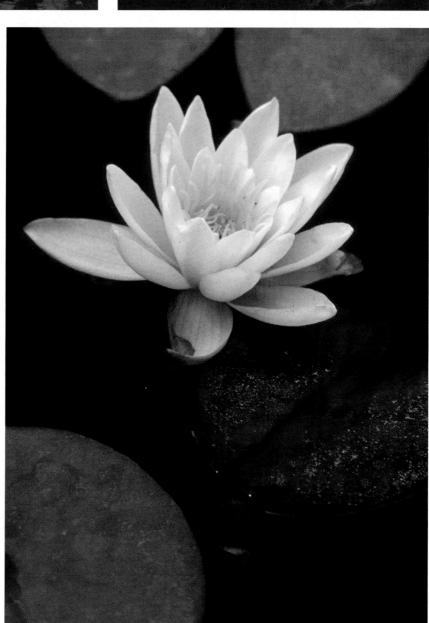

Filters for Black & White
GAIN MORE CONTROL OVER YOUR PICTURES WITH COLORED FILTERS

THE USE OF COLOR FILTERS in black-and-white photography offers the photographer a unique opportunity. They don't cause a color cast—it's black-and-white film, after all! However, these filters will selectively lighten or darken certain colored objects by blocking out particular colors of light. Using color filters gives you considerable control over lightening or darkening elements in the final black-and-white image.

The rule of thumb is that a certain colored filter will lighten its own color and darken its opposite. (The color wheel on page 84 shows these relationships.)

Note how the nice blue sky in the color image below becomes washed out in the straight (no filter) image (opposite, top left). Adding a yellow filter (opposite, top right) makes the sky slightly darker; an orange filter (opposite, second row left) makes it darker still; and the red filter delivers the maximum effect (opposite, second row right). This is because a "blue" sky is really closer to "cyan" than the true color blue. (Blue is a combination of cyan and magenta; hence the yellow has some effect on the lesser cyan component.)

Combine the sky-darkening red filter with a polarizer and you get an almost black sky (opposite, third row right). Be careful when combining filters, especially on wide-angle lenses, because you may get unwanted darkening of the corners (vignetting).

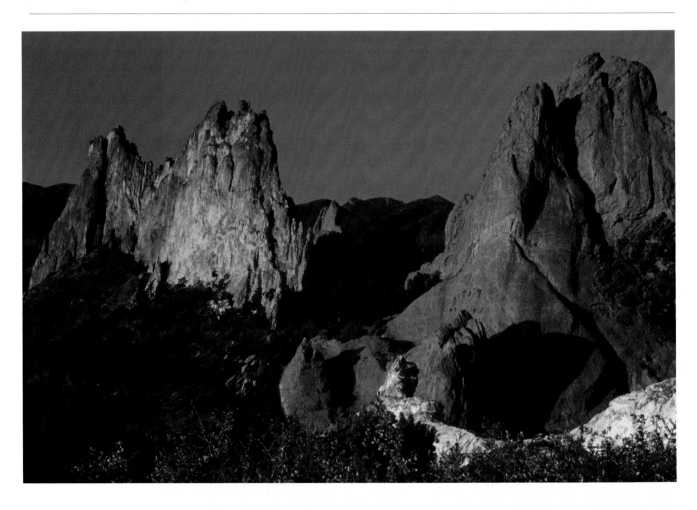

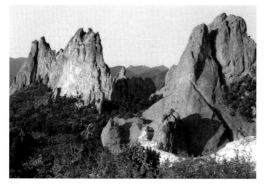

STRAIGHT (NO FILTER)

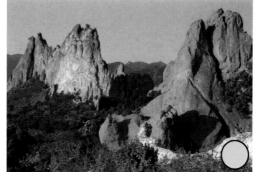

YELLOW FILTER

If you plan to shoot black-and-white film, you'll need to learn how filters of different colors affect the final black-and-white image. The photo on the opposite page is the scene as recorded on color film.

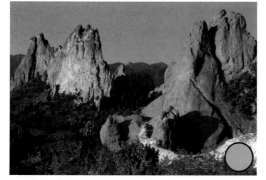

ORANGE FILTER

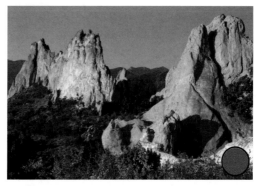

RED FILTER

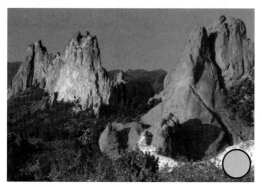

POLARIZER

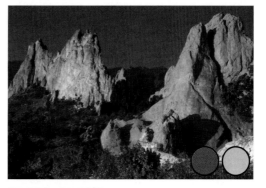

RED FILTER & POLARIZER

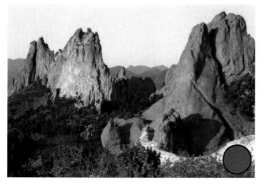

BLUE FILTER

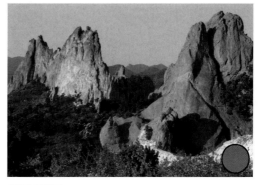

PURPLE FILTER

Perhaps more dramatic are the still-lifes shown here. Notice how much you can change the relative lightness or darkness of the red placemat just through the use of a filter. The same is true for the cyan and yellow place-mats and even the orange carrot.

Compare the still-life images to the color wheel (right). A red filter lightens its own color (the red cloth and the apple) and darkens the color on the opposite side of the color wheel (the cyan cloth under the apple, and the cyan wood tulips).

When would you use the information provided by the color wheel? Most commonly, photographers use color filters to darken the sky (red filter) and make white, billowing clouds look more dramatic. Magenta (pinkish) filters are good in black-and-white portraiture to lighten acne, blemishes, and ruddy skin tones. A green filter will lighten green foliage and grass, which sometimes lends a more romantic, dreamlike quality to landscapes.

The color wheel is a quick reference for choosing the right filter in black-and-white photography. A filter of a certain color will lighten similar hues and darken those on the opposite side of the wheel.

Compare the straight color image (opposite) to the straight black-and-white image (top) and to the versions shot with colored filters. At first glance, they may seem similar, but the variations can make a dramatic difference in your photos.

RED FILTER

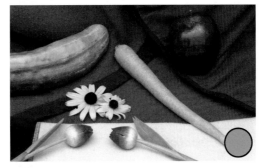

ORANGE FILTER

YELLOW FILTER

GREEN FILTER

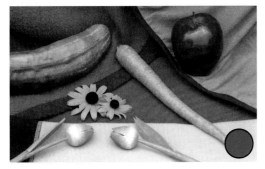

BLUE FILTER

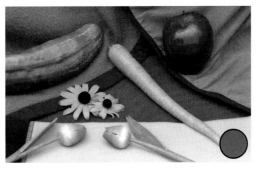

PURPLE FILTER

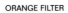

Understanding Composition

Today's cameras have so much automation and so many advanced capabilities that much of the difficulty surrounding the "science" of photography has been removed. Exposure has been simplified, fill flash doesn't require mathematical computations for success, films have been vastly improved, and digital cameras give instant feedback. It's no longer difficult to achieve technical excellence, even with a point-and-shoot camera.

What this means is that the division between "great" and "okay" photography has much less to do with the technical side of the equipment and much more to do with artistry. The quickest way to improve your artistry is to learn the "rules" of composition and gain a better understanding of aesthetics.

You'll first need to identify your subject and then "interpret" it to produce a beautiful image. Your tools for doing this include the equipment you choose, your shooting position, your choice of lighting, and how you compose the image. Good photographers learn basic design concepts—including color theory; the artistic use of leading lines, textures, and patterns; and the Rule of Thirds—then practice them so that they become almost instinctual.

WHEN GORGEOUS LIGHT hit a perfect sand dune (opposite), photographer Russ Burden snapped off the top left photo. Because of the contrast ratio, the film was unable to give any detail in the shadowed side, so it became stark black and very dramatic. However, the composition was unbalanced; there was no area of interest other than the curved line of the crest of the dune.

After a moment's contemplation, Russ decided to add the tree (second row, left). This composition was still lacking; he had centered the crest of the dune, and the picture became static.

In his final solution (top right), Russ swung the camera left, placing the tree on the left and leaving only a third of the dune in shadow. The effect was that the tree in the lower left helped anchor the picture and balanced the larger, lighter portion of the scene with the smaller, shadowed side of the dune. This composition follows the Rule of Thirds (see pages 102–103), an important design concept that helps photographers create balanced pictures.

The Power of Zooms

Because most high-end point-and-shoot cameras have zoom lenses, and most SLRs allow you to change lenses, you can use focal length to vary your compositions.

The basic idea is that you can make your subject look closer by zooming to "tele" or changing your lens to a long focal length (such as 105mm or 200mm) or make it look farther away by selecting a wide angle (such as 28mm or 35mm).

You can also affect perspective and the relative size of foreground and background subjects by altering both the focal length of the lens and your distance from the subject. (See pages 28–29 for a more thorough explanation of perspective.)

How You Hold the Camera

Amazingly, the way you hold the camera can have a big effect on the image. Simply rotating the camera 90 degrees for a vertical picture can make a huge difference. Vertical images are especially useful for vertical subjects such as waterfalls, people, and trees.

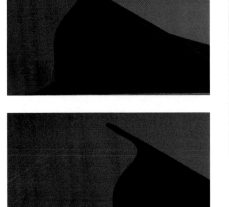

When perfect light hits a perfect subject, you need to explore your subject. The first image (top left) is very dramatic, but it's unbalanced. The second shot (bottom left) adds a critical foreground element, but the division of light and dark is too centered and stagnant. The final image (right) is more balanced; the foreground tree anchors the smaller, shadowed side.

If you have a zoom lens, you can use it to vary the composition.

Simply switching to a vertical format improves the picture by altering the function of the tree. In the image on the left the tree dominates the picture, while in the image on the right it serves as a frame to highlight the rock outcropping.

Exhaust All the Possibilities

RARELY IS YOUR FIRST IMAGE YOUR BEST IMAGE, SO KEEP SHOOTING

FOR MANY BEGINNING photographers (and even a few experienced pros) it is easy to get "wowed" by a subject. Imagine cresting a hill after a long hike in the woods—suddenly you're looking over a glorious, sun-drenched valley. The excitement and exhilaration of the moment is hard to capture on film with just a quick snapshot.

Your reaction to the scene reflects not merely its appearance; it also includes your feeling of accomplishment for having done a difficult hike, the pleasant sensation of the cool wind on your forehead, and the smells of the flora in the valley. None of these sensations can be translated to film, and that great single shot you took might look a lot weaker when you get home.

Experienced photographers use that first quick shot as a warm-up—"I've got it on film, just in case the sun disappears." Then they begin evaluating each element of the picture to figure out how to maximize or improve it.

Moths are particularly easy subjects if you catch them in the cool morning hours, before they are warm enough to fly. Their immobility gives you the opportunity to try different angles, lenses, and apertures—chances you would be denied when the insects are more active.

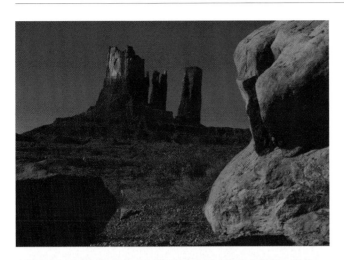

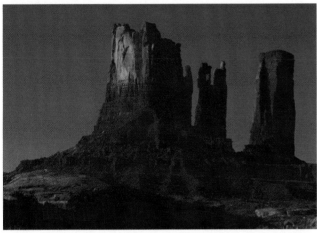

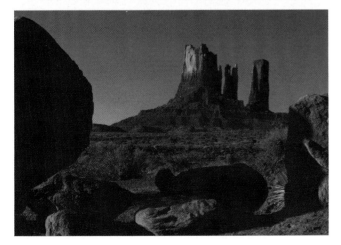

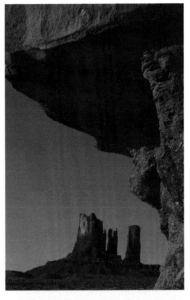

When the photographer found this rock formation, he knew he had a good thing. He began his sequence of pictures with the photo at top left and then swung his camera clockwise, shooting an entire roll. The final image (bottom right) uses the near rock to both frame the main subject and add a sense of grandeur and scale to the image.

Interaction & Engagement
WHERE YOUR SUBJECT IS LOOKING OR MOVING AFFECTS THE COMPOSITION

Interaction Between Subjects

The people or animals in your photographs can affect the composition in surprising ways. When your subjects are looking at one another, there's a link between them (both editorially and visually) that will help unite your picture's composition. An image of two people looking away from each other reflects discord.

Looking into the Frame

Even when you have a single subject and interaction is not an issue, the direction of your subject's gaze is critical. Always make sure that your subjects are positioned so they are looking or facing toward the center of the frame rather than toward an outer edge. If they are on the right side of the frame and looking to the right, the result will be very disconcerting.

The same is true of motion. Always try to leave visual room in the composition for the subject to "move into." Rather than centering the image, leave more space on the side toward which the subject is moving.

Human Context

Adding a person to a landscape adds context and helps viewers imagine themselves in the picture. The autumn scene (opposite, center) is pretty, but it is not until we see the woman walking along the road that we feel the pull of the curve of the road and start wondering what lies beyond it.

Adding Scale

Another reason for adding a person is scale. Without the hiker in the natural arch (opposite, bottom), the viewer would have no idea whether the arch was inches wide or vast. The presence of a human body helps the viewer understand the relative size of the image.

Subjects who are looking at each other make for a united composition. Had the woman and the boy been looking in opposite directions, the image would have conveyed a feeling of discord.

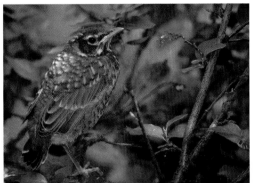

Always leave space in the composition on the side toward which the subject is looking or moving. In the image on the left, the bird is looking at the edge of the frame, which makes the picture look cramped and lopsided. In the image on the right, the bird is looking toward the center of the frame, and the composition feels more balanced.

A human form in a landscape adds both scale and context to an image.

The Importance of the Horizon Line

EVEN IF YOU CAN'T SEE THE HORIZON, ITS PLACEMENT IS VITAL TO YOUR PICTURE

BECAUSE OF MECHANISMS in the human inner ear and our sense of gravity, every person has an instinctual understanding of where the horizon is at any given time. That basic sense explains why it is so disconcerting to be spun upside-down on an amusement park ride. We instinctively want to know what's up and what's down, and we reference it by the place where the land meets the sky.

Can't See the Horizon?

In some pictures, such as the seascape (below, center), the horizon is visible. In others, such as the river scene (below, bottom), it is an implied (or perceived) horizon line. Note that in the river scene the true horizon is not the tops of the trees but rather where the river disappears into the distance. You can't see the actual horizon line, but you can "feel" where it is in relation to the land and the shooting angle.

A crooked horizon is just sloppy photography that makes the picture seem unbalanced.

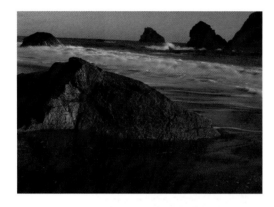

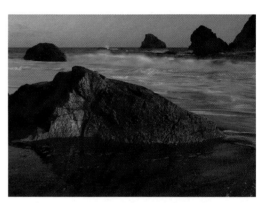

Low light brings out the texture of the sand (right), making the image more interesting than the version that features a cloudless sky (left).

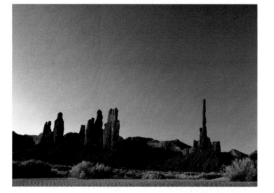

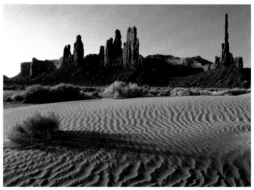

An inability to see where the earth and sky meet doesn't mean there isn't a horizon line. The perceived horizon is where the river disappears into the background. By dropping the camera low and raising the horizon in the picture (right), a bright and distracting, but boring, gray sky (left) is eliminated.

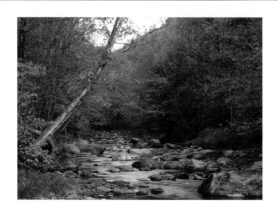

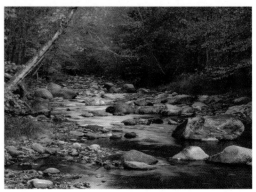

Keep It Straight

The first rule for using the horizon line is to keep it straight, unless you have a conscious design reason to tilt it.

High or Low

The second rule is to avoid bisecting the picture with the horizon. A centered horizon line creates a static composition, so do this only when you want to create a feeling of stasis.

In most situations, it's best to push the horizon line (or the implied horizon line) into the upper or lower third of the frame. Evaluate the sky and the foreground, then decide which is more important from both a design and a story-telling viewpoint. In the Namibian landscape images (below), the zebras are the subject. The top image emphasizes the dry grass and tells a story of drought, while the one with more sky evokes the vastness of the plains.

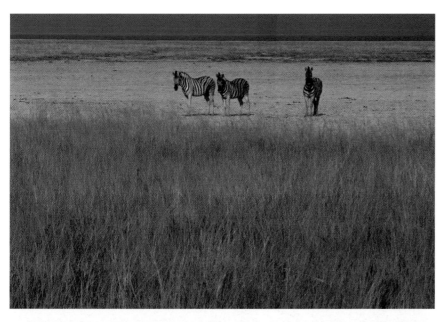

Both photos are good, but the placement of the horizon line changes the editorial content of the picture. The high horizon line in the top image emphasizes the grasslands, and you can almost feel the heat and dryness. The low horizon line in the bottom image emphasizes the cloudless sky and gives the viewer an understanding of the vastness of the seemingly never-ending Namibian plains.

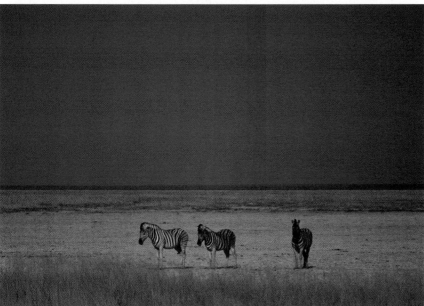

Compositional Use of Lines

THE TRICK IS TO RECOGNIZE COMPOSITIONAL LINES & USE THEM TO ADVANTAGE

THE HORIZON LINE is not the only important line in photographic design. Other types of lines play an important role in photography. Leading lines can focus the viewer on important compositional elements in a picture. Diagonal and wavy lines tend to make a picture seem more dynamic, while straight vertical and horizontal lines tend to make a picture more static.

Right Angles

From the point of view of composition, lines that extend straight up and down, or right and left, are inherently static, evoking words like "unchanging," "timeless," and "everlasting." Combine these lines with a subject that suggests these same words (like the stone columns in the photograph on the opposite page) and you double the impact.

Diagonals

Because the eye tends to follow diagonal lines, they add motion to a picture. A diagonal can be straight-edged, such as a fence line that draws the viewer's eye to a distant barn, or radial, like the diagonal stripes of a hot-air balloon that all point to one place. More often, diagonal lines are less distinct and less obvious. Natural objects, such as the foreground stones in the top right picture on page 98, point diagonally at the cabin in a more subtle manner than a fence would, but they achieve a similar effect.

Curving Lines

Wavy or curving lines imply motion. They make almost any picture livelier because, in following them, our eyes dance around the composition. The best curving lines eventually point toward the subject, as in the rock image below.

Lines themselves can be the most important aspect of a picture, making it more about the abstract patterns created than the subject itself. In both images at right, the lines lead the eye.

The dynamic, wavy lines created by striations in the rock lead our eye to the main subject, a tall peak in the background. In the left photograph, vertical waves combine motion and stability. In the right image, lines waving in different directions make for a lively composition.

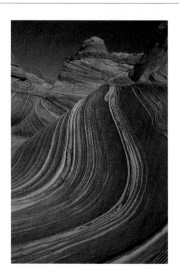

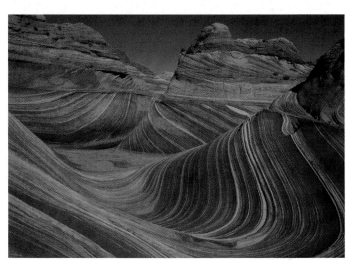

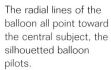

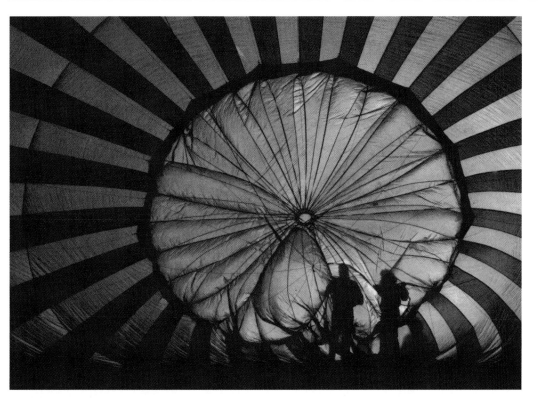

The radial lines of the balloon all point toward the central subject, the silhouetted balloon pilots.

The vertical lines of the stone columns, along with the connotations of the subject itself, help communicate a feeling of power and stability. Note how the diagonal railing helps enliven the composition and balance the strong vertical lines of the columns and the horizontal lines of the steps.

The Power of Leading Lines
ONE OF THE MORE SUBTLE USES OF LINES IS ALSO ONE OF THE MOST POWERFUL

SOMETIMES YOU SEE a photo that really works, but you can't immediately figure out why from a compositional standpoint. The answer may be that it uses leading lines. Such lines do not need to be obvious or blatant, like the man-made lines of marble columns. Instead they can be subtle—a shadowed area, a tall or long subject, or a perceived direction that is implied by the way a subject is moving or directing its gaze.

In this subtle use of lines, the sunlit, vertical plants reach upward and point the viewer toward the main subject.

LEFT: A dark, shadowed area leads the viewer's eye from the bottom left, diagonally up the image, then directly back into the main subject, the rock outcropping.

BELOW: This image is a mixture of stabilizing verticals and dynamic curving lines. The diagonal road and the perceived direction of the hiker's travel pulls us down the road and makes us wonder what is around the corner. The strong diagonal of the road is anchored by the vertical, static trees for a balanced overall composition.

Foreground, Midground & Background
LANDSCAPE PHOTOS THAT STAND THE TEST OF TIME UTILIZE THESE ELEMENTS

MANY OF THE GREATEST photographs have interesting picture elements in the foreground, midground, and background. Of course, there are exceptions, such as portraits, where the only subject is the person. But you'll almost always see at least two strong picture elements in great landscape pictures.

Consider the image below, top. The rocks in the foreground are the first thing you see, because they are large, light-colored, and in the foreground. These rocks also serve the purpose of visually anchoring the picture, and they create a leading line (see pages 96–97) that points to the midground cabin (the main subject). The line of the roof then echoes the ridge of the mountain in the background.

For comparison, we retouched out the foreground rocks in the same image. It's still a good picture, because the subject is so amazing, but it's weaker than the other.

The image on the right is an excellent example of the use of foreground, midground, and background. Compare it to the version above, in which the foreground rocks have been removed through retouching.

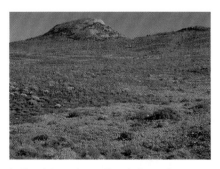

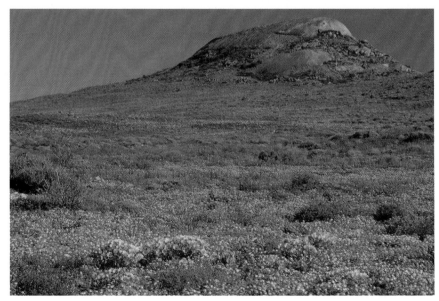

In the picture above, the photographer came upon a pretty scene but had no foreground focal point, so he wandered around the field of flowers until he found a clump of yellow flowers surrounded by pink (right). Now he had a foreground subject with a dramatic background.

The same is true of the field of flowers (opposite, bottom). Here, the photographer came upon a great subject and then searched for a foreground picture element—in this case, a group of yellow flowers surrounded by pink.

Make a Hierarchy

It's important not to include just any three picture elements in the frame. If all the objects are in the midground or all are in the background, the result will be a confusing competition between them, and the image will seem to lack a single main subject. Consciously pick your main (dominant) subject and then "wrap" it with one or two other minor subjects. Preferably these minor subjects will not be on the same plane—that is, they will be in the foreground and background if the subject is in the midground.

The mesa alone, or the tree alone, would have been a boring picture. By using the tree as a foreground element, the photographer created a winning picture of the mesa. Note also how the black silhouette helps to emphasize the drama of the early-morning light.

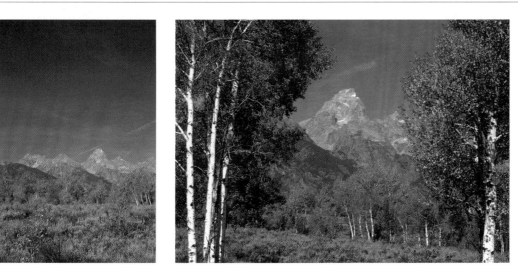

The breathtaking Grand Tetons look uninteresting in the straight snapshot (left). It was not until the photographer "placed" trees in the foreground and midground that the mountains came to life (right).

Framing Technique

A FRAME IS A FOREGROUND ELEMENT THAT SURROUNDS THE MAIN SUBJECT

ONE OF THE MOST POWERFUL foreground elements you can create is a frame. This aptly named compositional element surrounds the subject the way a picture frame surrounds a photograph or painting.

Unlike a picture frame, the foreground "frame" in a photograph need not completely enclose the subject. More commonly, it will relate to part of the subject. Either way, its purpose is to force the viewer's eye deeper into the composition, toward the main subject.

Turn Bad into Good

In landscape photography, we often find too many objects between our distant subject and the camera. It may seem that trees are always "in the way." Luckily, low-hanging branches often make excellent frames. However, you will need to finesse your camera position to avoid a few common pitfalls.

Framing Pitfalls

When designing your frame, try to avoid cutting off the silhouette of your main subject, because doing that defeats the purpose. A higher or lower shooting angle or a different focal length lens may do the trick.

Take special care that your foreground frame is not more interesting than the main subject. If it is, abandon the concept of a frame, and try to figure out how to turn this element into the main subject instead. Remember that the goal of the frame is to bring the viewer's eye in toward the main subject first, and then later to pull back and look at the framing element.

In the portraiture example (opposite), we see the woman first, and then "pull back" to see the man. Had he been facing the camera, he'd have been too important and become the main subject rather than the frame—and the picture would not have worked as well.

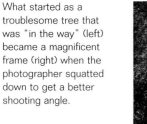

What started as a troublesome tree that was "in the way" (left) became a magnificent frame (right) when the photographer squatted down to get a better shooting angle.

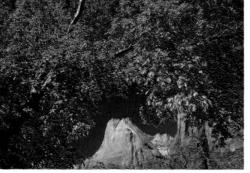

The difference between the outcome of the straight shot (left) and the framed shot (right) is exponential. But it took a conscious effort by the photographer to realize that he had a beautiful main subject, under exquisite light, but that it needed more. Once you come to such a realization, move around and try to find the other elements, such as the framing tree.

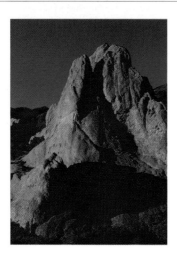

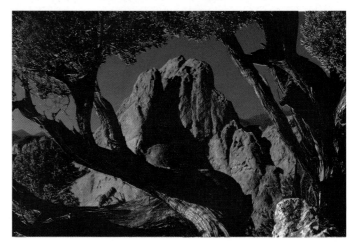

Just a small intersection of the tree with the silhouette of the rock outcropping ruins the effect (left). Instead, the photographer played with lens selection and shooting angle until the tree exactly mirrored the landscape (right).

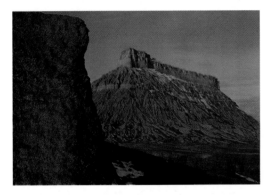 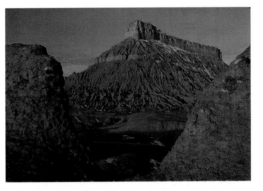

One foreground rock outcropping makes the picture seem unbalanced (left). When a second outcropping is added (right), the two form a balanced frame.

Trees are the most common frame, but they're not the only type.

The Rule of Thirds

THIS DESIGN GUIDELINE HAS STOOD THE TEST OF TIME

EVEN IF YOU WERE that rebellious kid who was always breaking the rules at school, you'll want to consider following this one. The Rule of Thirds is a compositional aid that helps you create balanced, successful photographs. The vast majority of great photographs follow this rule or take it to even further extremes.

What Is the Rule of Thirds?

Start by drawing an imaginary grid over your camera's viewfinder that divides the frame into three equal sections both vertically and horizontally, for a total of nine identical sections.

The four points where the lines intersect become the most important "real estate" in the image. The lines themselves are the second most important part. Your goal is to place your important picture elements (such as the foreground, midground, and background elements, discussed on pages 98–99) at the intersection points or, at the very least, along the lines.

Pushing It Further

You may also want to push the rule to an extreme and place the objects further toward the outside of the frame. This often works, especially with wide-angle images. However, minimizing the rule rarely works, because the more you move your subject and other picture elements toward the center of the frame, the more static and lifeless the image becomes.

POINT-&-SHOOT USERS

The Rule of Thirds suggests that you move your subject out of the center of the frame, which is where your camera tries to focus. With your subject off center, the scene through the viewfinder may look in focus, but it may not turn out that way on film. To be safe, always use your focus-lock function when shooting off-centered subjects.

On most cameras, depressing the shutter halfway down while you're centered on the subject locks the focus and exposure. Continue holding the shutter button in this position while you recompose. Then push the shutter button down completely to take the picture.

In the top version, although the photographer placed the horizon low, he left the windmill in the dead center of the composition. When he swung the camera to the right, the windmill, the trees, and the horizon all follow the Rule of Thirds (bottom).

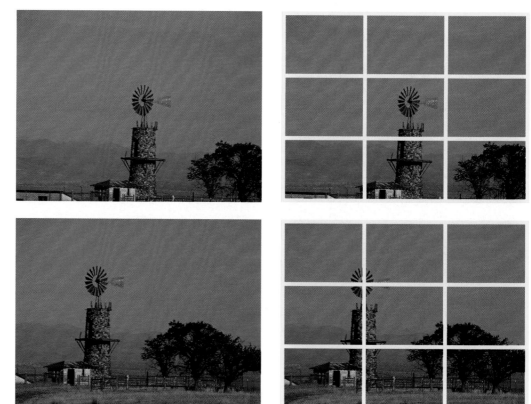

Horizon lines, discussed on pages 92–93, work well if they are placed to coincide with the top or bottom horizontal line, and they can often be successfully pushed even higher or lower for creative purposes.

At first, you'll have to work at designing your photographs to fit the Rule of Thirds, but soon it will become second nature and almost instinctual. In fact, if you go back and review your favorite pictures that you took before you understood the Rule of Thirds, you'll probably find that they fall into this pattern.

Verticals, Squares & Other Ratios

The Rule of Thirds is very flexible and works equally well for horizontal and vertical images, and for panoramic and square images. It also can be applied to portraits of people and pictures of wildlife (see examples on pages 115 and 143).

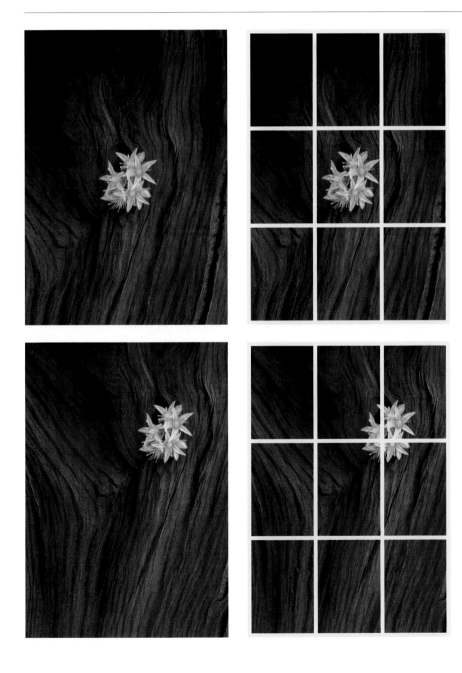

Even the simplest compositions benefit from avoiding a bull's-eye design (top) in favor of an off-center composition (bottom). Note that for a vertical format, the frame is still divided into nine equal sections—it's just that now these sections are vertical.

Simplify Your Subject
SOMETIMES THE HARDEST PICTURES TO TAKE ARE THE SIMPLEST IMAGES

IT GOES AGAINST LOGIC, but often the simplest pictures are the most difficult to take. More often than not, the photographer is confronted with a scene that has too much "stuff" in it, too many scattered picture elements that would compete for the viewer's attention.

The photographer's goal is to mentally determine a hierarchy among all the potential subjects and other picture elements. Which are important? Which are distracting?

Important elements are either visually pleasing or interesting, or editorially important—that is, they tell a story. To simplify, you need to eliminate picture elements that are unimportant from a story-telling point of view. Doing so is especially important if they are distracting and could compete for the viewer's attention. Large, bright, colorful, or symbolic elements (such as a flag or an object that evokes a concept or a feeling) tend to be the most distracting.

Easy Ways to Simplify

There are several easy ways to simplify your images. The first is to zoom in or step closer to your main subject, thereby cropping out more of the background and foreground. Instead of shooting the whole panoramic scene, decide if the same story—or a better story—can be told with just one detail.

You may not need to show the full flower in the foreground, but instead just a snippet or even just a hint of it, such as the out-of-focus yellow flower held in front of the lens in the picture on page 164.

A second method is to try to use the camera angle and the lens you select to separate important picture elements from the background and from other elements. For example, a photo usually works better if the main subject does not intersect a distinct horizon line in the background. This is especially important for silhouetted subjects, which can also sometimes merge together or become angled in such a way as to become indistinct. Think of how much more interesting a silhouetted profile is than the round blob you would get if you photographed the back of a head.

A close-up of the bride and groom's hands, wedding rings, and bouquet is an elegant way to tell a full story with a single detail.

Remove all the unimportant picture elements, such as the bushes and dirt, and move in on the important ones—in this case an orange flower in a sea of purple flowers.

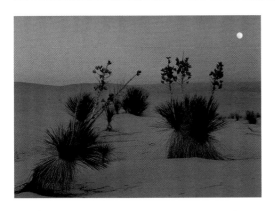

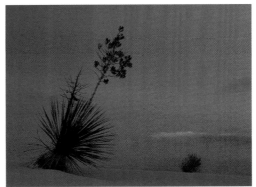

When the horizon line intersects your subject, it can "interrupt" your composition. This is a common problem when you're standing and shooting from eye level. Instead, drop down to a low angle to isolate the subject against the sky and avoid an intersecting horizon line.

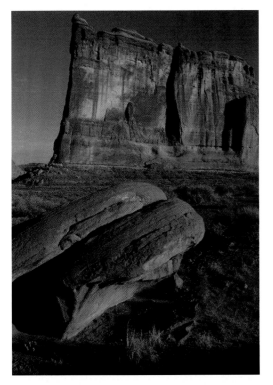

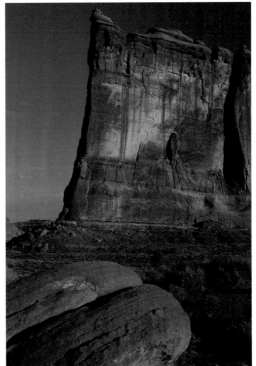

When the entire boulder was shown in the foreground of the picture (left), it became distracting. Instead, the photographer simplified the picture by stepping closer to include only a small portion of this foreground element (right).

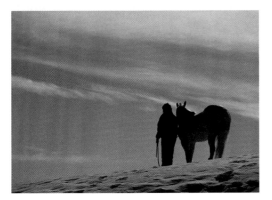

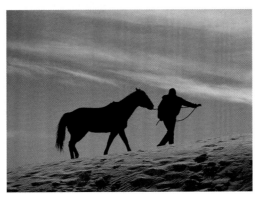

For an effective photograph, you must simplify the outline of silhouettes and near silhouettes. Avoid merging subjects (left), and look for separation. Profiles and side views in which legs and arms are separated from the body's trunk convey the most information and tend to yield the best results (right).

Texture, Patterns & Abstracts
THE SUBJECT OF THE PHOTOGRAPH CAN BE THE DESIGN IT CREATES

PHOTOGRAPHERS OFTEN GET very literal in their photographs, and the subject can be described with a noun—it's a boat, a bird, or a person. However, sometimes you'll want to take pictures only for beauty's sake, and the subject becomes more elusive. A good photograph can simply be about the light, textures, or patterns found in nature or in man-made objects.

A Photo Hunt

To be successful with this type of subject, you must begin to think abstractly. The best way to learn is to embark on a "photo hunt" in which you specifically look for interesting textures and patterns. The beach is especially well-suited for this type of self-assignment, because the sand, stones, and shells tend to be monochromatic, so there are fewer bright colors to distract from the textures created by light and shadow. Early or late in the day, when the sun is low, the skimming light casts long shadows and makes even small nuances in shape seem more extreme.

When you find a likely subject, play with the composition, putting important elements in off-centered positions until you come up with a balanced picture. You'll probably want to avoid man-made repetitions that are exact, because this creates "wallpaper" rather than a balanced overall image. The inevitable variations in nature provide more compositional options.

Remember that even though your picture is about texture, it will still work best if there is one dominant element. In the pictures on these two pages, the solo rocks (below left and opposite top), the tree trunk in the sea of poppies (opposite bottom), and the beetle tracks (below right) all fit that bill.

Try spending an afternoon shooting a whole roll of nothing but textures and patterns—you'll be amazed at how this exercise will open your eyes to the possibilities all around you, and you'll start noticing the patterns and textures in the world of your daily life.

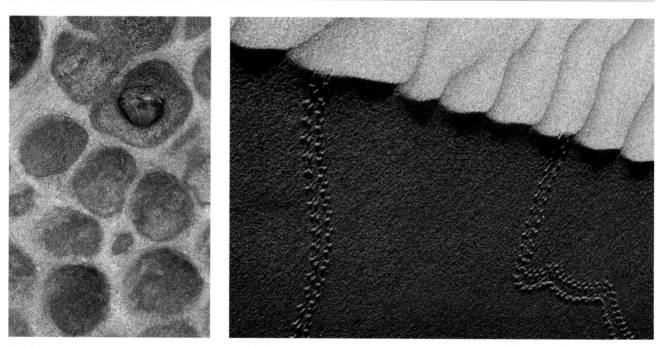

A solo rock rests in depressions sculpted by water (left). Late sun brings out the texture of a sand dune scarred by the tracks of a beetle (right).

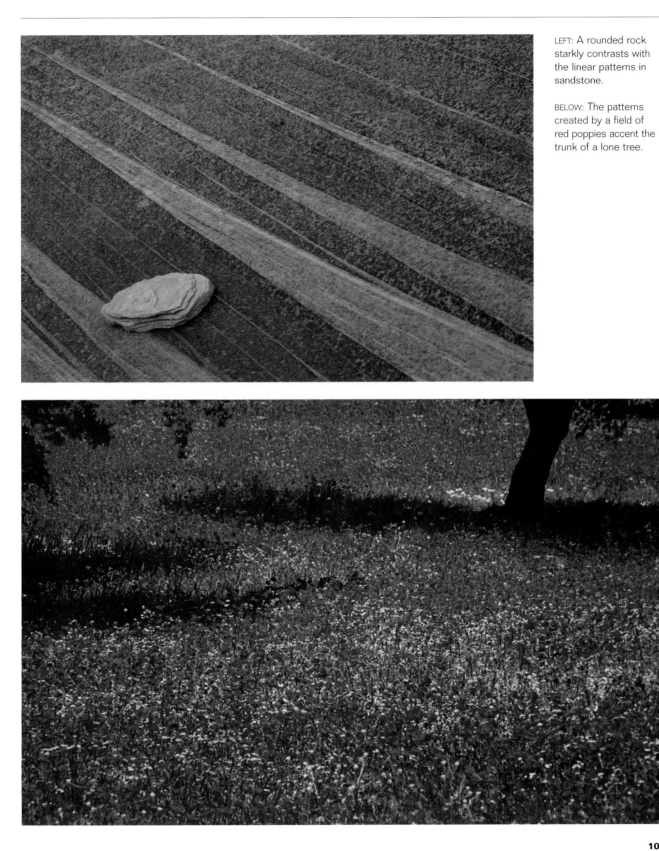

LEFT: A rounded rock starkly contrasts with the linear patterns in sandstone.

BELOW: The patterns created by a field of red poppies accent the trunk of a lone tree.

The Impact of Color

COLOR TRANSFORMS YOUR COMPOSITIONS IN SEVERAL MAJOR WAYS

THE COLORS YOU USE in your photographs, and where and how they are placed, can have a significant impact on your final picture. One major reason is that certain colors are associated with moods and feelings. Blues often evoke words like "cold," "cool," "refreshing," and "melancholy." Reds are "hot," "sexy," and "sporty."

Colors can be heavily shrouded in symbolism, in the way that Americans associate red, white, and blue with patriotism. Likewise, certain colors or color schemes are often associated with particular places, such as the Caribbean, with its typical colorful buildings.

The compositional use of color can impact the final image in several ways.

- *Dominant color.* The subject can be of one dominant color or color scheme that sets the mood for the whole image.
- *Juxtaposition.* You can juxtapose radically different colors for bold effects, such as a yellow flower against a bright blue sky.
- *Color accents.* Strategically placed colorful elements can highlight the picture.
- *Color repetition.* A color in the subject can echo another element in the foreground or background to create a unified composition.
- *Frames.* Color can be used to frame a subject so it becomes more prominent. (See pages 100–101 for more details on framing.)

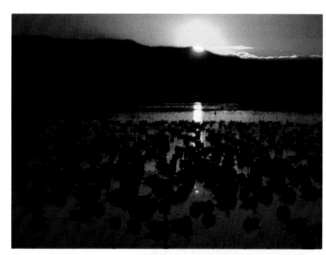

Color can be used to set a mood (top left), set the dominant tone (bottom left), or frame the subject (right).

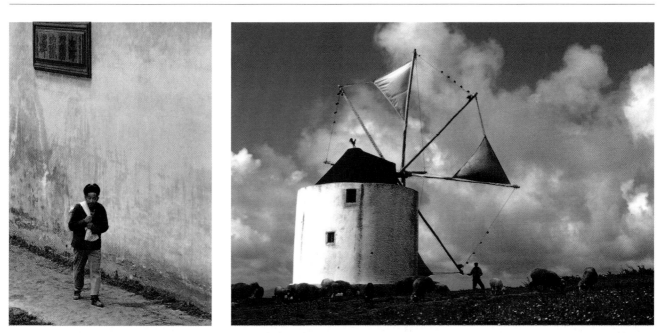

LEFT: The photographer found this yellow wall in a small village in China. He set up his camera and "waited in front of the stage for the right actor to arrive." RIGHT: One colorful aspect in a relatively monotone image provides a visual accent.

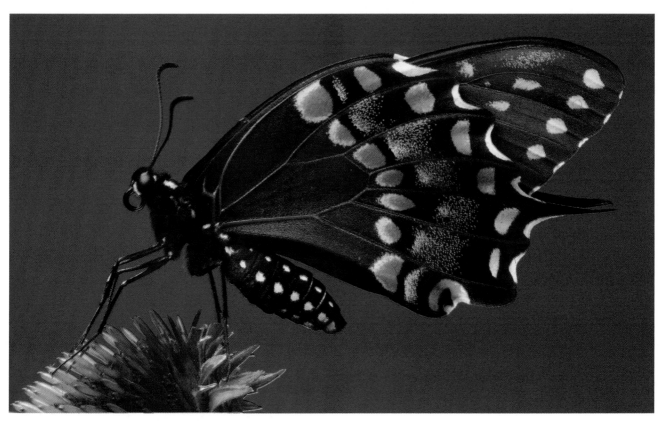

The yellowish markings on the wings of this moth are echoed in the color of the flower it is perched on. The repetition of color within the picture helps balance and integrate the composition.

Symmetry & Repetition

SOMETIMES BREAKING THE "RULES" CREATES WONDERFUL PICTURES

IF YOU'VE READ the preceding compositional tips, you'll realize that the pictures on these pages break many of the "rules." The fact is that the compositional elements of symmetry and repetition have their own set of rules.

Reflections

Probably the most common opportunity to use symmetry and repetition is when you set out to photograph reflections. The landscape image (opposite bottom) breaks the horizon rule—the horizon runs through the center of the picture. Usually this would create a static composition, but in this case that static quality gives the image a feeling of timelessness and permanence. The repetition caused by the reflection reinforces these same qualities.

Note also that there is more repetition than just the reflections: The triangles of the trees echo and repeat the triangles of the mountain peaks.

Symmetry

The bridge image at the top of the opposite page is symmetrical—the right side is almost identical to the left side. Like reflections, symmetry can give a composition a static and timeless quality.

The bridge picture also utilizes repetition; it repeats the form of the foreground saddle with the background saddle of the bridge. Even though the picture seems very "centered," it still manages to follow the Rule of Thirds because the strongest vertical and horizontal lines match those of the yellow grid.

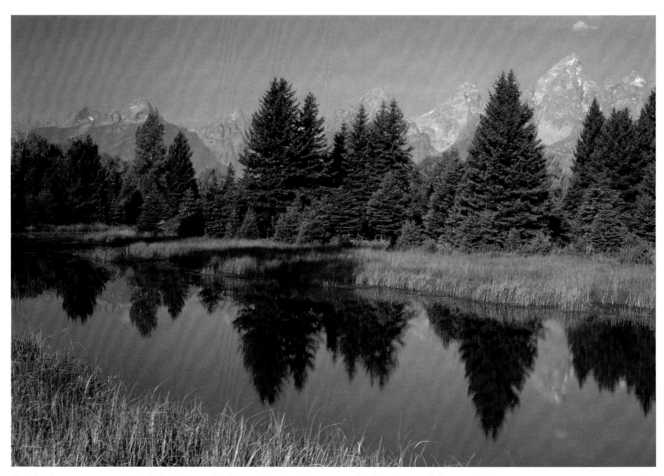

This landscape uses repetition in both the reflection and the way the trees echo the shapes of the mountains.

The right and left side of the bridge picture are fairly symmetrical, and the suspension saddle in the foreground is repeated in the background under the arch. Although the bridge is centered, its dominant lines follow the Rule of Thirds grid (right).

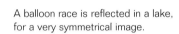

A balloon race is reflected in a lake, for a very symmetrical image.

Photographing People

Whether you are the designated "family photographer" by choice or by default, you have a big job. Not only do you want to document your family and friends in photographs, but you'll want to create images for your scrapbooks and walls that stand the test of time.

A few key techniques will help you succeed, whether you're taking candids or posed images. For simple portraiture, most people look best when they're photographed with certain lenses and particular qualities of light. Even without a single piece of advanced equipment, you can create professional-quality portraits by following the centuries-old technique of using a north-light studio. For more dramatic results that set a mood or make a statement, you can play with light, lenses, and poses.

Portraiture is a specialty that is greatly benefited by digital photography. The instant playback on a digital camera allows you to show models the results you're getting and involve them in the process. It's sometimes amazing how quickly a reluctant model will start making posing suggestions or otherwise help you work for an even better image.

Focusing Challenges

Most point-and-shoot cameras have very center-oriented autofocusing systems. They are designed to focus on whatever the photographer places in the center of the frame. If it is a bright, sunny day and your subject is far away, autofocusing probably won't make a difference because of depth of field (see page 35). But when you want to shoot two people, the center of the frame is usually not the subject but rather the background (see top example, opposite). Since you are looking through a viewfinder that is not coordinated with the lens, you won't know that the focus is not correct until you get your film back. To meet this challenge, you need to practice focus lock:

1 Center the subject and push the shutter button halfway down to lock the focus and exposure.
2 While still holding the shutter button in the halfway position, recompose the image.
3 When your image is composed as you want it, completely push the shutter button down and expose the film.

Photographers who use SLR cameras do not have this concern. Their cameras often have more sophisticated focusing systems that usually avoid this problem, and in any case they can see the missed focus in the viewfinder.

Choose Your Eye Level

Shooting at your subject's eye level should always be your first choice. There will of course be times when you want or have to shoot from a different angle, but in general if you raise or lower yourself to your subject's eye level, you will significantly improve your images. This is a simple tip, but this action alone will make a huge difference in your photographs of people.

Candids with Telephotos

If you have a zoom lens or a choice of lenses, creating a portrait is a good time to make use of a telephoto. For starters, it's easier to get candid images if you use a telephoto lens because it allows you to work from a discreet distance.

ANY
CAMERA

HINTS FOR IMPROVING EVERYTHING FROM FAMILY SNAPSHOTS TO FORMAL PORTRAITS

PHOTOGRAPHING PEOPLE

Most point-and-shoot cameras are engineered to focus on the center of the frame, as in the photo on the left, so you'll often need to use focus lock when shooting pictures of couples.

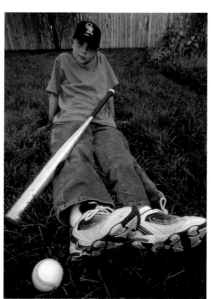

LEFT: Eye-level portraits tend to be the most flattering and have the least distortion. With a baby or a small child, this usually means getting down on your hands and knees. Shoot from your subject's eye level for the best results in most situations.

RIGHT: Wide-angle lenses let you take images from close range. However, the wider the lens and the closer you get, the more optical distortion you will see.

Telephoto lenses (and the T setting on zooms) let you take candids from a discreet distance. Look for moments when the subjects are interacting with each other or with the environment.

Even if the subjects are aware of your presence, if you aren't right on top of them they will be less inclined to give their "canned" smile for the camera and are more likely to go about their normal business.

Other Lens Factors

People also tend to look better when they are photographed from a distance. The classic portraiture lens is in the 80–135mm range. Though with such a lens you will have to shoot head-and-shoulder portraits from a greater distance than you're probably used to, the result is generally more complimentary.

SLR cameras (and a few high-end point-and-shoots) allow control over aperture selection, which is important if you want to create a pleasantly blurred background that won't distract from your main subject (see page 37).

The Rule of Thirds

The eyes of your subject are also important in terms of composition. The old saying about the eyes being the window to the soul is a cliché because it is so true—eyes are expressive and unique, so they become the most important element in a portrait. Use the Rule of Thirds (see pages 102–103) to place the eyes where they will be most balanced from a compositional viewpoint.

Posing Your Subjects

For formal portraits, you'll need to help your "models" pose. Most people become very self-conscious when you point the camera at them—they tend to stiffen and stand squarely facing you. Rarely does this static pose give you what you want.

Portraits often look better if the subjects are not squared off toward the camera. Try to encourage them, with specific suggestions, to turn their shoulders or hips away from you. A simple request to "Face toward that tree" (so their shoulders and hips are pointed slightly off camera) and "Now turn just your head toward me" will result in a better image. However, you'll need to use finesse, and decide how much posing you can get them to do before they lose patience.

If your models aren't looking straight at you, they should be looking into the center of the frame (that is, not at the edge). If they are

HANDS CAN BE AWKWARD IN POSED PHOTOS

It's critical that you help your models pose their hands. Typically, when the camera comes out nobody knows what to do with their hands, and often the result looks stilted or awkward.

Men tend to look better with crossed arms than women (below left), because it is a "stronger," more confrontational pose. It also shows off the biceps.

The side of the hand is generally preferred for women, because the profile makes the hands look smaller and more elegant. The hand will usually look better if the fingers are together (below center).

For casual poses, the subject can place her hands in the pockets of jeans or a jacket (below right), especially if she is leaning against a wall or tree.

Holding a prop often eliminates the question "What do I do with my hands?" It also can serve the purpose of relaxing the subject; holding something familiar—such as a football for a varsity senior—makes the subject feel and look more comfortable and natural.

walking or even have the trunk of their body pointing right or left, make certain they walk or turn toward the center or far side of the frame, rather than the near edge. The result will be a much more balanced and less cramped-looking composition.

Posing Groups

As soon as you bring together a group of people, posing becomes more difficult. Count on taking extra frames just to insure that everyone has their eyes open on at least one shot.

Next, try to orchestrate the pose. The natural instinct is to line up everyone in a row, but this usually does not make for a balanced composition, and the faces will be tiny if the group is a large one. Instead, try to layer the people into rows, with some tucked in front and others behind.

A multi-tiered surface like a picnic table works well, because you can seat some people on the bench and some on the table, and have others stand behind or kneel in front. This creates a composition with fewer gaps. More important, it condenses the group so that each face is larger in the final picture.

Again, try to pose individuals so that their shoulders point slightly toward the center of the group. The end result will be a tighter and more pleasing composition.

LEFT: Lenses in the 80–135mm range often create the most flattering portraits. They also enhance the out-of-focus background effect of using wide apertures.

RIGHT: Unposed or arbitrary groupings tend to have gaps and look unconnected. Layer the individuals so that they overlap and their faces are at different levels.

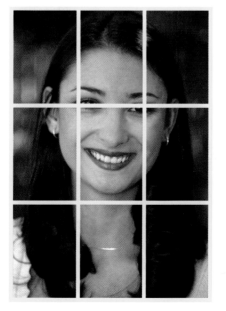

Your subject's eyes are the most important aspect of any portrait—we tend to look at a person's eyes first. Because of this, beginning photographers often want to center the eyes because that is what they are looking at through the viewfinder (left). However, if you compose the pictures so the eyes follow the Rule of Thirds, your composition will be much better (right). See pages 102–103 for a more complete description.

Lighting for Portraits
THE QUALITY OF THE LIGHT AFFECTS HOW COMPLIMENTARY YOUR PORTRAITS WILL BE

BEAUTIFUL, SUNNY DAYS do not always yield beautiful portraits. The old rule that says a photographer needs to keep the sun at his back is good for average snapshots, but for portraiture, the result is often a squinting subject. Worse still, if the sun is high there's a real possibility that every line and wrinkle on the subject's face will be emphasized with deep shadow.

Simply moving into the shade makes for softer, more complimentary light and eliminates the need for the subject to squint or wear sunglasses. Deep shade, however, can be too soft and directionless, resulting in flat, dull images—so you may want to consider livening it up with fill flash.

Other Lighting Solutions

If you're stuck with high sunlight that casts deep shadows on your subject's face, switch your camera to fill flash. This technique brightens the shadows yet lets the overall sunny exposure be recorded on the film as the dominant lighting.

To achieve a similar effect, you can use a reflector to bounce light back onto your subject. White, silver, or gold poster board works well, and fancy collapsible reflectors are available in stores that sell photographic supplies.

Harsh sun causes squinting and uncomplimentary shadows (left). Shade renders the face better and makes squinting a nonissue (right).

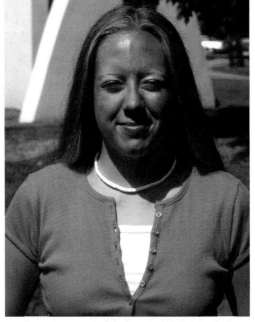

High sun causes the subjects' faces to fall into shadow (left). Without changing the daylight part of the exposure, the photographer added fill flash to lighten the faces (right). The overall effect still communicates "sunny day."

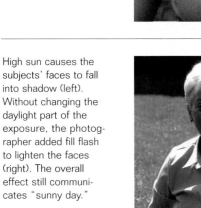

Deep shade can be too flat, resulting in a dull picture (left). The photographer got a better result by placing the subject where a dapple of light through the trees highlights her hair though her face is still softly rendered by the shade (right). Fill flash or force flash are also options (not shown).

LEFT: A white reflector next to the camera can be angled to bounce sunlight back at the shadowed front of the subject. A reflector creates an effect similar to that of fill flash, but softer.

RIGHT: A gold reflector bounces back warmer light.

When Should You Turn Off the Flash?

OVERRULE YOUR CAMERA IF IT WANTS TO FIRE THE FLASH IN DIM BUT BEAUTIFUL LIGHT

THE BUILT-IN FLASH UNITS on both point-and-shoot and SLR cameras have gotten so good that it's tempting to use them all the time. In fact, when in doubt, use the fill-flash mode because it often "saves" pictures and rarely hurts them. That said, there are definitely some situations when no flash is by far the best solution.

Pitfalls of AutoFlash

Autoflash mode on most cameras means that the flash will automatically fire if the camera thinks it is needed. (This is not the case if you must manually pop up your flash before using it.) The problem is that in any dim-light situation, the camera will automatically fire the flash. This usually overpowers the existing light, and the result is a flash-illuminated subject. If the background is distant, it will often go black.

However, many times the "dim" light is perfect for portraits because it is beautiful in color, direction, or quality—and it is still enough light for you to get a sharp image if you steady the camera and/or switch to a faster-speed film.

You may need to put your camera in flash-off mode, which is most often represented by an icon that combines a lightning bolt with the circle-and-slash "no" symbol.

Excellent examples of light for which flash-off mode is best include late-afternoon sunlight, twilight and dawn, and the soft light from a north-facing window.

Silhouettes at sunset or pictures of shadows require flash-off mode. The subject is the darkness itself, and you don't want to light it with flash.

Sometimes you need an intermediary solution because neither flash off (left) nor autoflash (center) delivers a perfect photo. High-end cameras offer flash compensation or slow-synch flash, both of which enable you to balance flash with daylight (right). (See pages 54–57 and 64.)

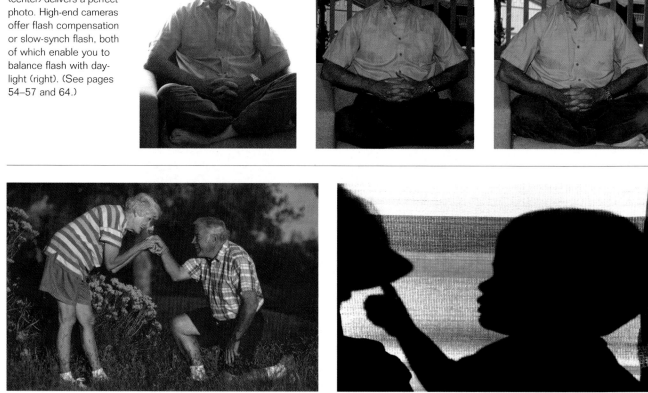

Late sunlight can be too beautiful to "destroy" with flash (left). Turn your flash off when your subject is a shadow or a silhouette (right).

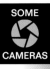

 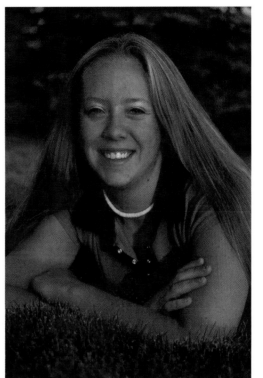

These two portraits were taken moments apart, but in the image on the left the camera's autoflash overpowered the natural light and turned the background black. The natural light is prettier (right).

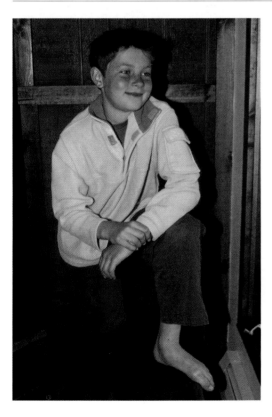 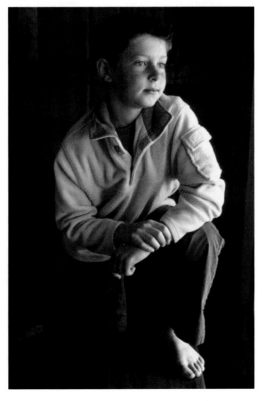

Northern window light is relatively dim but beautiful for portraits (right). It has been a favored lighting of painters for centuries. Flash ruins the effect (left).

Portraits in the Studio

BRING YOUR SUBJECTS INSIDE & TURN YOUR LIVING ROOM INTO A STUDIO

WHEN YOU CREATE your own lighting, you gain ultimate control over your portraits. The lighting can be as simple as household bulbs in 10-inch reflectors or as elaborate as expensive professional-studio flash units.

The Main Light

Any portrait should have a main light that sets the direction and tone of the image. Where that light hits the subject (with respect to where the nose is pointed and the camera is angled) has a monumental effect on the final image, as the examples in this section show. Hence, deciding about the main light becomes the studio photographer's most important action.

In addition to its angle toward the subject, a light's hardness or softness makes a big difference. Softboxes, such as that shown in the studio shot (below), create very softly contoured lighting for "beauty" shots. Bare bulbs create hard-edged shadows and more dramatic results, for 1940s-style "Hollywood" shots. Whether you use a softbox, a bare bulb, or something in between, the farther a given light source is from the subject, the harder it becomes.

If you can recruit an assistant, have him walk around the subject and point a bulb in a 10-inch reflector at her from different angles, heights, and distances, while you observe from the camera angle. You'll be

A softbox is a common main light for portraiture (above). Rotating the light around the subject in 30-degree increments (one hour on an imaginary clock) radically alters the way the model's face is depicted.

5 O'CLOCK POSITION

4 O'CLOCK POSITION

3 O'CLOCK POSITION

Some of the softness of a light source depends on its size relative to its distance to the subject, with bigger and closer delivering a softer result. Even a standard bare bulb gets softer if it is brought closer to the subject (right). (The hair light illuminating the left side of the picture was not changed.)

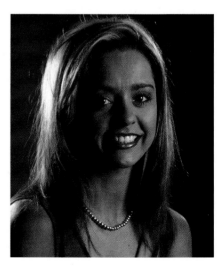

amazed at the number of different looks just one light can create.

Additional Lights

In addition to the main light, most studio portraits use one or more secondary lights and light modifiers.

FILL LIGHT. This light fills the shadows caused by the main light. The main light is placed on one side of the subject, and the fill light on the other.

FILL REFLECTOR. Instead of getting fill from a light, you can place a white, silver, or gold reflector so that it bounces some of the main light back at the subject, filling the shadows.

HAIR LIGHT. As its name implies, this light is designed to add a highlight to hair. It can be pointed at the shadowed side of the hair or used to backlight the hairline.

RIM OR SEPARATION LIGHT. Like a hair light, this one is designed to separate the edge of the subject from the background. It usually comes from a high, back angle and skims the edge of the subject's hair and shoulders.

BACKGROUND LIGHT. This light is pointed at the backdrop from a high or low position so that the light unit itself can't be seen by the camera. Its sole purpose is to brighten the backdrop.

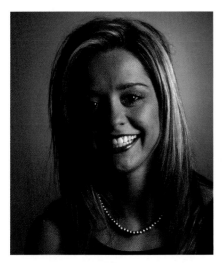 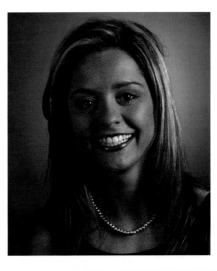

A hard light, like a bare bulb from a lamp, can produce dark shadows (left). By placing a reflector to the left of the camera, the photographer was able to bounce back some of the main light to fill the shadows (right).

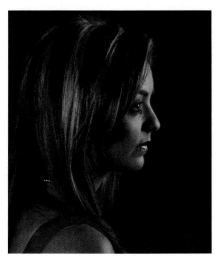 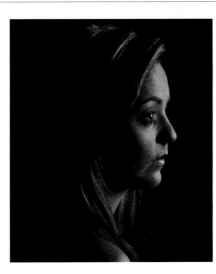

Both profile portraits have the same main light, but the version on the left adds a hair light. While two lights show more detail, the simple light is more dramatic (right).

None of the lights or the reflector work well by themselves, but when they are combined the result is a professional-looking portrait. If you are using flash units, you will need to have them "synchronized" so that they all fire at the same time. Professional units do this with wires, slaves, or infrared signals.

BACKGROUND LIGHT ONLY

HAIR LIGHT ONLY

FILL LIGHT ONLY

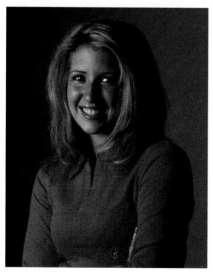

MAIN LIGHT ONLY

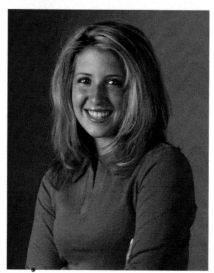

MAIN AND FILL LIGHT

MAIN, FILL, AND HAIR LIGHTS

MAIN, FILL, HAIR, AND BACKGROUND LIGHTS COMBINED

Sports & Action

Great sports and other action subjects have yielded some of the world's most exciting pictures. This is definitely a specialty in which high-end equipment will help you succeed. But even with just a point-and-shoot camera you can achieve good results if you learn a few tricks.

Long focal-length lenses let you get close to the action for frame-filling images. A wide zoom lens lets you quickly adjust the composition as the subjects move closer or farther away from your shooting position. Control of apertures and shutter speeds on high-end cameras allow you to isolate the subject with a blurry background, freeze fast action, or artistically blur part of the image with panning.

Once you understand some basic concepts for success, you'll need to do a lot of practicing. If you shoot film, keep careful notes of your techniques, including shutter speed and aperture settings. When you get the processed film back, compare the notes with your results to learn what worked and what didn't.

Digital cameras offer the option of nearly instantaneous feedback. But don't get sloppy. Stop for a few moments and think about what worked and what didn't in each picture. It's the best way to learn.

THE SINGLE MOST efficient way to improve your sports pictures is to learn the sport. This will allow you to predict where and when the action will occur, so you'll be ready.

Slow Autofocusing
A point-and-shoot or an entry-level SLR camera may not be able to autofocus quickly enough. You'll either end up with misfocused images, or there will be such a long delay between pressing the shutter button and the actual picture-taking that you'll miss the height of the action.

If your camera has manual focusing, you may want to use it. If not, try to predict

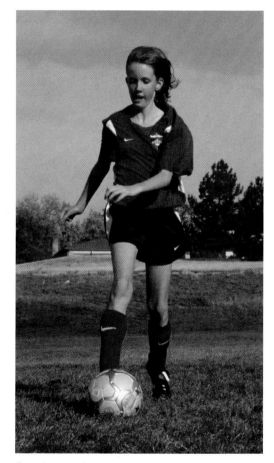

By selecting a low angle, the photographer was able to eliminate many of the distractions in the background. The low-angle shot also isolated two important picture elements (the girl's face and the soccer ball) against the relatively simple background features of sky and grass.

where the action will be (such as at first base in a baseball game) and lock the focus on that spot. This is usually done by holding the shutter halfway down. Wait with the shutter depressed (and the camera ready to go) until the subject arrives. Then finish pushing the button all the way down and complete the picture.

Backgrounds

Action photos tend to look best if the subjects are isolated against a relatively undistracting background. You can achieve this in several ways:

- Zoom in to eliminate the background and to fill the frame with the subject.
- Crop the image later to eliminate a bad or distracting background.
- Change your shooting position so that the backdrop is better relative to the subject. For example, choose a high or low angle to put more sky or more ground behind the subject, or move around your subject so that you see it against a better background.
- Select a wide aperture to blur the background (see pages 36–37).
- Use the panning technique described on the next page to blur the background.

CAN'T GET CLOSE ENOUGH? CROP!

Even with a point-and-shoot camera that has a zoom lens, you'll probably be too far away to create frame-filling photos of sports action. This doesn't mean you should give up—it just means you might have to spend a little more time and money after the fact to have the best parts of the picture enlarged. For good results, on bright, sunny days use ISO 100 or ISO 200 films, which enlarge with better image quality than faster films.

Notice how the primary image was later cropped into a standard rectangle and the popular double-wide panoramic format. The latter has the advantage of eliminating most of the distracting background.

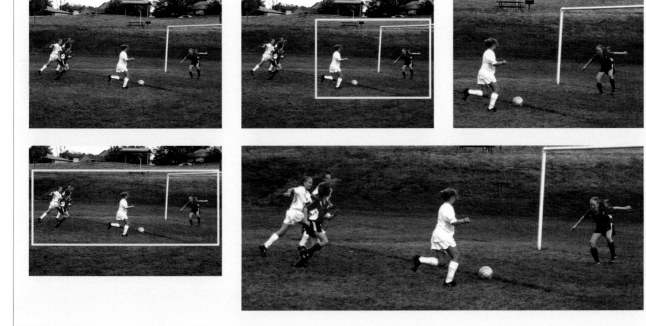

Sports & Shutter Speeds

The series of photos of a bicyclist (opposite) compares in detail the different effects that shutter-speed selection can have on action pictures. For all but the last (panning) image, the camera was on a tripod, and the shutter was fired when the bicyclist entered the field of view. It is important to note that the shutter speeds are relative to the focal length of the lens. Had the photographer used a longer lens, the magnification of the subject on film would have been greater, and its relative speed as it moved across the viewfinder greater. Likewise, with a wide-angle lens, the bicyclist would have been smaller and less blurred because he would have traveled a shorter distance across the frame during the same amount of time.

In the 1/2-second image in which the camera was not panned (opposite, bottom left), notice how the bicyclist almost disappears. He was in the center of the frame for such a small portion of that 1/2-second that he barely recorded on film. The background recorded sharply because the camera was kept absolutely still by the tripod.

Meanwhile, in the panning example (opposite, bottom right) the photographer followed the bicyclist in the viewfinder so that he was centered in the frame during the entire exposure and could be recorded relatively sharply on film. The background, however, is an indistinct blur because it was constantly changing relative to the bicyclist as the photographer followed him with the camera.

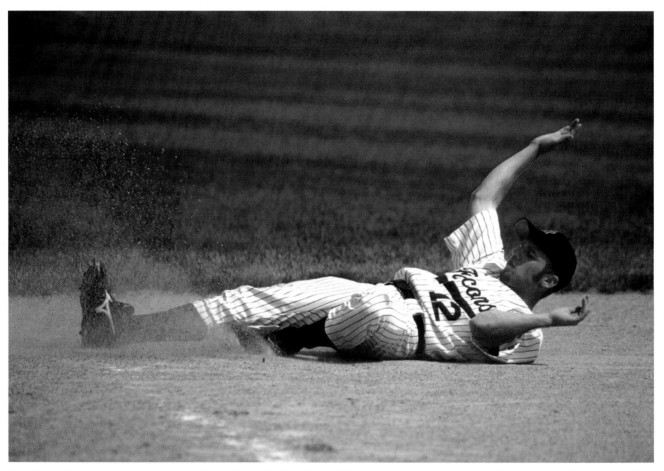

To get consistently great sports action photos you'll need to invest in an SLR camera and a telephoto lens. The camera will allow you to select shutter speeds capable of freezing high-speed action, and the lens will get you "close" to the action for frame-filling shots.

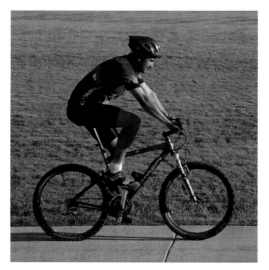

FROZEN AT 1/500-SECOND

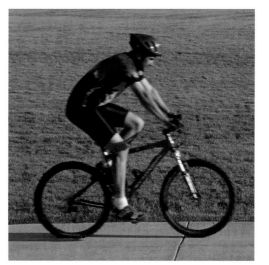

1/125-SECOND

This series of photos depicts how a moving subject records at a given shutter speed. In the first five images, the camera was kept stationary. As the shutter speed got slower, the bicyclist became more and more blurred until he almost disappeared (1/2-second).

In the bottom right image, the camera was panned to track the subject during a long exposure. The result was a relatively sharp bicyclist and a very blurred background.

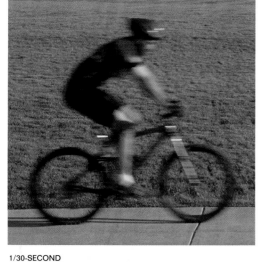

1/30-SECOND

1/8-SECOND

1/2-SECOND

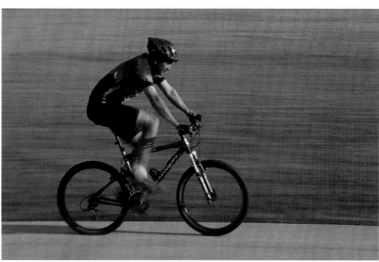

PANNING AT 1/15-SECOND

Travel Photography

Everyone wants to come home with photographs that show where they've been and the adventures they've had. When you're traveling, the things and people you see can be so intriguing that you may shoot a lot, thinking you're getting amazing images. However, in your excitement, you may forget to pause and compose the images well.

Take a moment to think about the goal of each picture. Are you trying for just a pleasing image that will be part of the record of your trip, or do you want to communicate something about the local culture or tell a story? If so, use lens selection, lighting, camera position, and other techniques to compose the best image you can.

Planning is important, from deciding how much equipment to pack to potential subjects you might want to shoot. Film photographers can carry a lot of film or buy it along the way. Digital photographers can carry numerous removable memory cards or sticks, but these are far more expensive than film. Most likely, you will be faced with the problem of limited memory. If you take a laptop computer with you, you can transfer the images to it to free up more camera memory, or you can transfer and save the images without a computer by using a portable CD burner or microdrive. If you're traveling to a large city, you may find a vendor who can transfer your images to a CD.

It's HARD ENOUGH to plan your wardrobe for a trip, let alone predict the types of pictures and how many you'll be taking. Before you leave, discuss with your traveling companions whether this is primarily a photo expedition or a vacation during which you'll take some snapshots. This will avoid misunderstandings and conflict on the trip if, say, you decide you want to spend an hour or two loitering in front of a monument waiting for the "right light." Non-photographers just might not understand!

The Packing Dilemma

Thinking ahead will also help you plan your camera gear. For snapshots, you may be able to get away with a point-and-shoot camera outfitted with a zoom lens and a tabletop tripod (so you can be included in some of the pictures).

However, if you want to come home with some award-winning shots, you'll probably want to pack, at the very least, an SLR camera with a wide-range zoom and possibly two or three lenses. You'll certainly want a wide-angle lens for vistas and interiors, and a telephoto for candids of distant subjects. A flash is important for the same reasons flash is always important (see pages 50–67). A tripod will help you to get good shots in dim lighting in museums and churches (if cameras are permitted) and to take self- or group portraits in front of monuments and other scenes.

Don't Be Over-ambitious

When you're planning your trip, the temptation is to cram as much as conceivably possible into it—especially if you're traveling great distances or at great expense. On paper an ambitious itinerary might sound wonderful, but the reality may be that you won't have enough time to absorb the sights, sounds, tastes, and culture of one area before you charge off to the next. Group tours are infamous for trying to squeeze too much into the time allotted. The end result is that you come home with confused memories of a lot of "things" you saw, but no real feeling for the place.

The problem is compounded if you plan on photographing the journey. You may see a perfect subject but under horrible light that does it no justice. Wouldn't it be nice to go to lunch or explore a museum and then come back hours or even days later for a better chance?

Human Scale & Context

In scenic areas you'll certainly want to photograph pristine landscapes and picturesque vistas, but don't forget to include people in some of the images. Local people add context about the culture as well as human scale.

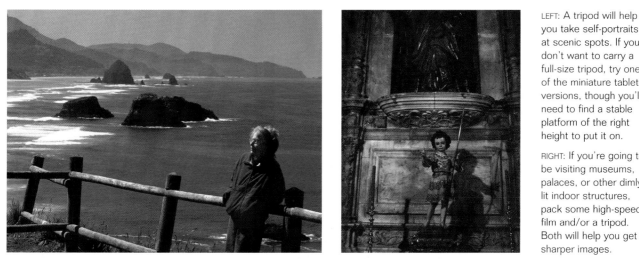

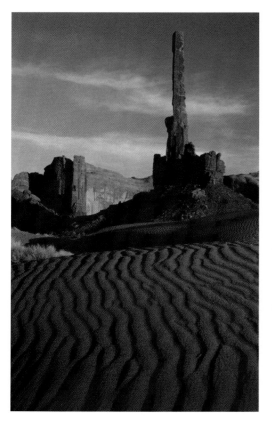

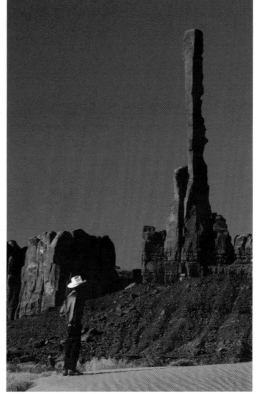

LEFT: A tripod will help you take self-portraits at scenic spots. If you don't want to carry a full-size tripod, try one of the miniature tabletop versions, though you'll need to find a stable platform of the right height to put it on.

RIGHT: If you're going to be visiting museums, palaces, or other dimly lit indoor structures, pack some high-speed film and/or a tripod. Both will help you get sharper images.

When traveling to picturesque spots, you'll want to come home with memorable scenic photographs. Pure scenics can be beautiful (left), but don't forget to include people in some pictures for context and scale (right).

If you're not lucky enough to find willing "models" locally, recruit your traveling companions. The natural arch (below) is a wonderful subject, but without a person there is no way to tell if it is tiny or monumental in scale. Asking a travel partner to hike to the overlook on the other side eliminated the problem.

Everything Is New

When traveling to a new place, especially a foreign country, everything is radically new—sometimes so much so that you want to photograph everything. Unfortunately, that is what most of us do, not necessarily in terms of rolls of film as in the number of elements we stuff into one picture! The problem is that when you get home, you can be faced with reconciling the differences between the incredible scenes you saw and the confusing, jumbled images you ended up shooting.

The root of the problem is that you can have trouble sorting out what is important from a compositional and story-telling viewpoint. You'll need to consciously discipline your overloaded senses and try to pick out single elements that tell the story. You're better off coming home with three simple images than one confusing scene.

Control the Lighting

Don't forget to use the lighting skills discussed in other chapters. You can alter how the light affects your subject by changing your shooting angle or the subject's position, or by modifying the light through flash or reflectors.

A Word on X-rays

Powerful X-ray machines can fog your film, causing light streaks or reducing overall contrast. Heightened security at airports and other ports has changed the "rules" about X-raying film. The airport machines that screen your checked baggage now do more damage than the carry-on screening. The best approach is to ask to have your film hand-checked. If this is not allowed, run it through the carry-on X-ray machines. Technology changes rapidly, so check the Internet for new advisories concerning X-rays.

The faster the film speed, the more it is prone to X-ray damage. The effect is also cumulative, so multiple X-rays can "add up" to visible blemishes on the film. Therefore, record how many times unprocessed (unshot or exposed but undeveloped) film has gone through the machines. (X-rays do not affect processed film.) If you will be going through a lot of security checkpoints, consider buying fresh film as you travel and having exposed film processed in cities along your route.

Without a person in the scene, there is no sense of scale and the viewer doesn't know how large the arch is. See page 91 for a similar example.

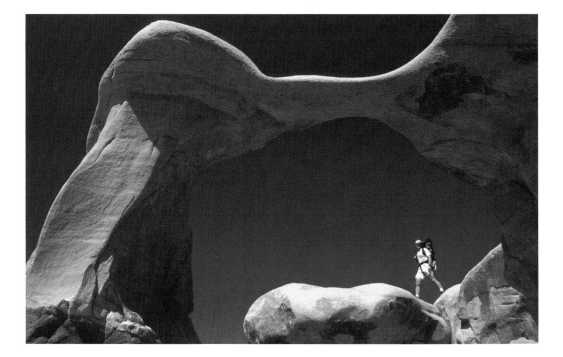

When you visit a new place, the different culture, sights, smells, and tastes can overwhelm the senses. The temptation is to capture it all in one shot (left), but the best pictures might be in the details (right).

A white cloth or collapsible reflector can bounce fill light back at your subjects for improved travel portraits. The second photograph (right) benefits from the more even lighting provided by a reflector.

THE STORY IS IN THE DETAILS

Your travel photographs don't have to be of big subjects to be powerful and communicate a sense of the place. Beans and local produce for sale at a foreign market, the uniform of a palace guard, or a detail of a squash blossom necklace worn by a Navajo weaver can all do this successfully.

Pets, Zoos & Wildlife

Our pets can be a big part of our lives, so it's no wonder we take a lot of pictures of them. And wildlife, whether in a zoo or its natural habitat, is always a great subject, if more difficult, as it often requires specialized equipment because of the obvious limitations you may face in terms of approaching or "posing" wild animals.

You may find it difficult to capture the beauty and personality of your pets. However, think in terms of the techniques you'd use with people and you'll have better results. Of course, you'll need to make adjustments. For example, shooting at the subject's eye level may involve getting very low for a cat or stepping on a stool for a Clydesdale horse.

Digital cameras that allow you to compose the image with the monitor instead of the viewfinder can be a real advantage. Most animals are very aware of your eyes and where you're looking, and a camera raised to your face often looks like a big eye. Friendly animals (especially dogs) may come running if they think you're looking at them in this way, and shy or fearful animals may want to get away. Holding the camera at your hip and taking just occasional peeks down at the monitor may give you better candid results.

Get Down to Their Level

By far the quickest and easiest way to improve your pictures of your pets is to get down to their level. We commonly shoot pictures of people at their eye level, because we are relatively the same height as our subjects. But few pets are as tall as we are—unless your cat happens to be perched on the mantelpiece.

Not only is the low angle more intimate in feeling (you're looking literally and metaphorically "eye to eye"), but it causes less optical distortion. In the turtle photographs (opposite top), the low angle is good, but the ground-level image that records the turtle's actual eye level is even more intimate.

The photographer had to lie on the ground (top) to get a good angle of this police dog searching a truck for narcotics (bottom). Photos © Meleda Wegner & Jen Bidner

132

WE LOVE OUR FAMILY PETS, BUT THEY CAN BE REALLY TOUGH TO CATCH ON FILM!

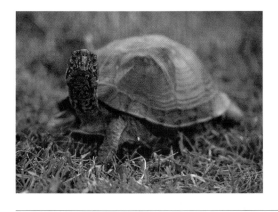

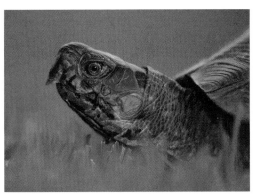

Different pets have different heights, and a low angle can yield some nice shots of low-to-the-ground creatures, but eye level means eye level. The camera had to be literally on the ground to get an eye-level image of a turtle (right).

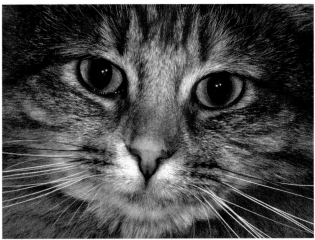

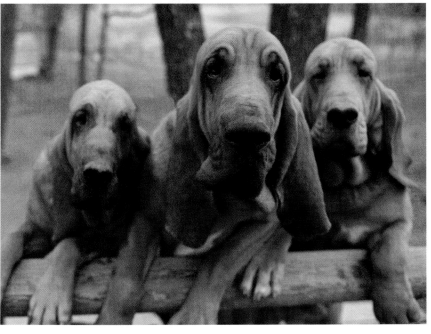

ABOVE LEFT: When taking posed portraits of people and their pets, try to position them in a tight group, without gaps between their bodies. A seated pose brings the heads of the woman and her dogs to a closer level than had she been standing. This pose also let the woman hold onto her dogs in case they broke their "stay" command. Photo © Jen Bidner

ABOVE RIGHT: Don't be afraid to get up close and personal—especially if your background is cluttered, distracting, boring, or unimportant.

LEFT: Most pet owners know exactly how to get their pets' attention. Noises, toys, food, and favorite treats usually work. Have the person who is trying to get the animals' attention stand directly behind you, so the subjects look straight at the camera. If you want a three-quarter (partial profile) instead, place the person to one side. Photo © Jen Bidner

Telephoto Lens

If you have a telephoto (T) setting on your point-and-shoot zoom camera or a telephoto lens (such as 105mm or 200mm) on your SLR camera, you may want to use it for portraits. For starters, this puts some distance between you and the pet. If you take candids when animals are unaware of your presence, you can avoid sloppy dog kisses or parrot pecks on your lens.

Additionally, telephoto lenses render the subject well, because these longer focal length lenses cause less distortion than wide-angle lenses. And they are able to put the background more out of focus, especially if you can select a wide aperture such as f/2.8 or f/4, as the photographer did for the photo below left.

Wide Angles

Don't completely discount wide-angle lenses, however. They are useful when you want to include multiple pets, the background, or both.

When a family that owns a German shepherd moved to a new home, they took the image below right and used it on their change of address announcement, with the headline "Gunner's New Dog House." A wide-angle lens allowed them to get both the dog and the house in the picture from just a short distance away.

Shutter Speeds

Most SLR cameras and a few point-and-shoots enable you to select your shutter speed. If you want action shots of fast-moving pets, there are two shutter-speed considerations. You can select a very fast shutter speed to freeze the action (which may require switching to a faster film) or you can combine a slow shutter speed with panning the camera to create an artistic blur (see page 127).

LEFT: A telephoto or zoom lens setting, such as 105mm or 200mm, is the perfect portrait lens for head-and-shoulder shots. Photo © Jen Bidner

RIGHT: A wide-angle lens enables you to include background scenery as well. Photo © Jen Bidner

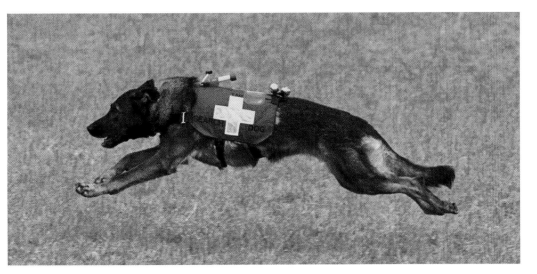

A fast shutter speed will freeze your fast-moving pets so they record sharply on film. Photo © Jen Bidner

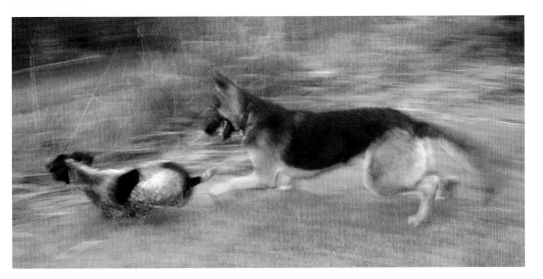

When you can't achieve or don't want a fast shutter speed, you can pan the action for an artistic blur. Panning is following a moving subject with the camera during a long exposure. This image also included flash illumination. See page 127 for a comparison of panned and un-panned images. Photo © Jen Bidner

Decide on a shutter speed according to how fast your subject is moving and the lens you are using. Here, the image was shot at 1/30-second. This was fast enough to sharply record the unmoving grass and ball. However, the dog was rolling his head faster than other parts of his body, so that portion of the picture is very blurry. Photo © Meleda Wegner

The image on the left has areas of darkness. Fill flash lightens shadows and delivers saturated colors (right).

Fill flash saved the day on this backlit portrait of a girl and her pet. Without it, the girl's entire face would be in dark shadow. Another alternative would have been to place a large white reflector to the side of the camera, to bounce light back onto her face.

If it is raining or snowing, your flash will help light up and freeze the action. However, it will also illuminate individual droplets and flakes, which will show up as out-of-focus light spots. This technique can be fun because even a drizzle or flurry can record like a storm. You'll need to take several images, in case the spots cover important picture elements. Photo © Jen Bidner

Fill Flash

Fill flash is also a very effective technique with pets, especially in sunny conditions and with pets that are dark. The flash will lighten shadows caused by direct sun and add a catchlight to the eyes. When in doubt, use fill-flash mode—it generally helps the picture.

If you're photographing in dim lighting, you may want to use the red-eye-reduction mode on your camera, because some pets are prone to a "green-eye" version of the red-eye phenomenon. For more on red-eye and reducing it, see pages 52–53.

Exposure Problems

Black pets and white pets can trick your camera into over- or underexposing your pictures, especially if the animal fills the frame. If your camera offers exposure compensation, use it to correct this problem. Select +1.0 or +1.3EV for white animals and −1.0 or −1.3EV for dark animals.

You can also use lighting to improve your pictures of very light or very dark animals. Shade or overcast conditions will lower the contrast difference between highlights and shadows, allowing subtle variations in the coat to show up better. If you have to shoot in direct sunlight, use fill-flash mode for the best results.

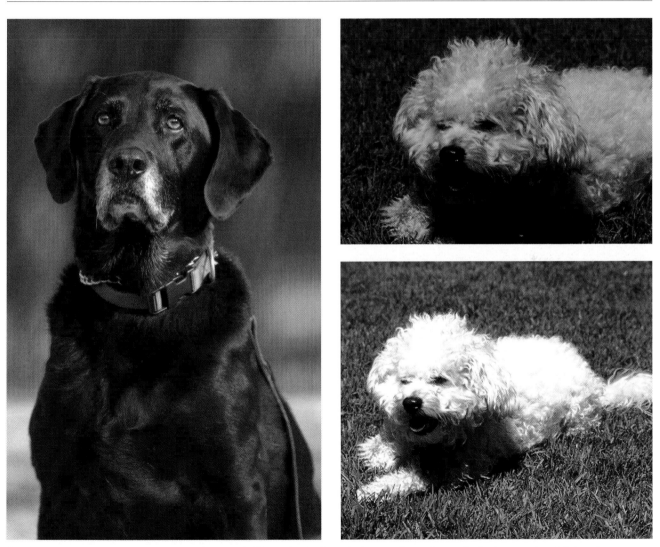

Black or white pets can be challenging to photograph. They either look washed out or dingy white in the final picture (top right) or show up as pure white or black with no details. Try to shoot them in shade or when it's cloudy, and use fill flash when you're in the sun. Exposure compensation will also help if your camera offers this feature: Underexpose a black animal (left; photo © Jen Bidner), and overexpose a white one (bottom right).

A Trip to the Zoo

THE FIRST STEP TOWARD WILDLIFE PHOTOGRAPHY IS PRACTICING AT THE ZOO

BEFORE YOU SPEND thousands of dollars on a safari to Kenya or plan a trek into the wilderness somewhere in the United States, you may want to hone your wildlife skills at the zoo. Not only will you learn how to use your equipment for this purpose, but you'll have the time to study the animals and improve your compositional skills.

Unique Challenges

Most zoos do their best to create "realistic" environments, but these settings still leave a lot to be desired. Your best bet is to try to produce frame-filling images that eliminate much of the background. If your camera has a zoom, use the telephoto (T) setting. SLR camera users can switch to a longer focal length lens, such as 200mm or 300mm.

You can also use the sun to your advantage. Pick a position in which the animal is sunlit yet the background falls into shadow. Then it's just a matter of waiting until your subject moves into the right spot. Many animals are shy and most active when the zoo is least crowded, which makes early-morning and off-season visits very fruitful for photographers. Other animals are active or sluggish depending on the season; polar bears for example, are always at their liveliest in the winter.

Semi-trained Wildlife

No wild animal is ever truly trained, but many can be safely handled by experts. Check with local falconers, rehabilitation centers, and nature centers to see if they have captive wildlife you can photograph. Depending on the animal, you may be able to stage an image for maximum success by, say, using an antique weathered window frame as a prop when photographing an owl (opposite top).

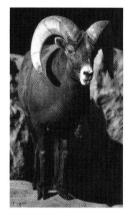

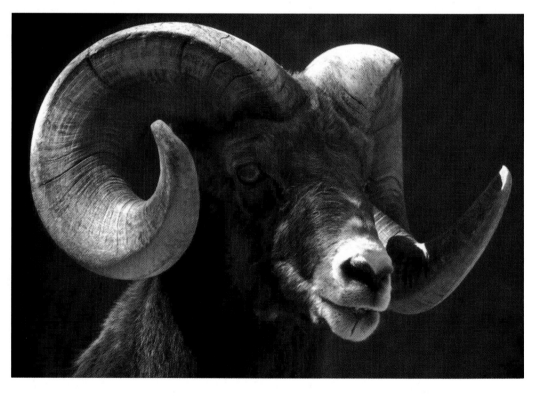

You can use telephoto lenses and lens settings to fill the frame with your subject, thus eliminating an obvious zoo setting (above). In the portrait (right), the bighorn sheep is in the sun, but the background falls into shadow, making it impossible to tell if it was shot in a zoo or in the wild.

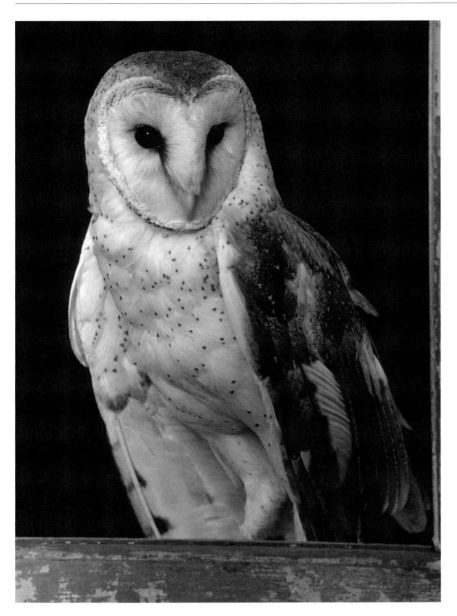

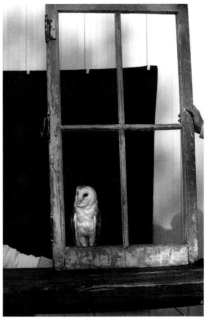

Wildlife rehabilitation centers sometimes have captive wildlife that can be safely handled by the staff (above). This may allow you to stage pictures that would be difficult to get in the wild (left). If you have the opportunity to photograph such animals, make sure the staff works closely with you. Remember to heed their instructions so that you do not unduly stress the animals.

ELIMINATING A FENCE

If you have to shoot through a chain-link fence, place your lens right up against it, centering the lens in the largest open section. Then select the widest aperture. The fence will record so out of focus that it may not even be visible. The photo on the left was taken from several inches away from the fence, while the one on the right used this technique. Photo © Jen Bidner

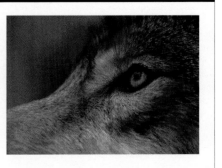

Wildlife Photography Basics

CERTAIN TYPES OF WILDLIFE ARE EASIER TO PHOTOGRAPH THAN OTHERS

UNLESS YOU'RE VERY LUCKY or are in a place where the animals are habituated to humans, you won't be able to get close to most wildlife. Because many animals are most active at dawn and dusk, you'll also often be shooting when the lighting is dim. Most point-and-shoot cameras simply don't have long enough lenses or the low-light capability for you to get successful wildlife pictures in most situations.

Equipment for Wildlife

For the best results, you'll want to use an SLR camera with a long focal length lens, such as 200mm or even 400 or 500mm. If you can't afford a lens in this focal length, you can double the focal length of most lenses with a 2X teleconverter that fits between the lens and the body of the camera.

Long lenses are hard to keep steady, and they require faster than normal shutter speeds to get sharp pictures. If you use a teleconverter, you reduce the amount of light entering the camera even more. Compound this with the fact that you will often be shooting in low-light situations and it becomes almost imperative that you shoot most wildlife images with a tripod or other type of camera support (see page 43 for more details.) Even with a tripod, you may need to switch to a high-speed film to freeze moving subjects.

Know Your Subject

After you get the right equipment, the second most important factor for success is knowing your subject. If you study the behavior of the wildlife you hope to photograph, you can begin to predict where the animals will be and when. For example, if you want to photograph deer, read a book on deer hunting. If you learn how to get close enough to a deer to shoot it with a rifle, you should be close enough to shoot it with your camera.

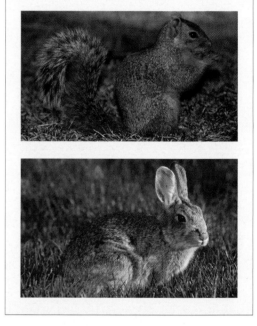

HONE YOUR SKILLS ON BACKYARD WILDLIFE

Most home owners try to chase away backyard critters like squirrels, rabbits, and raccoons. But you may find them to be terrific subjects. Consider "training" them to come to a photogenic spot by putting out food for them. Learn their patterns and then wait for their arrival. Patience usually delivers great picture opportunities, especially for animals that are habituated to humans.

A slight change in the photographer's position causes a radical change in the background. The vegetation in the right image is less distracting than the distant vista and high horizon line. This change will be the greatest with long focal length lenses and when your subject is farther from the backdrop.

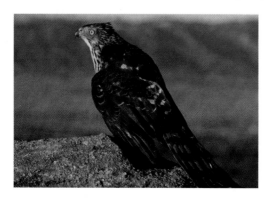

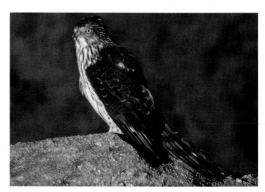

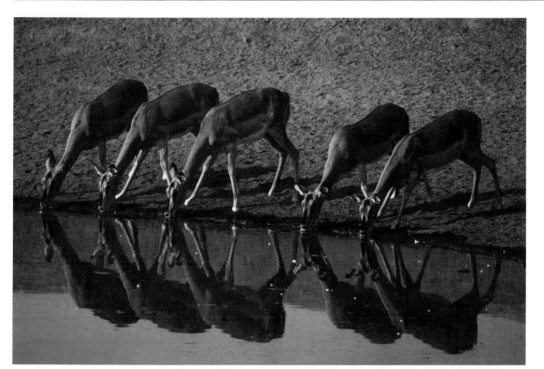

You increase your chances of success if you can predict where your subjects will be and then wait for their arrival. In Namibia during the drought season, for example, you will find all the action at the watering hole (left). And if you know the feeding preferences of hummingbirds, you can make an educated guess about which flowers they'll be attracted to (below).

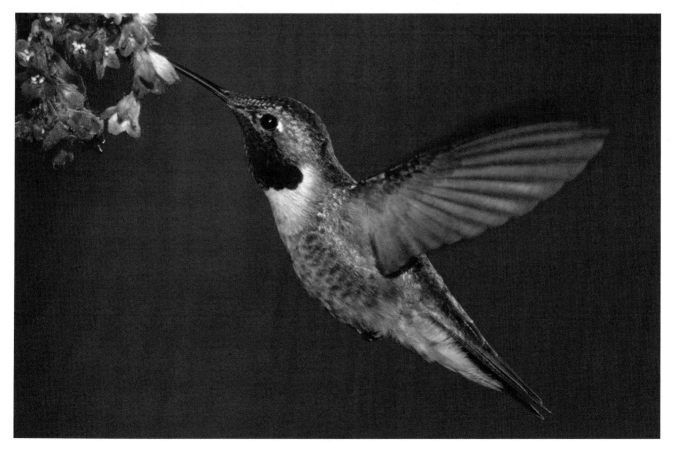

Pick Your Angle

In another similarity to methods used for hunting, wildlife photographers must consciously and constantly observe the backdrop for their activities. A hunter doesn't want to shoot a rifle if there is a house behind the target, no matter how distant. Likewise, as a photographer you want to try to position yourself so that the background is as interesting, beautiful, or uncluttered as you desire.

Most likely, you'll often be using long focal length lenses and wide apertures, which tend to blur the background (see pages 36–37). However, sometimes the blurring alone is not enough, and you'll need to consider your camera position. When shooting at the high magnification delivered by this type of lens, just a small change in your angle to the subject can completely alter what the camera sees behind the subject, especially if the backdrop is a great distance away.

Compositional Considerations

Hopefully you will have studied and practiced the rules of good composition on easier subjects than wildlife. If so, you'll be able design your picture almost instinctively when you have just a fleeting moment to shoot. You'll often hear professional photographers lament that they only had time to "get one shot off" when the animal momentarily stepped into the sunlight, then turned tail and disappeared.

The Rule of Thirds is one of the more important design aids for all visual images. This concept suggests that important picture elements be placed at the outer third of the photograph, rather than at dead center. (See pages 102–103.)

This "rule" works just as well for animal portraits as for scenics that include wildlife. Compare the eye positions in the two owl pictures on the opposite page, and notice how the one in which the eyes intersect the lines works better than the "bull's-eye" composition.

Room to Move

Where the animal is looking, in terms of its position in the frame of the picture, is crucial as well. If the animal is turned toward or moving toward the center of the frame, the picture will seem much more balanced than if the subject is looking at or turned toward the near side of the frame. When viewing the picture, our eyes want to follow the direction the animal is looking or moving, and it's better that this leads us into the center of the image rather than out of it. A good way to remember this is that you are "leaving room" (that is, empty space) in the picture for the subject to look or move into the picture, as opposed to looking or moving out of the frame.

The red flora in the background may be beautiful in its own right, but it is distracting as background for this image of meerkats (left). Placing them out of focus by selecting a wide aperture helps reduce the distraction, but shifting the camera position for a much simpler background is better (right).

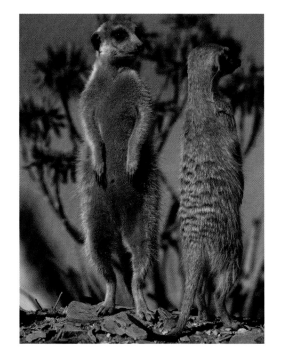

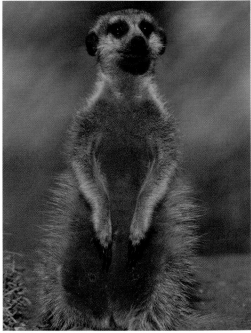

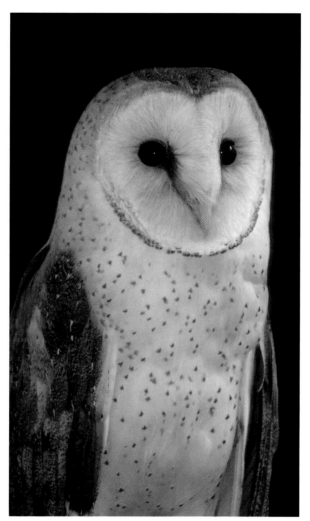

The Rule of Thirds is a compositional aid that helps photographers place important picture elements in the image. The goal is to put the important elements at either the intersection points of the grid or along the lines. In portraits, the eyes are the most important element, so they should be placed at the intersection points, rather than in the center of the frame. (See pages 102–103 for more.)

For a much more balanced composition, try to frame your photograph so that the animal is looking or moving toward the center of the frame (right) rather than toward the near side (left).

Lenses for Wildlife

TO GET CONSISTENT EXCELLENCE, YOU'LL NEED THE RIGHT EQUIPMENT

EVERYONE GETS A LUCKY SHOT once in a while, but if you're serious about wildlife photography you'll need to invest in lenses and cameras that have these three features:

1 **FAST APERTURES.** So-called "fast" lenses have a very wide minimum aperture, such as f/2.8 or f/2. These settings allow you to shoot with faster shutter speeds or with slower, higher-quality films in dim-light situations, including in the deep shade of the forest or at dusk and dawn, when many species are most active.

2 **AUTOFOCUSING SPEED.** A camera and lens that can autofocus (AF) quickly will yield more usable images. Some cameras offer multiple AF modes, with one designed specifically for continuously tracking a moving animal in the viewfinder without "dropping" the subject.

3 **AUTOFOCUSING ISLANDS.** A camera with multiple AF focusing points may help you (and the camera) pinpoint the focusing on off-center animals and ignore branches and other foreground elements that may be located between you and the subject.

More Than Just Telephotos

Long focal length lenses (often called telephotos) are by far the most common lenses for wildlife photography because they bring distant subjects closer through magnification. But they're not the only choice. Wide-angle lenses are useful for shooting animals in their natural environment or in large flocks or herds. Macro and close-up lenses let you shoot small subjects at closer than normal distances (see pages 24–29 for more information on lenses, and 152–163 for information on macro photography). You can also use wide-angle and macro lenses for close images of more approachable animals.

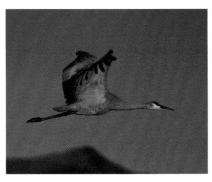

Fast autofocusing is great for tracking moving subjects. Try switching to manual if you find your camera does not autofocus fast enough.

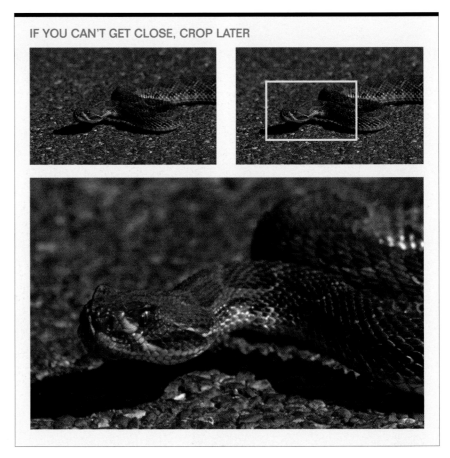

IF YOU CAN'T GET CLOSE, CROP LATER

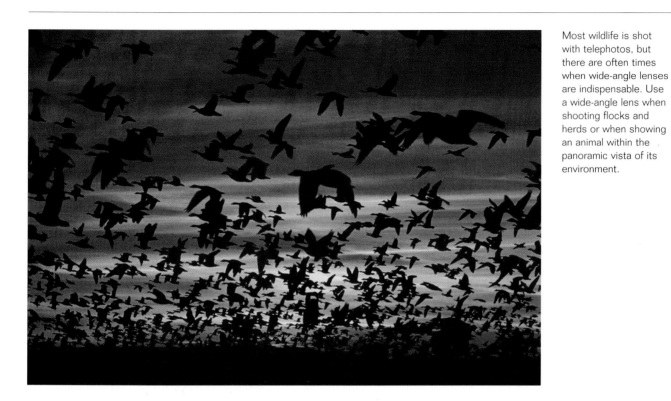

Most wildlife is shot with telephotos, but there are often times when wide-angle lenses are indispensable. Use a wide-angle lens when shooting flocks and herds or when showing an animal within the panoramic vista of its environment.

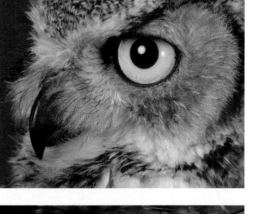

Telephoto lenses are your primary choice for wildlife (left), but close-focusing (top right) and macro (bottom right) lenses are also useful for small or approachable subjects.

Lighting, Exposures & Wildlife
FULLY UTILIZE YOUR CAMERA'S APERTURES, SHUTTER SPEEDS & ACCESSORIES

WILDLIFE PHOTOGRAPHY is quite a specialty, yet it follows a surprising number of the "rules" discussed in the portraiture and sports sections of this book.

Wildlife photographers commonly use long focal length lenses to shoot their pictures from a distance. This is partly because it can be difficult or dangerous to get close to animals that are not habituated to humans. In the case of moose, bison, bears, and other animals that can attack when approached, the danger is to the photographer. But your presence can also be very dangerous to many animals, because it may cause undue stress, force them off their feeding grounds, or cause them to abandon their young.

Shutter-speed Selection

The problem with long lenses (200mm, 300mm, or even 500mm and 600mm) is that you must use extremely fast shutter speeds just to eliminate camera shake when you hand-hold the camera. The rule of thumb is that the film speed should be equivalent to the lens focal length—for example, 1/200-second with a 200mm lens, or 1/500-second or faster for a 500mm lens.

Even if you mount the camera on a tripod to avoid camera shake, any movement of the subject is magnified on the film. This means that if you're accustomed to using a wide-angle lens to photograph your pet dog running in the yard, you'll need a faster shutter speed when you use a 500mm lens to shoot a coyote running at the same speed.

Aperture Selection

Photographers often select wide apertures for wildlife photography because they're working in less than optimum lighting conditions. However, these apertures have a creative advantage as well. Wide apertures like f/2.8 or f/4 tend to put the background and foreground out of focus. This not only serves to emphasize the subject; it also helps eliminate distractions in the background. It is an especially effective technique for wildlife portraits.

On the other hand, when the background is integral to the story told by the photograph—for example, when you want to show the animal against a broad vista of its environment—you may do better with a narrow aperture such as f/22 or f/32.

As with sports photography, you need to use a fast shutter speed for images of animals in action.

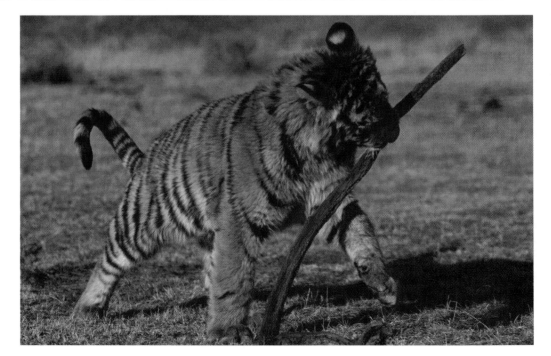

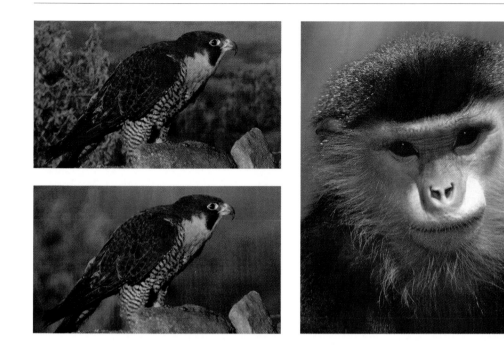

Careful aperture selection can produce a more pleasing background. Just as in human portraiture, a wide aperture (low-number f/stop) blurs the background with telephoto lenses (right). Compare the falcon pictures shot at f/22 (top left) and f/5.6 (bottom left).

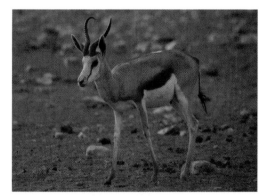

Telephoto lenses require faster than "normal" shutter speeds just to keep the picture from blurring when you hand-hold the camera. Both images were made using a 200mm telephoto lens. The out-of-focus photo (left) was shot at 1/60-second. The sharper photo (right) was shot at 1/250-second.

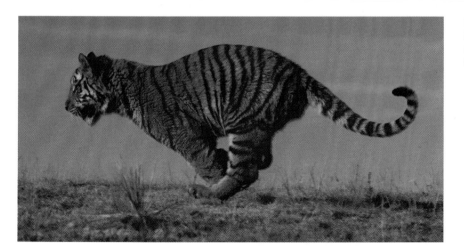

Combine a super-telephoto lens (300mm or higher) with a fast-moving subject and you'll need to jump to an extremely fast shutter speed, such as 1/1000-second or faster.

Natural Lighting

Pay attention to the angle of the light that is hitting your subject. Understanding your subject's habits will allow you to pick your shooting position in relation to the angle of the sun. Full front, side, rim, and back lighting can make a big difference in how the subject appears in the final image.

Patience also allows you to wait for changes in the lighting. The animal may make a subtle move, such as turning its head into the sun, or the overall lighting may change when clouds move over or away from the sun.

Exposure Compensation

Especially light or dark animals can be a problem in terms of exposure if they fill the frame. A black bear will fool your camera's exposure meter into overexposing it, and it will look bluish or washed out. A white mountain goat or wolf will cause most cameras to underexpose the image, resulting in low contrast and dark or bluish images.

Patience can make a huge difference, as Mother Nature alters the lighting through the course of minutes, days, weeks, and seasons. In these elephant images, cloud cover (top) was replaced five minutes later by direct sunlight (bottom).

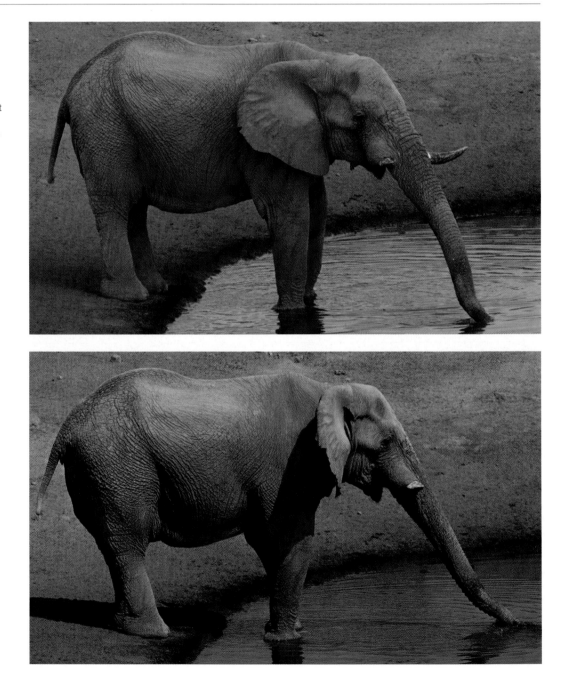

A small change in the subject's or the photographer's position can reveal a catchlight in the subject's eye. The bird's eyes are dark in the photo on the left. In the one on the right, the photographer waited for the bird to turn its head and caught the light reflected in its eye.

A difference in your position or the subject's position can alter the angle of the sun in relation to the shooting angle. Note the difference between high front lighting (left) and rim lighting (right).

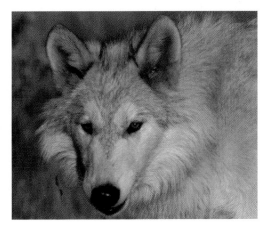

Exposure compensation may be necessary with especially light or dark subjects. The image of the left was made with no compensation. For the photo on the right, the photographer compensated by +1.0EV.

Fill Flash

If your subject is close to you or if you have a powerful accessory flash, you can use fill flash with great success on wildlife subjects. Specialized telephoto flash units focus the light for long-distance shooting. Be careful that you have a clear shot at your subject, because if foreground elements are overexposed by the flash, they may record as big bright blobs in the photo.

Flash Compensation

Better cameras and flash combinations offer flash exposure compensation, so you can reduce or increase the amount of fill flash relative to the existing light. This results in more natural-looking images. Photographers usually select –1.0 to –2.0EV

of flash exposure compensation for natural-looking fill flash.

Captive & Trained Wildlife

Rehabilitation centers, falconers, and animal trainers sometimes have "trained" wildlife that can be "posed" for photos. Some make their animals available for hire. Others may be willing to barter with you—you can use their "models" for photos, in exchange for usage rights to the images for personal use or promotion.

For the best results, try to take the picture in a natural setting, or bring in props like an evergreen sprig. More controllable animals, such as hawks, can be brought into a studio situation for classic portraits with multiple lights. Makeshift studios can be created outside as well (see page 139 for an example).

Fill flash can be used to lighten the shadow side of nearby wildlife subjects (right). It can brighten the subject and add catchlights to the eyes as well.

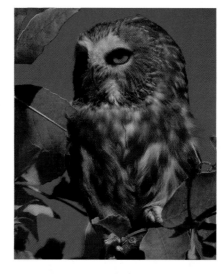
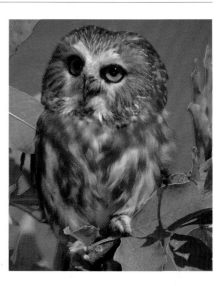

Enormous subjects, like an elephant, can be illuminated with fill flash if you have a powerful accessory flash unit. The left photo was too dark. For the right image the photographer used fill flash from a powerful accessory flash unit.

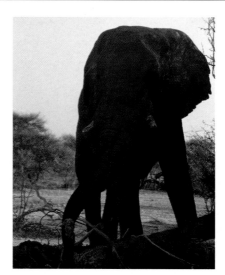

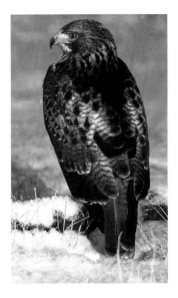

Flash can sometimes help your wildlife pictures when the natural light is too dim, as in the image on the left, but full autoflash might be too strong (right). A camera and flash that can deliver flash exposure compensation can be useful in these situations. Here, the best result was achieved with the flash set to 1.3 stops less exposure (–1.3EV) than the existing natural light (center).

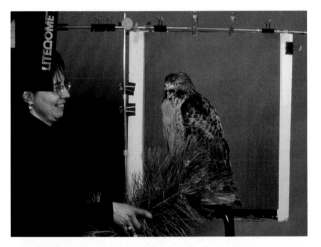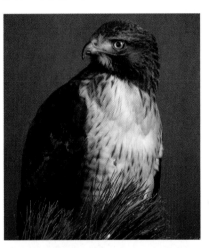

Hawks and other trained wildlife can be brought into the studio for multiple-light portraiture setups.

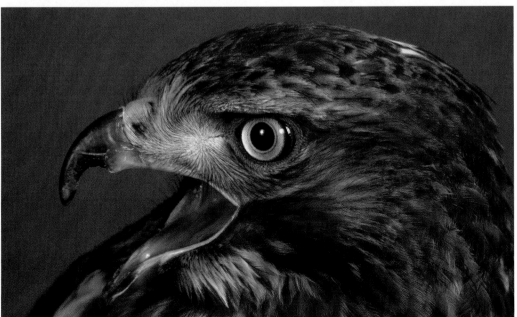

Close-up & Macro Photography

Macro (close-up) photography is inherently exciting, because it gives viewers an up-close view of the world they are not likely to see with the naked eye. Yet it's surprising how easy it is to take boring macro pictures. When photographers get their first macro lens, they almost always start shooting like crazy because this new close-up view of the world is so intriguing. In their excitement, they often forget the rules of good composition.

Macro photography also involves many technical concerns. It's often difficult to get everything in focus, and even a tiny amount of movement on the part of the subject or the camera can cause blurring. And your built-in and accessory flash units will probably be too powerful and at the wrong angle for well-lit macro subjects.

Many digital cameras have incredible close-focusing distances compared to their film counterparts. It's not unusual for a high-end point-and-shoot digital camera to be able to focus just inches away from the subject. And on many SLR digital cameras, long telephoto lenses have closer minimum focusing distances than their film equivalents.

It is important to learn the minimum focusing distance of your camera or lenses (in the case of an SLR with interchangeable lenses). If you're too close, some point-and-shoot cameras will warn you with a red light in the viewfinder or an audible beep, or will refuse to take the picture. Others will take the picture, and the first you learn about the problem is when you look at your out-of-focus prints. If your camera doesn't warn you, consider changing your camera strap to a string that is the exact length of the minimum focusing distance. Then, when you are shooting close in to your subject, stretch out this strap to determine if you are within range.

On an SLR camera, you're looking through the picture-taking lens, so you'll see through the viewfinder if the subject is out of focus. If you're really close and depth of field causes portions of the subject to be out of focus, you'll need to try one of two techniques:

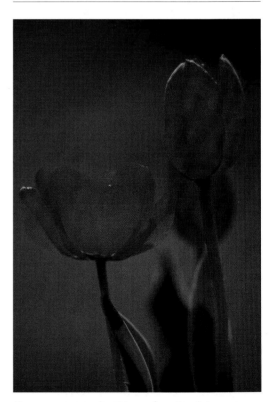

Know your camera's minimum focusing distance so you can get closer than normal images.

- *Narrow aperture.* Select a narrow aperture such as f/22 or f/32 to maximize depth of field. You won't see the difference in the viewfinder unless you use a feature available on some SLR cameras called depth-of-field preview (see pages 180–181).
- *Get parallel.* If your subject has a flatter side, change your position so you are parallel to it—the plane of sharp focus

in a picture is perpendicular to the lens axis (that is, it is parallel to your shoulders if you face the subject). As depth of field increases with narrower apertures, the plane of sharp focus stretches forward and backward but remains parallel to you. See pages 35–39, and 181 for more information on depth of field and aperture selection.

When you're shooting close up, you'll get more in focus if you stand parallel to your subject (left). The out-of-focus photograph (right) was taken at an angle.

POINT-&-SHOOT USERS: DON'T "MISS" THE SHOT

Because point-and-shoot cameras have two lenses—one for the film and one for the viewfinder—the pictures they take can suffer from parallax error: The film image may be different from what you saw in the viewfinder.

For distant subjects the difference in the angles of these lenses is negligible. But as you move closer to your subject, the problem can become more pronounced. The photo on the left represents the view in the viewfinder. In the actual picture, the composition would look more like the image on the right because of parallax error.

To understand this phenomenon, hold your finger 12 inches in front of your face. Close one eye and position the finger so that it blocks an object in the distance. Without moving the finger, open the other eye and notice that the distant object is no longer covered. Just the few inches of difference in the placement of your eyes causes the lines from the eyes to the finger and the back-ground to be at different angles.

In some cameras, parallax-correction frame markers in the viewfinder help you avoid chopping off key areas. If your camera lacks this feature, don't compose too tightly when you're very close to your subject. You can always crop the image later. Photo © Jen Bidner

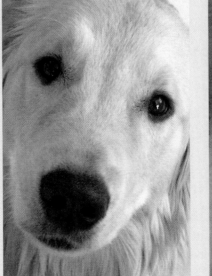
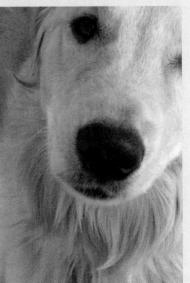

Macro Photography

TRUE MACRO PHOTOGRAPHY DELIVERS LIFE-SIZE IMAGES ON FILM

THE TERM "MACRO" is often misused in the photography world, especially in descriptions provided by lens manufacturers of their products. True macro means life-size images—and "life-size" refers to the image on the negative or slide film itself. In the case of a negative, you blow up the image by 400 percent when you enlarge from the 1×1.5-inch film to the 4×6-inch print. This means that your macro subjects can look much bigger than life-size in your prints.

So-called "Macro" Lenses

On the other hand, many manufacturers are now labeling their close-focusing lenses as "macro" even if they achieve only 1/4 life-size.

For a flower, 1/4 or 1/6 life-size might be fine, but for a close-up of a single petal or a portrait of an insect, you may be disappointed. Before purchasing a new lens, read the specifications carefully, and compare close-up capabilities if you plan to photograph very small subjects.

Economical alternatives to expensive macro lenses are extension tubes, bellows rail systems, lens-reversal rings, and close-up "filters."

Extension Tubes

Extension tubes are designed to fit between the camera body and the lens. These hollow attachments simply alter the close-focusing capability of the lens, thereby allowing you to magnify the subject on film.

TOP LEFT: Some high-end telephoto lenses provide minimum focusing distances that are excellent, but they are not truly "close-up" lenses because the subject is not life-size on the film.

TOP RIGHT: Some so-called "macro" lenses get you close to your subject, but the images they produce are not life-size on the film. This moth, if physically sitting on your 1×1.5-inch negative, would be larger than the film image.

BOTTOM: True macro lenses by definition deliver 1:1 life-size ratio (or larger) on the film. This means that when the picture is enlarged into a print, the subject will look huge.

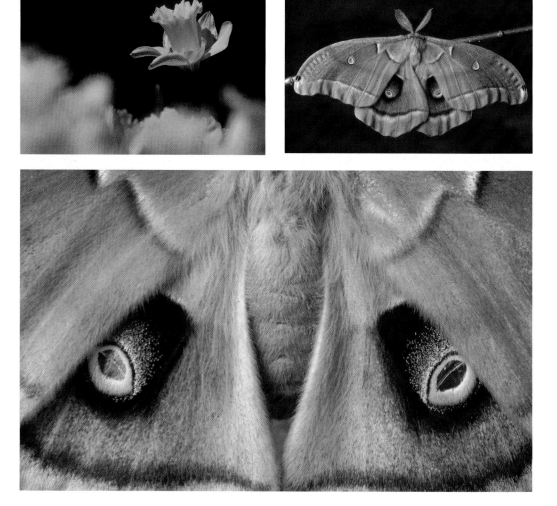

With an extension tube of any given length, the magnification change will be greater for wider-angle lenses. The tube does not affect the optical quality of the lens per se, but because of the increased magnification, any shortcomings or optical flaws will be magnified as well.

Bellows Attachments

Bellows attachments are adjustable versions of an extension tube in which an accordion-like extension on a geared or sliding rail is attached between the lens and the camera body. Moving the lens along the rail increases or decreases the extension between the body and the lens (and thus the magnification) as needed.

Reversal Rings

A lens-reversing ring, which fits between the camera body and the lens, is designed to position your lens backward in the mount. It might sound and look odd, but this system creates greater magnifications using normal and wide-angle lenses.

Close-up Filters

An inexpensive solution is close-up filters (also called close-up lenses or diopter filters) that look like filters and screw on to the front of the lens. They are available in several strengths, such as +1, +2, and +4 diopters. The higher the number, the closer the focusing capability and the greater the magnification.

LOCK & ROCK FOR PERFECT FOCUS

When you're really close to your subject and it's magnified in the viewfinder, it may be hard for your autofocusing system to lock onto it. Even the slightest movement of the subject from a breeze or a slight quiver of a hand-held camera will radically change the relative distance, as well as what is in the center of the viewfinder. When the camera tries to refocus, it may run through the entire focusing range, which eats up both time and battery power.

Cheaper macro lenses actually change their length when they are focused, positioning them closer or farther away from the subject, which then changes the magnification and composition! And if the front element of the lens rotates during focusing, filters on the lens will spin. While it's not a problem with most filters, you'll need to readjust polarizers and graduated filters every time you refocus. Look for a lens featuring "internal focusing" to avoid both these problems.

Instead of relying on autofocusing, you may be better off switching your camera or lens to manual focusing, if this is an option. Roll the focusing ring or toggle control to the minimum focusing distance (or watch through the viewfinder and select the distance that yields a composition that is close to the one you want). Then simply rock back and forth until the most important part of the subject is in sharp focus and click the shutter. This rocking technique not only saves time and battery power; it also helps you avoid a lot of frustration.

SIMPLIFY YOUR MACRO PICTURES FOR STRONGER COMPOSITIONS

1 HAVE PATIENCE. The photographer's patience paid off as the swallowtail butterfly moved to a lower section of the coneflower, which eliminated the light blue sky portion of the image on the left.

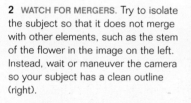

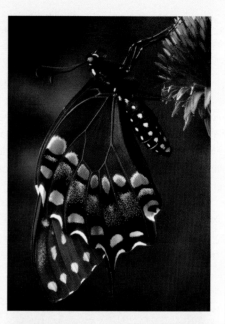

2 WATCH FOR MERGERS. Try to isolate the subject so that it does not merge with other elements, such as the stem of the flower in the image on the left. Instead, wait or maneuver the camera so your subject has a clean outline (right).

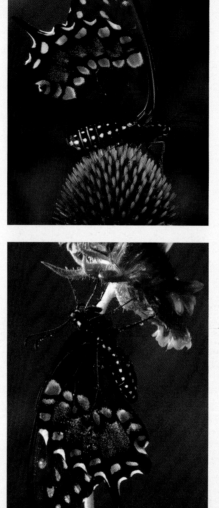

3 MOVE YOUR SUBJECT. You can often move small subjects to a better natural or man-made background. On cold mornings, you can usually move a moth or a butterfly to a better background, as the photographer did for the bottom right image.

A +1 refocuses the lens to 1 meter, a +2 refocuses it to 1/2 meter, and a +4 refocuses it to 1/4 meter. Multiple filters can be used together. For example, a +2 and a +4 create a +6 diopter that enables the lens to focus at 1/6 meter.

Unfortunately, close-up filters degrade image quality, and especially the sharpness of an image. Doubling up on these filters increases the degradation. If your lenses all have different filter diameters, you'll need to buy a set for each lens. Hence, if you can afford the other solutions mentioned above, you'll be much better off.

Depth of Field in Macro

One of the biggest challenges in close-up photography is maximizing depth of field.

At wide apertures, the plane of sharp focus is extremely narrow. This is not a problem—and is actually an advantage—if you want to throw the background or part of the subject out of focus. However, in pictures such as the two below right, the photographer wanted both the bee and the flower in sharp focus and thus used a narrow aperture (f/22) for success (bottom right example). Narrower apertures require longer shutter speeds than if the image were shot at a wide aperture. This means that the camera might need to be placed on a tripod to produce a sharp picture during a long shutter speed. The photographer could also switch to faster films or flash to allow use of f/22 with a faster shutter speed.

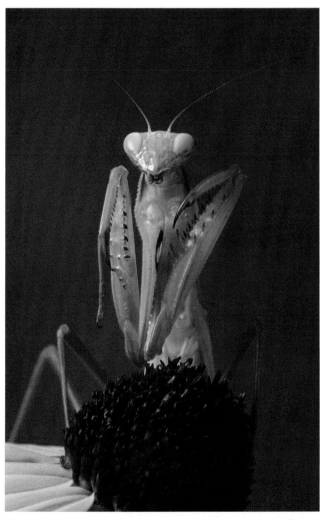

Close-up filters are an economical way to get closer to your subjects with a given lens, but they entail some degradation of quality.

A narrow aperture (f/22), as used in the bottom photograph, will help you get more elements of the image in sharp focus than a wide aperture (f/4), which was used for the top image.

The Quality of the Light

The quality of the light hitting your macro subject is very important. In some cases, such as the cocoons below, the sunlight in the image on the right brings the colors and textures to life, when compared to the flatter, duller version at the left, taken when clouds covered the sun.

Direct sunlight is described as "hard" because it creates hard-edged shadows. On hazier days, the atmosphere diffuses the light and makes it "softer" (that is, it has softer-edged shadows). Extremely diffuse light, such as in deep shade or on a rainy day, is almost shadowless, because the light seems to be coming from all directions and there is little shadow definition.

Create Your Own Light

One of the skills of a great photographer is the ability to foresee the type of light that will render the subject best. You can't tell the sun when to shine, but with small subjects, it's easy to modify it. You can diffuse direct sunlight by placing diffusion material (such as sheer white fabric) between the light and the

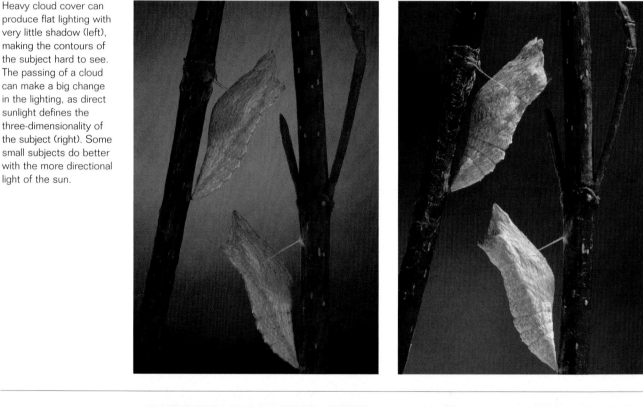

Heavy cloud cover can produce flat lighting with very little shadow (left), making the contours of the subject hard to see. The passing of a cloud can make a big change in the lighting, as direct sunlight defines the three-dimensionality of the subject (right). Some small subjects do better with the more directional light of the sun.

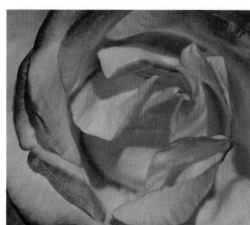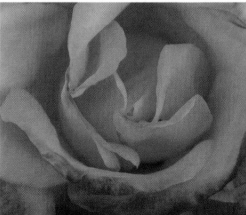

Direct sunlight is too harsh for the gentle subject in the photograph (left). Instead, the photographer placed diffusion material between the sun and the subject to soften the overall result (right).

subject. You can lighten shadows by placing a reflector near the subject to bounce light back onto the shadow side. You can add fill flash to lighten the shadows. Or you can completely override the main light source by using flash as the primary light source.

Reflectors to Fill Shadows

Most nature photographers carry some sort of reflector, because it is an easy way to fill shadows and add sparkle to sunlit macro subjects. If you're close to home, your reflector can be a piece of poster board. On the road, you might want to invest in a fancy collapsing reflector, or use clips and frames for securing a piece of material near your subject.

You'll also need to choose a color and texture for your reflector. Gold adds a warm tone to the picture. Silver is cool and neutral. Whites vary greatly from bluish to neutral to warm. Metallic reflectors give stronger but harsher fill. Matte and dimpled reflectors give softer fill.

The angle and distance at which you place a reflector will also affect the amount and the quality of the light.

A gold reflector fills the shadows while adding a warm overall tone to the image (right).

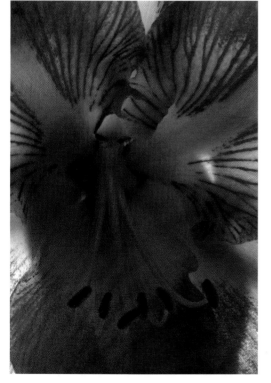
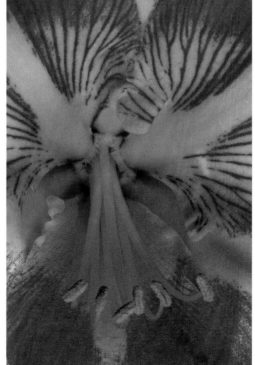

The photograph on the left is too dark. For the one on the right, a silver reflector bounced light back at the subject to fill the dark shadows caused by the bright sun, without adding a color cast.

Macro Flash

Some photographers are intimidated by the idea of macro flash photography, but it is actually simple in concept. You're doing "regular" flash and studio lighting, but on a small scale. However, it does require some specialized equipment.

The closer you get to your subject, the less effective your normal accessory flash becomes. For starters, most flash units cannot be reduced in power enough to avoid overexposure of a subject. Furthermore, most camera-mounted units will overshoot the subject because they are so far above the lens. Some higher-end units have a 5- to 10-degree downward swing to help with reasonably close objects.

Specialized macro flashes are designed to overcome these problems. There are two basic types. The first is sometimes called a ring flash, because it wraps around the lens like a ring. This puts it on the same axis as the lens, so there is no chance of it "missing" the subject.

Better ring flashes have multiple flash heads within the unit, so that one side or both can be activated for more directional light, or the power ratio can be varied for a main and fill-lighting effect.

If the ring flash is strong enough, it can be used for non-close-up photography as well.

Ring flash is popular with some fashion photographers because the lighting is very flat (it comes from the exact angle of the lens) and therefore hides facial flaws. If the subject is near the background, it also creates a distinctive halo shadow around the subject.

A second type of macro flash has separate flash heads, usually mounted on articulated arms that reach out on either side of the camera. Sometimes the flash heads can be swiveled or angled to further fine-tune the direction of the light in relationship to the subject. Units that allow the power in each head to be varied give you more creative control.

Macro flash with two heads around the lens (above). Macro flashes can be controlled in the same way as normal flash, delivering lowered power (in comparison to the natural light) for fill (right).

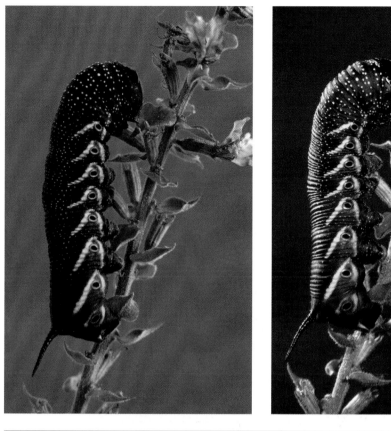

Macro flash units with two heads on small articulated arms can deliver different power from two directions (front light and rim light), creating the image on the right.

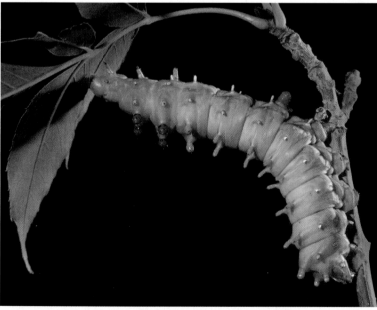

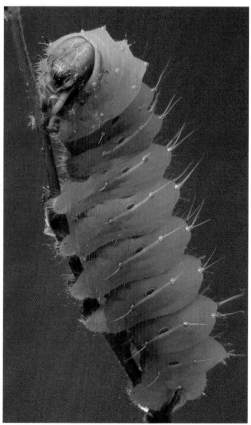

Macro flash (above) can also be modified through diffusion (right).

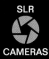

Both images are good, but they are very different. In the image on the right, a flash from the rear is added to provide a rim light that separates the flowers from the background and brings out their texture, but it looks less natural than a photograph made with just one light (left).

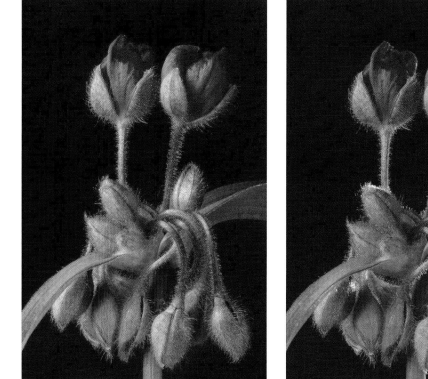

Two flash heads create a main light and weaker fill, for a very natural rendering of the main subject.

Miniature Photo Studio

Some small subjects, such as insects and cut or potted flowers, can be brought indoors, where you can create a miniature photographic studio. In doing so, if you don't want to invest in a macro flash, you have other lighting options. You'll be amazed at how much you can do with normal household bulbs, 10-inch dish reflectors, and white poster board for reflector cards. If you use household bulbs, to achieve good color you'll need to switch to tungsten-balanced film (see page 21) or use an 80A or 80B filter with standard daylight-balanced films (see page 77).

North-facing window light is also a good solution that delivers soft, diffused light. The shadows can then be filled with reflector cards.

Green or natural-toned fabrics or poster board can be used for a realistic background, especially if you throw it out of focus by placing it well behind the subject and selecting a wide aperture.

You can even "change the weather" by diffusing sunlight with translucent material (such as a sheer window curtain) or adding raindrops from a spray bottle.

POINT-&-SHOOT USERS

You can get great "studio" photos of flowers with household bulbs (use tungsten-balanced film) or window light. Determine your camera's minimum focusing distance, then mount the camera on a tabletop or full-size tripod.

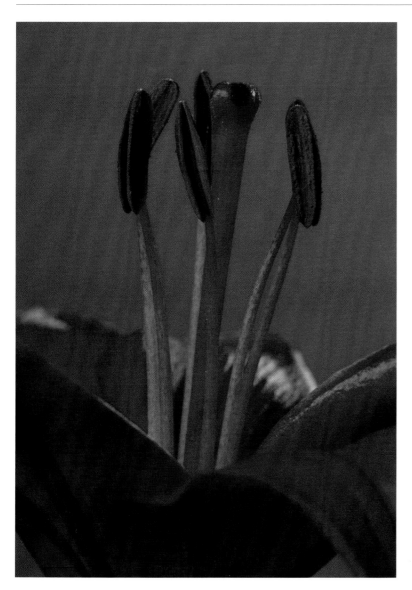

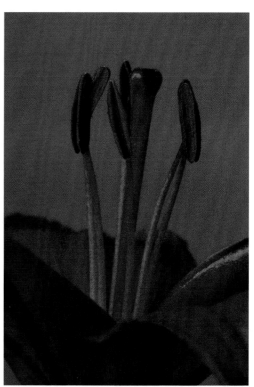

A second light is added in this studio photo (left) to highlight the edge of the flower and separate it from the background.

Photographing Flowers

12

Flowers are one of the most popular subjects for photography. Individual flowers can be stunningly beautiful, vast fields create abstract photographs, a foreground flower accentuates a distant mountain scene, and close-up images reveal the endlessly varied textures and patterns of nature. Most of the general shooting tips discussed in this book—including composition, lighting, and aperture selection—can be used for flowers.

However, there are a few techniques that work especially well with this subject, and a few mistakes you can easily avoid. The expectation is very high for flower images, because they have been a popular subject for artists since long before the advent of photography. Most flowers are inherently beautiful, so you'll be tempted to take straight portraits of them, but people are jaded by having seen so many images of pretty flowers that you'll have to go above and beyond standard "portrait" snapshots to earn any real admiration for your images. Concentrate on the composition and lighting, and perhaps use reflectors, diffusers, and water spray bottles.

Digital photographers have the advantage of being able to manipulate images with photo-editing software. They can punch up the color of bold flowers like tulips, alter the contrast of delicate flowers like orchids, and correct imperfections caused by insects or the weather. Film photographers can use scanners (or a vendor) to digitize their film or prints so they too can reap the advantages of photo-editing software like Adobe Photoshop.

Aperture Selection

When shooting single flowers, think of the image as a "portrait" and utilize the selective-focus technique described in detail on pages 36–37. Selecting a wide aperture (such as f/4) will throw a distracting background out of focus. On most point-and-shoot cameras you won't be able to select an aperture, but if the camera has a portrait mode (usually indicated by a head-and-shoulders symbol), use it for a similar result.

Color Trick

To create a more artistic impression, you can compose the image, then hold a flower right next to the lens. It will be so close to the lens that the camera can't focus on it, but the result will be a pleasant, blurred foreground color (see example below). Use focus lock on the distant subject to make sure the camera doesn't try to focus on the very close flower.

Take Control

If the weather isn't cooperating, you can fake it. A spray bottle with water will instantly turn an ordinary flower into a dew-dappled beauty. Likewise, you can move potted plants or cut flowers to alter the light or background.

Look for the Unusual

Keep your eyes open for interesting juxtapositions, such as springtime bulbs shrouded in snow or a determined yellow tulip in a field of red ones.

You can create a blurred foreground frame by holding a flower right next to the lens but only partially covering it. The result will be a colorful blur from the closest flower.

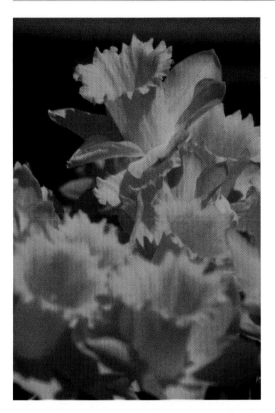 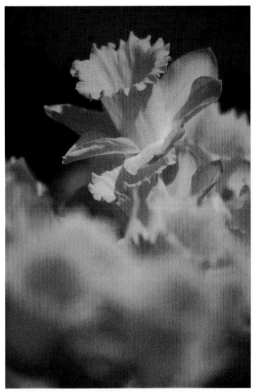

The aperture you use will affect how in or out of focus the background or foreground will be. The image on the left was made at f/22. The one on the right was shot at f/4. The effect is greatest with telephoto and macro lenses. If you can't control your aperture selection and your camera has a portraiture mode, use it.

Use a spray bottle with water to add instant "dew" to a subject.

Easy Ways to Control the Background

SHOW OFF THE BEAUTY OF THE FLOWER BY SIMPLIFYING THE BACKGROUND

BECAUSE FLOWERS tend to have complex shapes and delicate textures, it is important to simplify your backgrounds so they do not compete with the main subject. There are many ways to do this quickly and effectively.

Contrast Ratio

When the background is in shade or when the sunlight is suddenly dimmed by an opportune cloud, the background can be so much darker than a sun-lit subject that it records as dark and without detail.

Use Your Equipment

Using a wide aperture or portrait mode allows you to soften the background so that it does not compete with a sharply rendered subject. Fill flash can emphasize this difference even more, by adding light and popping the subject out from the now relatively darker background.

Alter the Background Completely

Since flowers are relatively small subjects, you can quickly alter the background by placing a piece of poster board or a swath of cloth at a distance behind the subject. Likewise, if the plant is potted or you are allowed to cut it, you can move it in front of various backgrounds. Photographs of a thistle plant (opposite) take on a very different feel as the background changes.

Shade darkens the background (right).

A wide aperture and fill flash separate subject from background. In these photos, the one on the left was shot at f/22, and the middle image at f/5.6. For the image on the right, the photographer added fill flash.

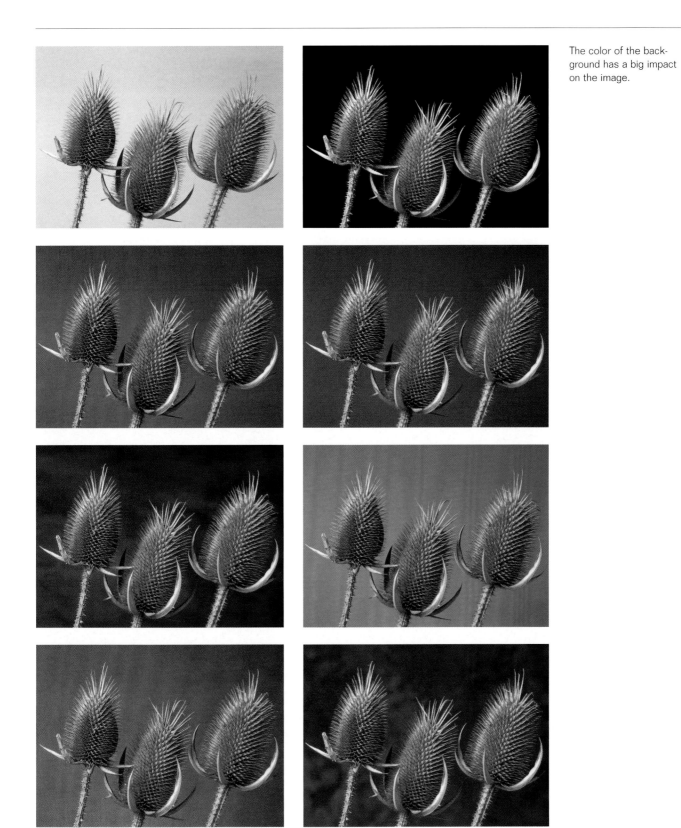

The color of the background has a big impact on the image.

Reflectors & Diffusers

WHEN SHOOTING FLOWERS, YOU'RE NOT STUCK WITH THE LIGHT NATURE DELIVERS

A SINGLE FLOWER, or even a bunch of flowers, is small enough that you can create a "mini-studio" even in an outdoor setting. Doing so allows you to modify the light and improve on what nature has delivered.

Modifying the Light

While a bright, sunny day may be perfect for a picnic, direct sun is often not the best lighting for flowers. It may work when you want to emphasize the texture of the flower, but in most cases it is too harsh and causes deep black shadows.

When cloud cover rolls in or you move into the shade, the light is much softer and more diffuse. This type of lighting tends to bring out the richness of a flower's colors, and it defines the shape of the petals with soft shadows.

If the clouds do not cooperate, you can soften the sun by using a diffuser made of translucent material, such as sheer white cloth or heavy-duty tracing paper. Ask a

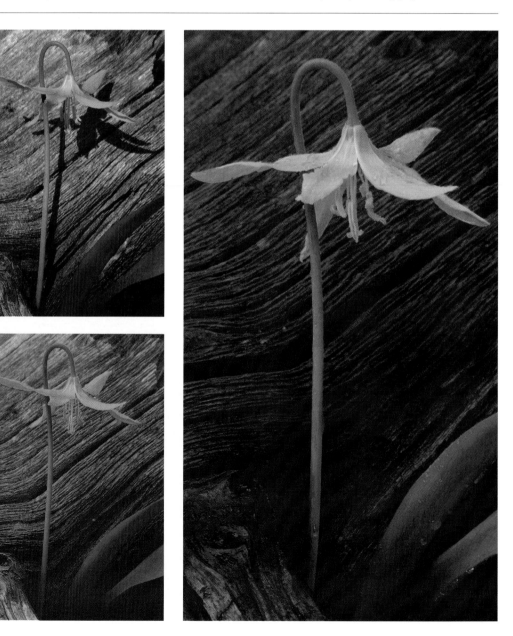

Direct sunlight is too harsh for this flower (top left). Cloud cover softens the light but can cause a blue cast on film (bottom left). A diffuser softens the direct sunlight, and water from a spray bottle helps saturate the colors (right).

friend to hold it in place, or rig it up with a tripod, light stand, or clamps.

Reflectors

If it is not practical to diffuse the light, you can reduce the harsh shadows by filling them with flash (see pages 170–171) or with a reflector. The latter simply bounces some of the light back at the camera to fill the shadows. Place the reflector to the side of the camera, or just above or below the lens. While looking

at the subject from the camera angle, tilt the reflector this way and that until you get the right amount of fill.

You can alter the quality and color of the fill with your choice of reflectors. Gold reflectors add a warm cast. Shiny surfaces give harder and stronger fill, while matte surfaces bounce back a softer, more diffused light. White FomeCore or tinfoil-covered cardboard are good home-made reflectors. Fancy collapsible reflectors are available at photography-supply outlets.

Direct sunlight produces harsh shadows (left). A gold metallic reflector bounces warm light back onto the subject to fill the shadows (right).

Compare the difference between the straight shot (left) and images made using a silver reflector (center) and a gold reflector (right).

Using Flash on Flowers
BUILT-IN & ACCESSORY FLASH CAN IMPROVE YOUR RESULTS

Built-in Flash

The flash that is built into most cameras can be a big asset in flower photography. Full autoflash mode may cause the background to go black, which can be good or bad creatively. Fill flash, on the other hand, will balance the flash with the sunlight, so that the natural light shines through, but it lightens the shadows.

Sunlight from the side or back tends to make flower petals glow, which can be beautiful. But sometimes this type of lighting turns the stem and other portions of the flower dark. Fill flash will brighten these darker areas, while the sun keeps the petals glowing.

Cautionary Tales

When you are working close to your subject, your on-camera flash may be too strong for the subject, causing details to burn out. Also, the closer you get to the subject, the greater the chance that the built-in flash will literally miss the flower. If you encounter these problems, consider the macro flash techniques discussed on pages 160–163.

Accessory Flash

You'll get better results if you use an SLR camera and invest in a good accessory flash unit. It will have more adjustable power (so it is not too strong for close-in work), and better units dedicated to your camera offer +/– exposure compensation.

Off-camera Flash

Some SLR cameras and flashes can be used off camera, which allows you to place the flash to the side or to the back of the subject. They are controlled either through a cord or remotely using infrared signals.

Placing the flash directly behind the subject can result in glowing petals. A high back light can create rim lighting that helps separate the flower from the background. In the studio or on a cloudy day, light from other angles can mimic sunlight. Note that flash can deliver very hard light, and you may prefer the softer effect of reflectors (see pages 168–169).

Macro flash units are designed specifically for close-up photography. Some units have more than one flash head, allowing you to create directional light by using only one side, or to create main and fill light by adjusting their power.

POINT-&-SHOOT USERS

Make sure you know your camera's minimum focusing distance, and don't get any closer. Then switch the camera's flash mode to fill flash. This will work only on larger flowers; if you get too close to a small flower, your flash may miss it entirely or be too bright.

The straight shot is nice, and the background is recorded brightly (left). Flash is so much stronger and faster than the daylight that the more distant background doesn't have time to record on film and registers as black (center). When this same flash is moved off camera and high and to the right of the flower, the lighting becomes more directional (right).

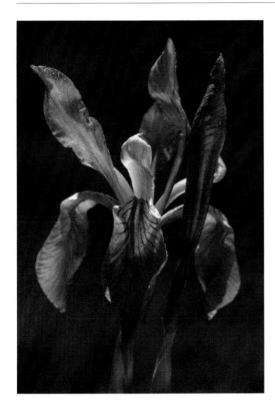 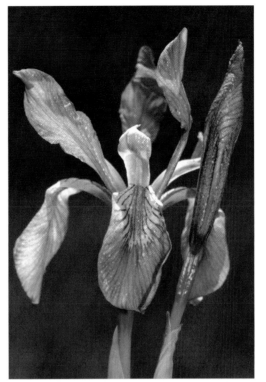

Direct sunlight (left) makes some of the petals glow, but the stem and other petals become very dark. Fill flash (right) brightens these dark areas but still allows the sunlit portions to shine through.

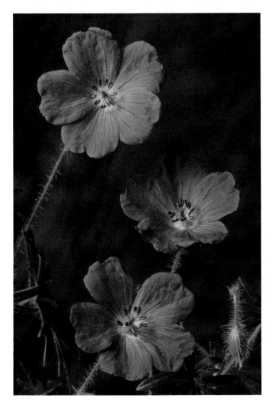 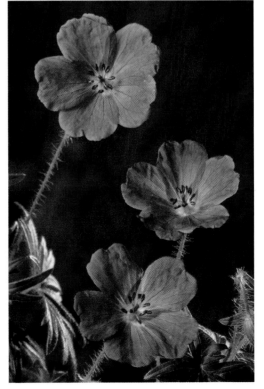

A flash placed high behind the subject helps separate the flowers from the background with a rim light (right).

Bring the Flower to the Studio
YOU CAN USE MULTIPLE LIGHTS TO MAKE A CLASSIC PORTRAIT OF A FLOWER

JUST BECAUSE FLOWERS are associated with outdoor photography doesn't mean that you can't bring them inside for studio-style portraits. They are in fact great studio subjects, because they are small and malleable.

Cut flowers can be carefully posed using flower-arranging tools like floral foam and floral frogs. In the studio, you have complete control over the lighting and can use as many or as few lights and reflectors as you want. Better yet, there are no breezes to move and blur the flowers, and you don't have to contend with changing lighting conditions as the clouds pass and the weather changes.

Most large studio flash units have incandescent "modeling" lights that the photographer can turn on while setting up the picture. They can be set to automatically turn off at the moment of exposure, so the sole illumination is the flash. Because flash illumination occurs too fast for the photographer to see well, these modeling lights provide a rough estimation of how the flash lighting will look so the photographer can set up the lights. Unfortunately, these powerful flash units are very expensive, and they are usually used only in professional photographic studios.

Some small SLR accessory flashes can be used off camera and linked to each other, allowing you to achieve multiple flash effects. However, you'll need to do a lot of experimentation because most do not have "modeling" lights that let you preview the image.

A third method is to use "hotlights," such as standard household lamps, garage-style reflectors, and halogen lamps. You can see the effect of these lights, but you'll need to use tungsten-balanced film (or an 80A filter) to avoid yellow images.

Or you can revert back several centuries and light your subject the way the painting masters did—with the illumination from a north-facing window. Then use white poster board or tinfoil-covered cardboard to bounce fill light back at the subject.

POINT-&-SHOOT USERS

You may not be able to use studio-style flash units with your point-and-shoot camera, but don't despair. You can gain a lot of control just by using the soft light from a north-facing window for your main light, and white poster board or cardboard covered with crumpled tinfoil as a reflector to fill the shadows.

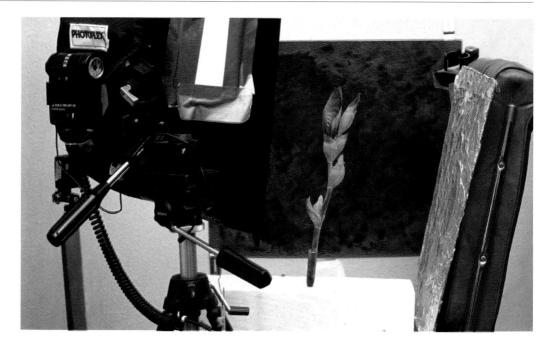

The photographer used studio-style flash units to take these images. Note how similar the lighting in the "flower portrait" on the opposite page is to the portrait of the woman on pages 122–123.

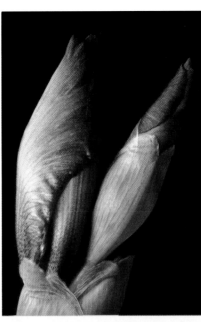

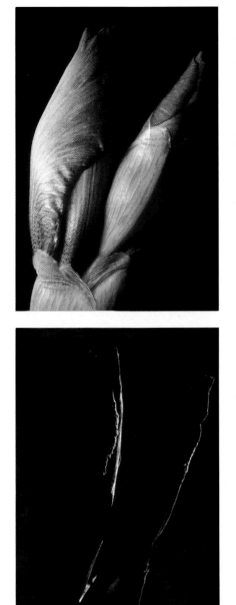

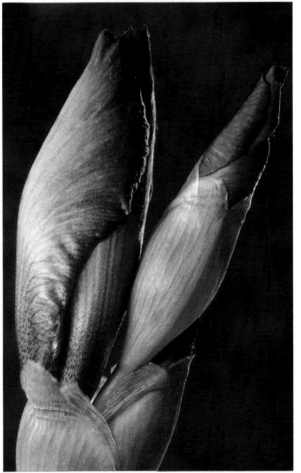

The main light is the strongest. It sets the tone for the whole image (top left). A reflector from the right lightens up the shadowed side (top center). The main light and reflector are joined with a background light that makes the dappled cloth backdrop visible (top right). A rim light from the back right side serves the sole purpose of separating the flower from the background (bottom left). The final result (bottom right) combines three lights and a reflector.

OTHER LIGHTING OPTIONS

If you don't have studio flash units or "slaved" accessory flash units, you can light your subject using standard household lamps, dish reflectors such as those made for garage work, and halogen lamps. Use tungsten-balanced film to avoid a yellow color cast. (See page 21 for more on tungsten films.)

13

Landscape Photography

You might find yourself looking at a landscape photograph and saying, "Wow! That photographer must have had amazing luck to catch that light." Well, he may have, but he probably made his own "luck."

Anyone can get lucky once in a while, but the best photographers work hard to improve their odds. They find a subject in dismal lighting conditions and pre-visualize its potential. Then they wait or return—and sometimes (but only sometimes) they're rewarded. Others work a single good subject over and over, searching for ways to improve the scene.

Many of the most picturesque landscape subjects are not accessible by car, so you may have to do some hiking. This is a disadvantage if you are a digital photographer with a limited number of removable memory cards, because you may run out of memory just when the light becomes perfect. And while you can view and edit your shot images to make room for more, battery life is also an issue. You may have to invest in a portable microdrive or extra removable memory cards or sticks, or haul your laptop with you.

Carry a Compass

Packing a compass (and knowing how to use it) is not just a survival skill for finding your way back to base camp or your car. It's a valuable tool for figuring out when a beautiful landscape is likely to be bathed in sunlight. You can figure out east and west (sunrise and sunset) in general terms, but for more accuracy you'll need to know the sun's altitude (height) and azimuth (arc) for the time of year at a given location, which you can find by using charts.

On the U.S. Naval Observatory's online site, you can type in a place and a date and see the altitude and azimuth of the sun. This free service is accessible at http://aa.usno.navy.mil (click on "Data Services").

The U.S. Naval Observatory also provides information on the moonrise, so you can plan your shots not just around the full moon, but also on where it will be in relation to your landscape subject of choice.

FLARE FROM THE SUN CAN DEGRADE YOUR IMAGE

Take care that direct sunlight doesn't hit the front element of your lens. If it does, you'll probably get flare, which shows up as light or colored spots or stripes, or as a general reduction in contrast. The easiest way to prevent flare, as in the image below, is to shade the lens with your hand or a magazine. If you're using an SLR camera, use a lens shade, but make sure you choose the right size shade for the focal length of the lens or you may get vignetting (darkening of the edges or corners).

Landscapes Require Patience!

TOP PHOTOGRAPHERS KNOW THAT PATIENCE & PERSEVERANCE YIELD LUCK

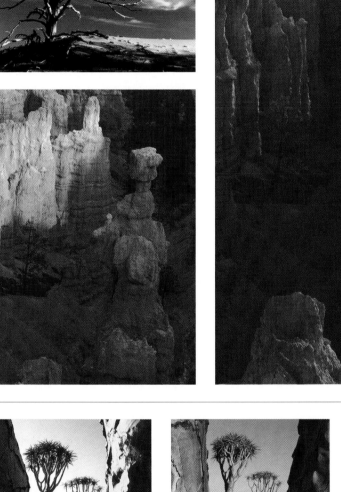

Read the local papers or consult the U.S. Naval Observatory's Web site (http://aa.usno.navy.mil) and learn the time of sunrise, sunset, and moonrise. The scene shown in daylight (bottom left) becomes much more dramatic when shot at sunrise (right). The moon adds a unique visual dimension to any photograph (top left).

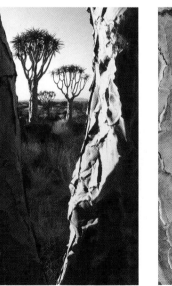

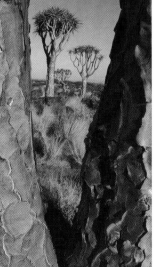

Sometimes it's hard to predict how the changing angle of the sun will affect your subject. With practice you'll gain the ability to pre-visualize the results and decide whether to wait, return, or move on to another subject. These three images were made at different times of day: at sunrise (left), in late afternoon (center), and at sunset (right).

Time of Year

Often overlooked is the fact that the sun changes its path with the seasons, arcing more to the north in winter and to the south in summer. This results in a different angle of light falling over landscapes according to the season. Seasonal weather and foliage variations also affect the subject. If you're lucky enough to live near picturesque locations, you'll want to visit them on different days and in different seasons. An obvious example is the brilliantly colored foliage that fall brings. And a sprinkling of snow gives the landscape a much different look than the lush colors of spring and summer.

Reality Check

Waiting at a scenic spot for hours or returning again and again often isn't practical. However,

Photographs of the same scene made in winter and summer can have an entirely different feel. A mildly interesting scene shot in the fall (bottom) takes on a new aspect during winter. Notice how the white clouds in the top image echo the dappling of the snow.

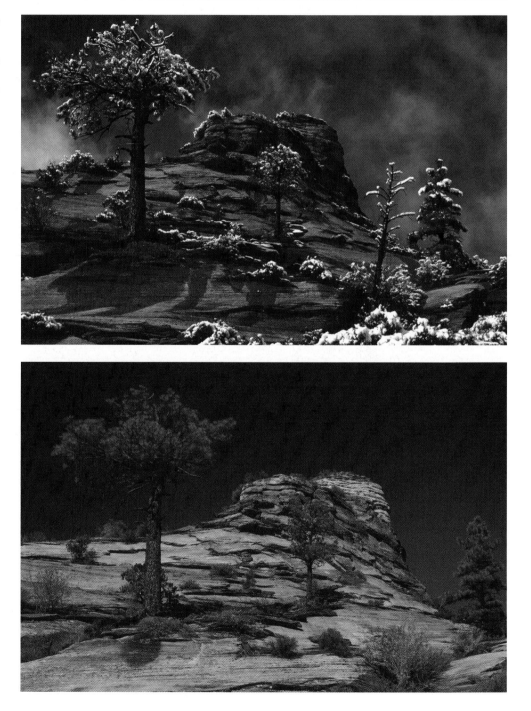

try to linger at least five minutes when you find a good subject. Even this brief period of time will give you the opportunity to take in the scene and see the subtleties, and with a few minutes of looking you may notice a potential foreground element or framing device (pages 98–101). Pausing a few minutes before moving on may allow serendipity to kick in—a cloud may shift or a rainbow might appear.

Bad Can Be Really Good

Knowing the arc of the sun won't help if the weather is bad, but don't discount a bad-weather day as a bad day for photography. Rain and snow storms, including their preludes and aftermaths, often provide excellent conditions for photography because they are dramatic. However, do take care to protect yourself and your equipment in case you get caught in really bad or dangerous weather.

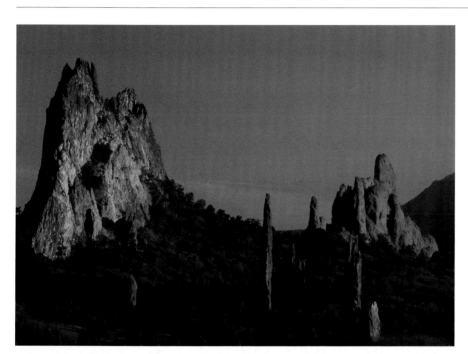

Time of day makes a huge difference in the direction of the light. At sunset, the main subject is front lit (left), while at sunrise it is shadowed (above).

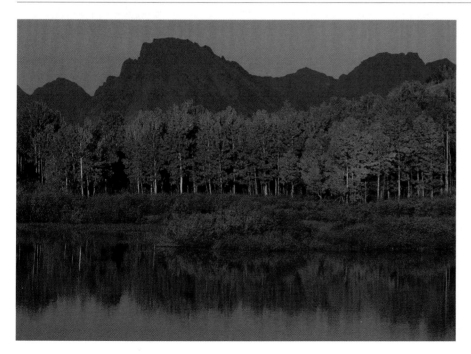

Distant cloud cover improves a good picture (above) by adding drama (left).

The Color of the Light

In addition to the direction of the light, you will find it has a distinct quality and color at different times of day. Late-afternoon sunlight has a very warm cast, because of its angle and its reflections through the atmosphere. Pollution in the atmosphere, whether man-made or natural (including volcanic eruptions thousands of miles away), can radically alter the late-day coloration of the light, often in ways that can be favorable to the photographer.

Daylight-balanced films are balanced for 5500°K (the "color temperature" of daylight that is equivalent to the color of the light from the midday sun on an average day). If you shoot under these conditions, your film will look neutral and "correct." If clouds cover the sun, the light gets bluish; rain causes it to become even bluer. Like late-afternoon light, early sunlight looks warmer. Before dawn and after sunset the light becomes bluer again.

The Quality of the Light

In addition to the color of the light, the direction of the light, the high or low angle of the sun, and whether it is diffused by clouds all affect the feel of the image. In the images on the opposite page, the predawn light is soft, diffuse, and bluish (bottom left), while the first rays of sunlight cast sharp-edged shadows and imbue the light with a warmer color (bottom right). The low angle of the sun makes the tiny ripples in the sand look much larger and more defined. In the top left image, the low angle is even more evident: The shadow of the yucca plant is twice as long as the plant itself.

Though we need to rely on nature for clear skies, cloud cover, and snow, the color of the light can be altered or enhanced with filters (see pages 76–81). They can provide a minor color correction to warm or cool an image or a more dramatic alteration, such as strong orange to enhance a sunset.

LANDSCAPE COMPOSITION & FILTERS

Much of the skill in landscape photography is how you compose your images (chapter 6) and your use of filters (chapter 5). Be sure to check these chapters for more landscape tips!

Time of day affects the color of outdoor lighting. Late-afternoon and early-morning sunlight have a warmer, reddish tone (right), whereas in overcast and rainy weather the light takes on a bluer hue (left).

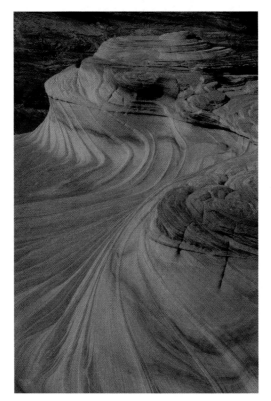

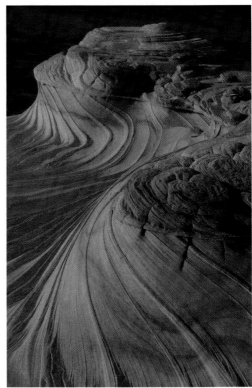

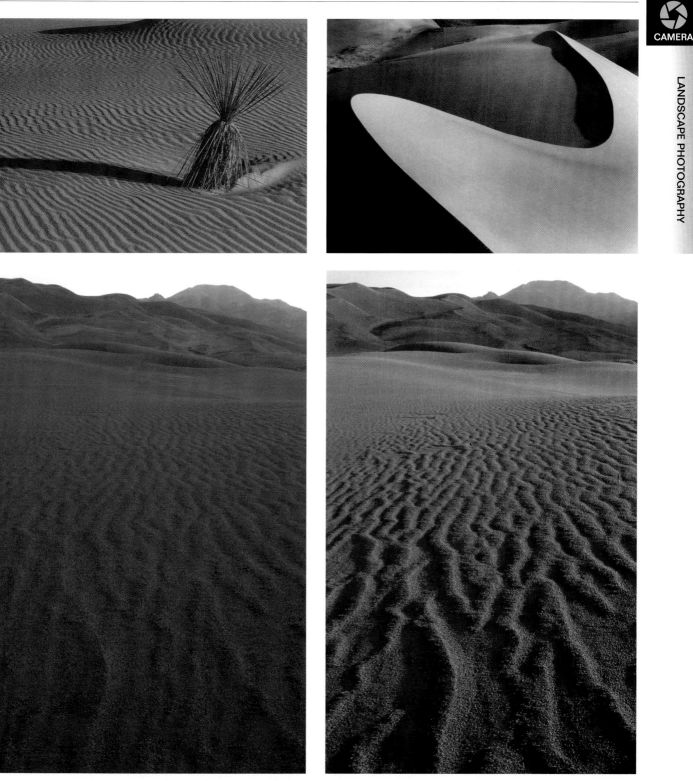

Low-angle sunlight emphasizes the texture of the subject, making small ripples as well as larger features in the sand look much more dramatic.

Landscape Exposure Considerations
APERTURES, SHUTTER SPEEDS & EXPOSURE COMPENSATION WILL HELP

FOR CONSISTENTLY EXCELLENT landscape and scenic photography, take control of your exposures. In most situations, you'll want to maximize depth of field (see page 35). This will enable you to utilize foreground and background elements more successfully (see pages 98–99).

Maximizing Depth of Field
To maximize depth of field, you'll need to use narrow apertures such as f/22 or f/32. The easiest way to do this is to select aperture-priority exposure mode on an SLR camera, and then select a high-number f/stop.

Depth-of-field Preview
On an SLR camera, you're looking through the picture-taking lens. In order to see a bright view in the viewfinder, the lens on an SLR camera stays open at the widest aperture until the moment of exposure. Some SLR cameras offer a depth-of-field preview button that lets you see how the aperture you plan to use will affect the image. Be forewarned that previewing depth of field darkens the image in the viewfinder because the aperture "stops down" and lets in less light.

If the image is too dark, mount your camera on a tripod and throw your jacket over the camera and your head to make a tent. In a few moments your eyes will adjust to the dimmer light, and you'll be able to check that all the picture elements you want recorded in sharp focus are in fact in sharp focus.

On a bright, sunny day, you'll be able to hand-hold your camera when shooting with a wide-angle lens at f/22, because your shutter speed will be about 1/60-second with ISO 100 film. But if the light dims because of changes in the weather or the time of day, or if you switch to a longer focal length lens that requires faster shutter speeds to hand-hold, you'll need to make changes.

Options & Solutions
Your solution might be to put the camera on a tripod, so you can use slow shutter speeds. However, you might still get blurred images if elements in the scene are moving—for example, if tree leaves are blowing in the wind. Another option is to switch to a higher film speed so that you can use the narrow aperture and a faster shutter speed.

You'll need to intentionally overexpose subjects that contain a lot of white. The top left image was made without exposure compensation. Adding +0.6 exposure compensation improves the image (bottom left), but +1.3 is needed to make the white tones look better in this situation (right). Likewise, pictures with a lot of black or dark tones require underexposure to keep them black in the final photograph.

The last option is to use the depth-of-field preview button to determine how wide an aperture you can "get away with" and still have everything in sharp focus. If your landscape is distant and near the infinity focus setting, you can use a wide aperture. But if you want to add nearby foreground elements, you'll need more depth of field (and narrower apertures) to get everything in sharp focus. In some cases, you may not be able to achieve this even at the narrowest aperture and will need to reevaluate your shooting position or lens choice.

POINT-&-SHOOT USERS

Some high-end point-and-shoot cameras have a landscape mode (often indicated by a symbol of a mountain) that weighs the camera settings toward narrower apertures and maximum depth of field.

Even if you don't have this mode, you still have options. If it is bright and sunny and your landscape is at a distance, your results will be fine regardless of the film you use. However, if the light is dimming or you want to add nearby foreground elements, your best bet is to use higher-speed films than you would normally use in order to maximize depth of field (see page 35).

A narrow aperture brings a nearby foreground element into sharper focus. The left image was shot at f/5.6, while for the right image the photographer set the aperture at f/22.

A tripod holds the camera steady so you can select a narrow aperture that requires a slower than normal shutter speed.

Modifying the Light

If your natural subject is small enough, you can modify the light. Harsh sunlight casts dark, hard-edged shadows and creates a high-contrast image. Film has a limited contrast range and can't provide detail in very dark-shadowed areas and bright-highlighted areas. If the contrast can be reduced, then the film can record details in both.

Placing diffusion material between the sun and the subject will soften the lighting. Diffusers create softer shadows and reduce the overall contrast, allowing more details to be seen in the highlights and shadows.

Reflectors work toward the same goal, but they don't alter the main light (the sun). Instead, they are placed in a position opposite the angle of the sun so that they bounce some of the light back at the shadowed side of a subject. This lightens (fills) the shadows so that the overall contrast is reduced.

You can purchase a collapsible reflector or diffusion unit that tucks into your camera bag. Such units are usually circular in shape. One

A diffuser softens the light and reduces the overall contrast of the scene (bottom).

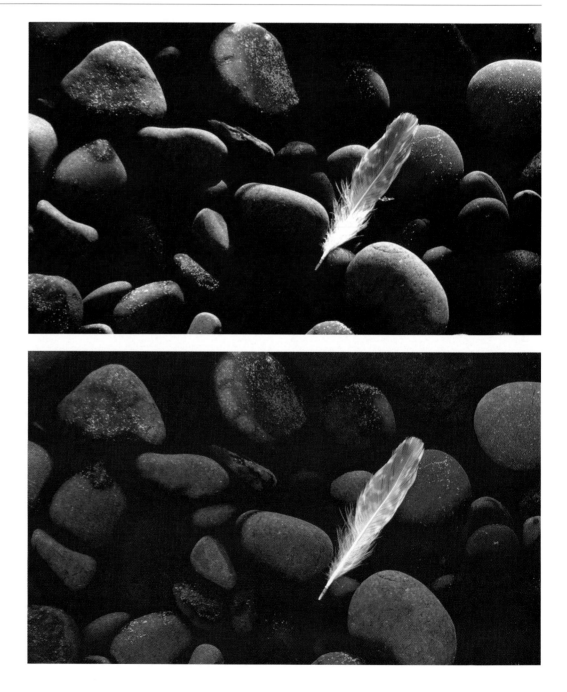

popular brand is PhotoDisc. Or, if you prefer, you can make your own. Look for sheer, neutral-white fabric as diffusion material. Note that there are many different "whites" that range from cool/bluish (often called bright or ultra-white) to warm/yellowish (often called natural or antique white) and everything in between.

Reflectors can be made from construction board, poster board, matboard, or cardboard. Shiny metallic surfaces reflect harsher, brighter light, though gold adds warm sunset tones.

Crumpled tinfoil can be taped over cardboard to create a reflector that adds bright fill light.

Larger reflectors and diffusers let you modify larger subjects, but even the collapsible type can be bulky. Beware: In windy condition, larger reflectors become bigger sails!

POINT-&-SHOOT USERS

You don't need a high-end SLR camera to reap the rewards of reflectors and diffusers. They can be used to improve pictures with any camera.

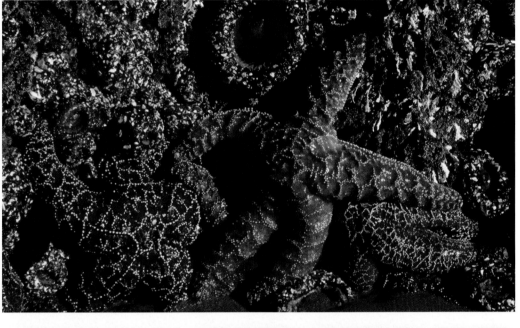

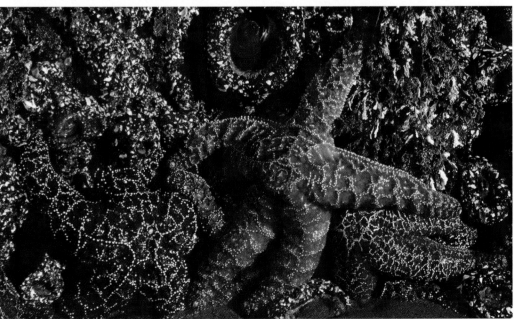

A gold reflector fills the shadows and adds a warm tone to the starfish (bottom).

SLR CAMERAS

Tips for Perfect Water

FILTERS & CAREFUL SHUTTER-SPEED SELECTION ARE THE KEYS TO SUCCESS

THE KEY TO WONDERFUL IMAGES of rushing water is your choice of shutter speed. Unless your intent is to showcase individual water droplets, you will get the best results with extremely slow shutter speeds. To succeed, you'll need to stabilize the camera with a tripod or other camera support, which will help to eliminate unwanted blurs. When the camera is stabilized it will record all stationary objects sharply, and the moving elements (the water) will be captured as an ethereal blur. See pages 44–45 for more details.

Polarizing Filter

A polarizing filter can change a photograph dramatically by eliminating reflections. In the example of the flower (opposite top), the reflections on the surface disappear when a polarizer is used, and the background becomes darker to emphasize the subject.

Though subtler, the waterfall scene (opposite bottom) is also improved by reducing the reflection on the wet rocks and the pool, which become deeply saturated in color when the reflection is removed. See pages 68–71 for more on using polarizing filters.

These two images show the radical difference between rushing water shot with an action-stopping shutter speed (top) and a long exposure that allowed the water to blur (bottom).

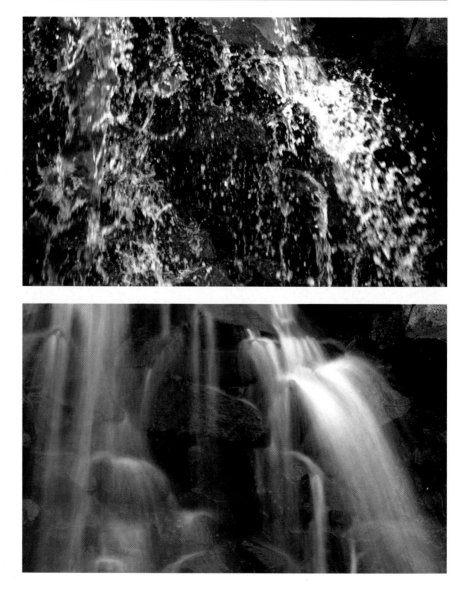

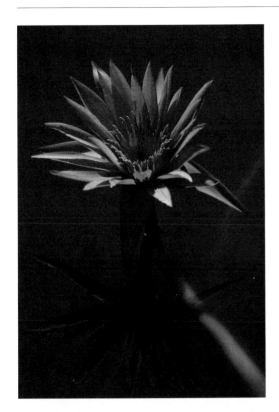 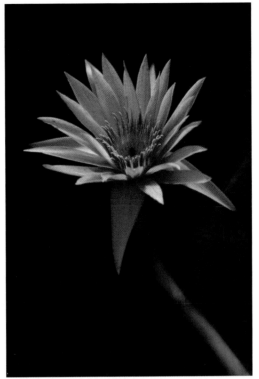

A polarizer removes some of the reflections on the surface of smooth water (right).

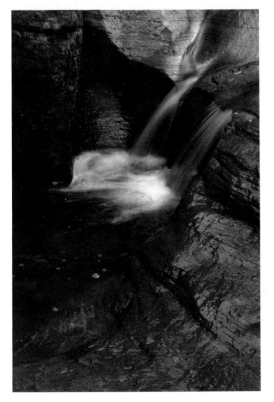 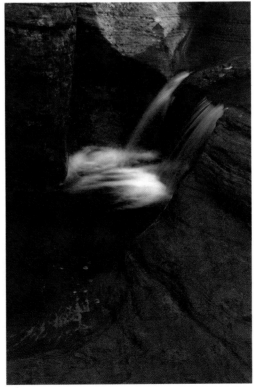

A polarizer will also remove some of the sheen on wet surfaces (right), allowing the colors to appear more deeply saturated.

Aerials & Underwater

Macro photography allows us to see the world in a way that is not always possible with the naked eye. Likewise, a bird's-eye view from the sky is fascinating. Here are five simple tips that will increase your chances of success, whether you're shooting from a scenic helicopter or light plane tour, or from a romantic sunset hot-air balloon ride.

In the same way, as air-breathing mammals we find glimpses of the underwater world exciting, whether it's a portrait just a few feet deep in the local pool or a deep-water image made during a scuba dive. Cameras made specifically for underwater photography (such as Nikonos) are great but expensive. Luckily, you can adapt your existing equipment with a special underwater housing that protects your camera from the water while allowing you to access the controls.

Digital cameras are great for a first-time aerial photographer, because you can use playback to check that your image is sharp (the number-one aerial photography problem). And digital scuba-diving photographers can delete images and shoot over them without resurfacing for another memory card. Film photographers, limited to the number of frames on their roll of film, don't have this opportunity for do-overs.

Aerial Photography

Most people who shoot from a light plane come home with poor, blurry pictures. The following suggestions should help:

1 TALK TO THE PILOT. A pilot who knows you're taking pictures will probably place you in the best viewing seat.

2 WINDOWS. Images shot through windows will suffer some degradation. In some smaller planes, you can open the windows, and in some helicopters the door can be removed. If that's not possible, position the camera close to the window, but don't lean on it. If your camera has infinity-lock or manual-focus modes, use them so the camera doesn't try to focus on the window.

3 FLASH OFF. Turn your flash off. It can't possibly light the earth below and might cause drastic underexposure. If the windows are closed, the flash will also cause glare.

4 AVOID VIBRATIONS. Don't lean on the fuselage of the plane or helicopter because you'll pick up the vibrations of the motor and take blurry pictures even at high shutter speeds. Instead, let your body act as a natural shock absorber. Hot-air balloons are a photographer's dream, because there is no motor once the desired height is reached, they move relatively slowly, and they're nearer the ground, so there is less atmosphere (and thus less haze) between camera and subject.

5 FAST SHUTTER SPEEDS. The vehicle is vibrating, and you're moving, so you'll need a very fast shutter speed. With a point-and-shoot camera, select a fast film. With an SLR, you may be able to use a slower film if you set a fast shutter speed. Don't worry about the aperture—you'll be at a great distance from your subject, so depth of field won't be an issue.

Underwater Photography

There are two radically different types of underwater photography—deep water and shallow water. Several underwater point-and-shoot cameras work to a depth of about 16 feet and are perfect for pools and snorkeling, as well

as boating, skiing, and other wet sports. A disposable, single-use underwater camera is an inexpensive way to get started.

Inexpensive underwater housings, such as those made by Ewa-Marine, look like industrial-strength Ziplock bags with a built-in filter for the lens and a glove for your hand. They come in many different sizes for everything from point-and-shoot cameras to larger SLRs with accessory flash. Most allow you to descend with your camera to depths of 30 to 150 feet.

If you plan to dive with your camera, you'll need a diving camera that can withstand the pressure of the water, such as one made by Nikonos or Sea & Sea. Heavy-duty underwater housings are also available for most cameras.

The deeper you dive, the less sun reaches through the water. Sunlight is also filtered by the water, so you see very little color with the naked eye—but it is there. A high-powered underwater flash unit (sometimes called a "strobe") will light the scene for the camera. Unfortunately, this flash also illuminates silt and particles in the water that make it murky.

UNDERWATER DIFFICULTIES

You can't change film underwater, so shoot sparingly if you're going to be diving for an hour. Even if you have the option to return to the surface, the camera must be thoroughly air-dried before reloading, because the slightest moisture can cause problems with the electronics and film advance. Many divers are switching to digital photography because they can "edit on the fly," deleting bad images while underwater to make room for additional shots. Additionally, large memory cards (some holding over a gigabyte of memory) provide many more images than a single roll of film.

Helicopters are extremely maneuverable, making them a popular choice for aerial photography. Photo © Jen Bidner

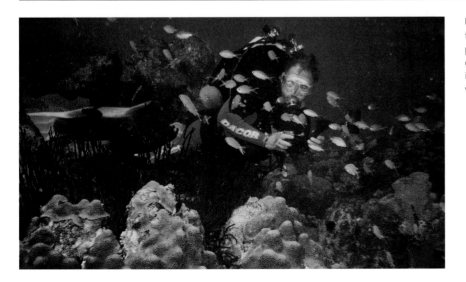

Underwater cameras are available in two classes. One is designed for use in pools and for snorkeling (to a maximum depth of about 16 feet), while the other is engineered for scuba diving in deeper water. Photo © Tony Amenta

Pictures for Online Auctions

If you want to sell products, fine-art photographs, antiques, or just old stuff from your garage on Ebay or other online auction sites, you'll need digital pictures. On page 17 we explain how to digitize your film images, or, of course, you can shoot with a digital camera.

You can also use a scanner to "take digital pictures" of relatively two-dimensional objects. You can even place some three-dimensional objects on the scanner and cover them with black velvet for adequate results.

Good auction pictures will definitely improve your sales. However, give some thought to what constitutes "good" in this kind of picture. Obviously, because you want the product to look great, you'll pay attention to composition, background, and lighting choices. But you don't want to make it look so good that it becomes "fiction." When the winning bidder receives the product and it looks much worse than the pictures, you'll probably get complaints and even a bad feedback rating. Therefore the photo should be an honest rendition of reality, but the best possible honest rendition!

Miniature Studios

If the products you hope to sell are three-dimensional, you'll need to create a miniature photo studio. Start by setting up a simple background with a large sheet, a tablecloth, or other fabric. True high-quality velvet is the best because its structure causes it to absorb light and make wrinkles and folds almost invisible in the picture.

Choose Your Lighting

Create your setup near a window or outside in the sun or shade. Shiny objects tend to do best with diffuse lighting, so shoot in shade or in the light from a north-facing window. Use a diffuser to soften direct sunlight. Fill shadows with a white poster board reflector or a piece of cardboard that has been covered with crumpled tinfoil. (See pages 117, 169, and 182–183.)

POSTING YOUR IMAGES

Follow the guidelines provided by the auction site for the desired size of your picture files before you "upload" them. If they are at too low a resolution, they will appear small or blocky and without detail. If they are too high in resolution, they will take "forever" for the end user to download, which could mean lost sales if the potential buyer gets tired of waiting.

In photo-editing software, save the image at about 2×3 inches at 100dpi (200×300 pixels) if the product has few details and fast loading is imperative. Go to a higher resolution of 4×6 inches at 100dpi (400×600 pixels) for more detailed products. Note that the images may not actually show up at that size if the individual viewers' browsers are set to unusual sizes.

Either way, save the image in the jpeg file format at a low-quality (high-compression) setting. If your software has a preview capability, slide the quality/compression scale during the "save as" process until you see a degradation in quality, then go one click higher in quality.

The photographer shot a very clean, simple photo using only a diffused flash unit, a silver reflector made of crumpled tinfoil taped to cardboard, and black velvet. Genuine high-quality velvet absorbs the light to minimize the appearance of wrinkles or folds.

A shiny metal cherub sculpture looks okay in direct sunlight (left). However, diffusing the sun with sheer white fabric (in this case a commercially made collapsible photo diffuser) softens the light and makes it look richer and prettier (right).

Create a backdrop by draping fabric that sweeps under and behind the subject (above). Then move in on the main subject (left). If the wrinkles and drapes in the fabric are distracting, you can remove them through retouching or switch to a velvet backdrop.

The Road Ahead

We hope the 600 pictures and nearly 200 pages of text in this book give you the tools you need to vastly improve your photography. But even the best book can take you only so far. Consider taking a seminar, workshop, or class to further hone your skills in a particular specialty. Or join a camera club to share ideas with other photographers.

When you start getting amazing pictures, it can be a natural impulse to consider going pro. Luckily, this does not have to be a major, life-altering decision if you begin on a part-time basis, selling a few pictures here and there in your spare time. You'll need to research a few business topics—most importantly, model releases and copyright laws.

If your aim in wanting to sell your photos is to turn your hobby into a great tax deduction, watch out! In order to claim photography business losses, you must be able to prove that you are trying to legitimately run a business and have a reasonable expectation of making a profit. See an accountant before trying this strategy.

Learning More

Photography is a continuing educational experience. Long after you have mastered your equipment, you will be honing your artistic skills and developing a personal style.

Workshops such as those taught by Russ Burden, who photographed most of the images in this book, are a good way to sharpen your skills and collect new ideas. Members of photography clubs get together and share ideas and images and enjoy group activities.

Community colleges often offer photography classes. Schools like the Rochester Institute of Photography, the California Arts Institute, and the Brooks Institute offer associate, bachelor, and even masters degrees in commercial and fine-art photography.

Annual conventions—like VISCOMM (formerly called Photo East)—and events sponsored by such groups as the Professional Photographers of America (PPA) and Wedding & Portrait Photographers International (WPPI) offer lectures on many different specialties and techniques.

Earning Part-time Money

Business-savvy individuals often find ways to subsidize their hobby by selling their pictures. Small newspapers will sometimes buy images from freelance "stringers" who shoot local sports and other events. Crafts fairs can provide a good venue for selling images. If you have a distinctive style, you may be able to do portraiture work. If you are knowledgeable about dogs or horses, you might want to approach local stables, breeders, or dog groomers and post a flyer on their bulletin boards.

If you have not honed your skills for such specialty work, don't claim something you can't deliver. Instead, explain that you are just learning or are an advanced hobbyist and that you're willing to shoot on speculation— if the pictures are not all the potential client has imagined or more, he doesn't have to buy them. Obviously, you don't want to do this for non-repeatable events like weddings and horse shows. Important one-time events are